Van Gogh and God
A Creative Spiritual Quest

Cliff Edwards

A Campion Book

Loyola University Press
Chicago, Illinois

© 1989 by Loyola University Press
Printed in the United States of America

∞

Library of Congress Cataloging in Publication Data

Edwards, Cliff, 1932-
 Van Gogh and God: a creative spiritual quest/Cliff Edwards.
 p. cm.
 Includes bibliographical references.
 ISBN 0-8294-0621-2 (alk. paper)
 1. Gogh, Vincent van, 1853-1890—Religion. I. Title.
 ND653.G7E34 1989
 759.9492—dc20 89-12744
 CIP
ISBN: 0-8294-0621-2

Excerpts from *The Complete Letters of Vincent Van Gogh* appear by
permission of Little, Brown and Company in conjunction with
the New York Graphic Society to whom the author and publisher
acknowledge their gratitude. Permission to reproduce photo-
graphs of van Gogh's paintings was procured from Vincent van
Gogh Foundation/National Museum Vincent van Gogh, Amster-
dam; The Anderson Gallery, Virginia Commonwealth Univer-
sity, Richmond, Va.; Collection of Mr. and Mrs. Paul Mellon,
Virginia Museum of the Fine Arts; Stedelijk Museum, Amster-
dam. Photograph on front cover: Courtesy of (Fogg Art Mu-
seum), Harvard University, Cambridge, Massachusets; bequest of
collection of Maurice Wertheim, class of 1906.

*to all the students
I have taught*

*to all the students
who have taught me*

Contents

Illustrations

Foreword

Cliff Edwards' *Van Gogh and God* is the book I have been eagerly
awaiting. After all these decades of van Gogh studies, finally
someone opens up for us Vincent's deepest quest and convinc-
ingly shows that the art of the "sorrowful, yet always rejoicing"
Dutch painter is of deep theological and spiritual significance.
Cliff Edwards radically dispels the view that Vincent was lost in
religious fanaticism until he found his true vocation as a painter.
He clearly demonstrates that the whole of Vincent's life and work
is a rich source for all those who search for a deeper knowledge
of God.

 This book brings back to me very precious memories. While
on the faculty of Yale Divinity School, I taught several seminars
on "The Ministry of Vincent van Gogh." There is no doubt in my
mind that these seminars had a much more profound effect on
my students than any other seminar or course I taught. I have
used many spiritual writers, especially the contemporary writer
Thomas Merton, as useful guides, but I have never found stu-
dents to be more personally, intellectually, and emotionally
involved than they were during periods of attentive looking at
Vincent's drawings and paintings. I still remember how we
would spend long hours together in silence, simply gazing at the
slides of Vincent's work. I did not try to explain much or analyze

much. I simply wanted the students to have a direct experience of the ecstasy and the agony of this painter who shared his desperate search for meaning. After such seminars it seemed that we all had been touched in places that no spiritual writer had been able to reach. A similar effect resulted from the readings of Vincent's letters. Their haunting, passionate expression of longing for a God who is tangible and alive, who truly comforts and consoles, and who truly cares for the poor and the suffering brought us in touch with the deepest yearnings of our soul. Vincent's God, so real, so direct, so visible in nature and people, so intensely compassionate, so weak and vulnerable, and so radically loving, was a God we all wanted to come close to.

The van Gogh seminar was born out of my own feeling of affinity with Vincent and his work. Few writers or painters have influenced me as much as Vincent. This deeply wounded and immensely gifted Dutchman brought me in touch with my own brokenness and talents in ways nobody else could. The hours spent walking through the Kröller-Möller Museum in the Netherlands and the days spent reading his letters were personal times of restoration and renewal. They were times of solitude in which a voice spoke that I could listen to. I experienced connections between Vincent's struggle and my own, and realized more and more that Vincent was becoming my wounded healer. He painted what I had not before dared to look at; he questioned what I had not before dared to speak about; and he entered into spaces of the heart that I had not before dared to come close to. By doing so he brought me in touch with many of my fears and gave me the courage to go further and deeper in my search for a God who loves.

And now here is the book: *Van Gogh and God*. It almost seems that Cliff Edwards, in his careful and sensitive study of Vincent's spiritual journey, is telling me that I was not crazy after all when I spoke of Vincent as one of the main spiritual guides in my life and when I invited students to discover him as a true source of theological reflection.

I have always felt uncomfortable with the many psychological and psychoanalytical interpretations of van Gogh's work. Although they opened my eyes for the significant connections between Vincent's personal life and the way he expresses himself in his drawings and paintings, I always sensed that there was something to be said and understood that went far beyond the

level of psychodynamics. It is Cliff Edwards' great contribution that he has helped us to better understand the spirituality of van Gogh. With remarkable lucidity, he shows how deeply Vincent's spirituality was molded by the Zen Buddhist as well as by the Christian tradition; the best of the Japanese as well as the Dutch spiritual heritage were being lived and expressed by Vincent in word and picture. Most original is Edwards' perspective on the "Oriental connection" in Vincent's work. The nonhuman-centered way of Zen Buddhism brings us close to Vincent's approach to nature and helps us to understand why Vincent saw health and restorative forces where we are inclined to see only violence, chaos, and approaching death.

Cliff Edwards' astute understanding of Zen Buddhism, as well as of Christianity, has allowed him to portray Vincent as one of the most significant spiritual figures of the nineteenth century—an artist who fully deserves the attention of modern theologians interested in the interreligious dialogue.

After reading *Van Gogh and God,* I understand much better why Vincent had such a deep effect on me and countless people. Cliff Edwards' study makes it clear that Vincent wants not only to lead us to a new way of seeing but also to a new way of living. He invites us through his art to a change of heart. Vincent always remained a minister and for that reason in front of his drawings and paintings we experience a call to conversion. That most likely is the deepest reason for his universal appeal.

I am deeply grateful that *Van Gogh and God* has been written and I am convinced that those who read it will find in Vincent a lasting spiritual companion.

HENRI J. M. NOUWEN

Preface

Vincent van Gogh was born in a small Dutch village in 1853 and was buried among the grainfields on a French hilltop in 1890. Of his thirty-seven years of life, sixteen were spent under the guidance of his parents in a Dutch Reformed parsonage, seven as an art gallery clerk, three in religious studies and service in England, Holland, and Belgium, one as an unemployed wanderer, and the last ten as a painter.

One hundred years have passed since van Gogh's death, and books, articles, exhibitions, symposia, psychological analyses, songs, dramas, and even an opera have been focused on his life and work. Nevertheless, the van Gogh mystery becomes deeper and the puzzles and contradictions regarding him increase with each passing year. How can this largely unrecognized and penniless artist who devoted only ten years to painting have gained such phenomenal global popularity in our day? What can account for the willingness of a Japanese insurance firm to pay the extraordinary price of 39.9 million dollars to bring one faded and cracked sunflower canvas by van Gogh to Japan? How can one explain the unprecedented 53.9 million dollars paid on November 11, 1987, for his painting of irises? The price paid for either painting would have been sufficient not only to build an entire modern museum but to adequately furnish it with representative art from all the ages.

Old questions remain unanswered and new questions force themselves upon those interested in van Gogh and the role of art in human culture. Why is it that this artist's work is as highly valued in the Orient as in the Occident? Was van Gogh insane,

and does his work reflect madness? What relationship is there between the dark portraits of peasants painted in Holland and the brilliantly colored landscapes painted in France? Questions range from the popular "Why did he cut off his ear?" to the more philosophic "How could an artist so attuned to the beauty of earth have chosen to leave it by suicide?" "Does van Gogh affirm life or deny life?" Each of these questions is one of our concerns, and will be addressed in this book.

There is, however, a more all-encompassing puzzle which is at the center of our study, a puzzle which may itself be the key to many of the mysteries and contradictions surrounding van Gogh. The puzzle is this: How can it be that among the hundreds of works dealing with van Gogh there is none devoted to a sustained study of his spiritual quest, his religion, his beliefs regarding God, salvation, the Bible, and immortality? Why has no theologian focused a major work on this creative artist who was brought up in a family of pastors, raised in a parsonage, nurtured in an atmosphere of daily prayer, Bible-reading, and worship? Why has so little been done to study van Gogh's aspiration to be a country parson, his service as lay preacher and teacher in Methodist parishes of England, his being tutored for entry to theological school in Holland, his attendance at an evangelical missionary training school in Belgium, and his work as missionary, preacher, and Bible-teacher among Belgian miners? Why has his spiritual quest not been studied as a possible key to the paradoxes in his life and work?

Interestingly enough, it is the sensitive art critic who has recognized that the uniqueness of van Gogh lies beyond art-critical concerns and moves into the (area of theology and spiritual formation] For example, the German art critic, Julius Meier-Graefe, one of the early "discoverers" of van Gogh's work, confessed that he might well have entitled his van Gogh biography "van Gogh and God."[1] Likewise, the famous American art critic, Meyer Shapiro, in his 1980 volume, *Van Gogh*, described the uniqueness of van Gogh's life to be "the fact that art was for him . . . [a choice made for personal salvation] . . . a deeply lived means of spiritual deliverance or transformation of the self. . . . an alternative to older moral-religious means." Shapiro affirmed of van Gogh:

His career as an artist is a high religious-moral drama and

not only a rapid development of a style and new possibilities of art. [2]

If art critics have recognized that religion and spiritual transformation are central elements in van Gogh's life and work, why is it that theologians and historians of religion have shown so little interest in him? Why have most scholars of religion, in fact, studiously ignored him? Anthologies and studies in religious thought have been broad enough to include the work of persons as diverse as William James, Sigmund Freud, Carl Jung, Friedrich Nietzsche, Claude Levi-Strauss, Tolstoy, Dostoevsky, Karl Marx, Kierkegaard, C. S. Lewis, and Albert Camus, but no major theological study or anthology has taken serious account of the "religious-moral drama" of Vincent van Gogh.

Perhaps one explanation for the absence of van Gogh from the work of theologians is directly related to the departmentalization of knowledge in the modern academic world. The very fact that in libraries the three large volumes of van Gogh's introspective letters dealing with his religious evolution and theological musings are housed among the art books rather than in the religious studies collections is enough to discourage many. Others may assume that "letters" are not a likely source for serious theological reflection, a rather odd assumption when one considers that the larger part of the New Testament is composed of letters.

It may be that neither the location nor the form of van Gogh's writings is primarily to blame for their neglect by scholars of religion. The heart of the matter may be that the wall Western religionists have erected between "word" and "image" has disqualified van Gogh as theological resource, for his religious quest is expressed not only in words but more uniquely in drawings and paintings. The Western prejudice in favor of "God as Word" has likely led to the avoidance of one who took seriously "God as Image." Theological discourse expressed as Word and words has been so privileged, the verbal manner of doing religion has become so comfortable, that one devoted to the making of images must be suspect and excluded from consideration. Prejudice and habit have led most Judeo-Christian scholars to the unyielding position that religion must be expressed primarily as *hearing* and *obeying*, and cannot be expressed significantly as *seeing* and *creating*.[3]

My purpose in this book is to help us move in the direction
that sensitive art critics have pointed out, to enter the territory
that theologians have generally ignored: the creative spiritual
quest of Vincent van Gogh that he expressed in both word and
image. It is my conclusion, after several years of investigation,
that an understanding of van Gogh from the perspective of his
spiritual search is a key to the unity of the artist's life and work,
casting new light on many of the mysteries and contradictions,
and solving certain persistent van Gogh puzzles. Further, I hope
that this work will make some contribution toward clarifying
problems regarding van Gogh in the art-historical and art-critical
areas. More important, I hope that this study will provide a new
dimension of meaning and significance for those who view van
Gogh's paintings.

Also I hope that this study will raise serious questions regard-
ing traditional limitations scholars have imposed upon theologi-
cal and spiritual formation studies in the West, that it will sug-
gest new sources for creative theological inquiry, and that it will
offer ways of liberation for persons who have felt themselves
suffocated, or excluded, by narrow definitions of religion and
restricted ways of doing theology.

A brief description of the structure of this study may be
helpful at this point. To begin with, there is a chronological guide
intended to provide a "bird's-eye view" of the course of van
Gogh's life and a chronology of his letters.

Chapter one details factors which seem to have alienated
Vincent van Gogh from "proper" middle-class society at an early
age, and will describe the manner in which he came to interpret
that alienation as a life-mission based upon biblical injunctions.

Chapter two seeks to prove that crucial interpretations of van
Gogh's life-development repeated in almost every book on the
artist are without sufficient creditable foundation and are likely
wrong largely because they have not taken his religious orienta-
tion seriously.

Chapter three describes a key element in van Gogh's reli-
gious transformation, his conversion from a man of one book,
the Bible, to a modern man devoted to contemporary literature
as "a new Bible for a new day."

Chapter four presents van Gogh's theology, demonstrating
how God is experienced in the depths of the artist's own failures,
a God whose vulnerability is viewed as humanity's best hope for

a life beyond death. In this connection, van Gogh developed a unique and creative "theology of the cradle."

Chapter five, entitled "The Oriental Connection," examines a little-known facet of van Gogh's life, his study and practice of Japanese art in order to broaden his own Christian faith with the experience of a Japanese-Buddhist approach to nature. We find the key to the global appeal of van Gogh's art in his synthesis of Eastern and Western experiences of spirituality.

Chapter six seeks to overcome the limitations of a Western code book, or psychological, approach to van Gogh's symbolism through a broader East-West approach to *symbol* that is more appropriate to an understanding of van Gogh's spirituality and his work.

My intention to provide a new perspective on van Gogh carries the responsibility for describing my own limitations and credentials. I am neither an art historian nor an art critic. I have relied upon, and gained much from, the work of experts in these fields. Always at my elbow have been such volumes as Jan Hulsker's *The Complete van Gogh* (1980), Marc Tralbaut's *Vincent Van Gogh* (1969), *Van Gogh: A Retrospective* by Susan Stein (1986), and works by Roskill, Rewald, Nordenfalk, Leymarie, and many others. Ronald Pickvance's catalogues to the New York exhibits, *Van Gogh in Arles* (1984) and *Van Gogh in Saint-Rémy and Auvers* (1986), and a variety of publications from the Rijksmuseum Vincent van Gogh in Amsterdam and the Rijksmuseum Kröller-Muller in Otterlo, Holland, have been especially helpful in my work. Also I have made regular use of the two-volume *Verzamelde Brieven van Vincent van Gogh* (1974) and the three-volume English equivalent, *The Complete Letters of Vincent van Gogh* (1958). The translation and numbering of van Gogh's letters used in the following chapters will follow the three-volume English edition because of its easier availability. In those letters van Gogh clearly indicated that as an artist he preferred the simple name *Vincent;* therefore, I will generally refer to him as such.

My own training includes degrees in biblical interpretation and comparative religion at Garrett Theological Seminary and Northwestern University, theological studies with the Protestant and Roman Catholic faculties at the University of Strasbourg in France, and biblical studies at the University of Neuchâtel in Switzerland. Interest in Asian religious thought led me to spend a year in Kyoto, Japan, at Daitokuji temple, where I studied

Buddhist art and wrote a little book on nature mysticism. Opportunity to deliver lectures on Asian art at the Virginia Museum of Fine Arts led to a series of papers on the influence of Asian art and Buddhist philosophy on the French impressionists. That study led to an investigation of van Gogh's letters and several trips to Amsterdam and Otterlo to study the artist's work and to view the collection he had made of Japanese prints.

I admit to a feeling of special kinship with Vincent van Gogh which has perhaps allowed me certain insights regarding the artist's background. Vincent was born a year after his parents had a still-born child, and was raised as the oldest of six children in a small village. I too was born a year after my parents had a still-born child, and was raised as the oldest of seven children in a small village. Vincent was a student of the Bible who served as a teacher and preacher within the Methodist Church before beginning his painting career. I was a student of the Bible who served as a teacher and preacher within the Methodist Church before beginning my academic career. Vincent developed a special interest in Oriental art and collected Japanese prints; for the past fifteen years I have done the same. Such similarities have led me to feel an intimacy with the dynamics of the van Gogh family and Vincent's religious quest which began with the Bible and village churches, moved into the wider realm of contemporary art and literature, and finally sought a relationship with Asian cultures.

For me, Vincent van Gogh's current popularity is a two-edged sword. Cutting in one direction, it provides a large and varied audience for this study, an audience already enthusiastic, curious, and moved by Vincent's life and work. That audience has gone out of its way to see van Gogh paintings, owns a van Gogh calendar, remembers Kirk Douglas in *Lust for Life*, and has a print of *Sunflowers* or *The Starry Night* on a bedroom wall. I am happy there is such an audience.

But the sword cuts in another direction. I believe there is something bizarre, grotesque, even destructive, in the conversion of a penniless sufferer's rejected and often threatening work into pleasant symbols of popular culture or cultish possessions for the very rich. It was often Vincent's deepest commitments and purposes that made his work an object of scorn and refusal to many people. Further, it was never his wish that the art of dead painters command high prices, but that the struggles of current

artists receive encouragement. Imagine how many creative artists might have been supported for years on the money required to purchase that one iris painting by the dead Vincent van Gogh.

My intent is that this book will draw on a broad and deep popular interest in Vincent van Gogh, and with this in mind I will focus whenever possible upon his own ideas in his own words. My further hope is that this book will uncover the very element in his art which often made it threatening and unacceptable to his contemporaries, allowing us the liberty of a genuine encounter and honest response to van Gogh's life and work.

Acknowledgements

I am grateful to the many who have helped me in the writing of this book: A grant from the Virginia Foundation for the Humanities and Public Policy and a Research Semester granted by Virginia Commonwealth University provided writing time, for which I am deeply grateful. Marcia Powell of Richmond discussed with me every line of the French text of Vincent's letters, and Dorothy Fillmore made valuable suggestions for improving my first draft of several chapters. My son David, a painter, taught me a good deal about the concerns of an artist, and my daughter Susan, a public school teacher, alerted me to questions of creativity and communication. My wife Jocelyne and two-year-old son Christopher provided a happy refuge after each day's research, and refreshed my mind on hikes along the James River. Jocelyne's father, Professor Fernand Marty, provided me with access to rare French periodicals of Vincent's day. Finally, I am grateful to Rev. George Lane, Director of Loyola University Press; to Jeanette Rubsam-Ertel, Senior Editor, who provided careful and thoughtful editorial assistance and made the putting of this book into print both a possibility and a pleasure; and to the dedicated production staff of Loyola University Press under the direction of Frederick Falkenberg.

Chronological Guide
The Life of Vincent van Gogh

"Brabant is ever Brabant, and one's native country is ever one's native country, and countries of exile are ever countries of exile" (letter 82a).

1853	Zundert in Brabant, Holland	March 30: Vincent born to the Reverend Theodorus van Gogh (1822-1885) and Anna Carbentus (1819-1907), followed by 5 more children: Anna, Theodorus, Elisabeth, Wilhelmina, and Cornelius
1869	The Hague	July 30: Vincent apprenticed as clerk at age 16 in Goupil and Company Art Gallery
1872		August: Vincent, age 19, begins lifetime correspondence with brother Theo, age 15
1873	London	June: Vincent transferred to Goupil's London branch; religious transformation begins

1875	Paris	May: Vincent transferred to Goupil's Paris branch: secludes himself for Bible-study
1876	Ramsgate and Isleworth	April: Vincent dismissed from Goupil and Company; teaches and assists a Methodist minister in England
		November: Preaches his first sermon
1877	Dordrecht	January: Family convinces him to take a job as bookseller's clerk in Holland; continues Bible-study
	Amsterdam	May: Moves to Amsterdam to be tutored for university exams for theological school
1878	Etten	July: Abandons studies; returns home to the parsonage, now in Etten
	Brussels	August: Enters Missionary Training School
1879	The Borinage	January: Appointed as an evangelist in the Belgian mining district
		July: Dismissed by the Synodal Board of Evangelization; remains to sketch the miners; decides to become an artist
1880	Brussels	October: Takes a room in Brussels to continue his art practice and seek help from other artists

1881	Etten	April: Returns to his parents' parsonage to draw and paint; falls in love with Kee Vos
		December: Argues with his father on Christmas and is ordered out of the house
1882	The Hague	January: Studies briefly with the artist Anton Mauve; takes an ill and pregnant prostitute, Sien, and her daughter, into his studio
		July: Sien's boy is born
1883	Drenthe	September: Leaves the Hague and wanders in the desolate Drenthe region, in debt and depressed
	Nuenen	December: Returns to parents' parsonage, now in Nuenen; arranges a studio behind the parsonage
1884		January: Vincent and sister Wil care for injured mother
		July: Margot Begemann falls in love with Vincent and attempts suicide
1885		March 27: Vincent's father dies
		April: Vincent paints *The Potato Eaters*
		October: Vincent paints his father's Bible in a still life

		November: Vincent leaves home forever; hundreds of drawings and paintings left behind are eventually destroyed
1886	Antwerp	January 18: Enrolls in the Academy of Art
	Paris	February 27: Moves into Theo's Paris apartment
		March: Attends Cormon's Studio classes; meets many of the impressionists; arranges café art showings; buys Japanese prints at S. Bing's shop
1888	Arles	February 21: Travels to South France to paint in a country "beautiful as Japan"
		March: Paints blossoming orchards
		June: Visits nearby Saintes-Maries-de-la-Mer to sketch boats and sea
		September: Moves into Yellow House; paints sunflowers
		October 20: Gauguin arrives
		December 24: Vincent mutilates his ear and is hospitalized; Gauguin leaves
1889		February 27: Forcibly hospitalized by police in response to a petition

April: Theo marries Johanna Bonger

Saint-Rémy

May 8: Voluntarily enters the Asylum of Saint-Paul-de-Mausole; paints irises, olive trees, cypresses, starry night

1890

January: *Mercure de France* carries Aurier article praising Vincent's paintings

February: Paintings sent to exhibition in Brussels; *The Red Vineyard* sells for 400 francs

Paris

May 17: Leaves the Asylum and visits Theo, Jo, and their child in Cité Pigalle apartment

Auvers

May 21: Takes a room at the Ravoux Café; meets Dr. Gachet

June 8: Theo, Jo, and child visit Vincent in Auvers

July 6: Worried Vincent visits Paris and his ill god-child

July 27: Vincent shoots himself; returns to Ravoux Café

July 28: Theo arrives to be with Vincent

July 29: Vincent dies

July 30: Funeral, with Anton
Hirschig, Charles Laval, Lucien
Pissarro, Père Tanguy, Émile
Bernard and others in atten-
dance

1891 Holland

January 25: Death of Vincent's
brother Theo; the two brothers
now lie side by side in graves in
the village of Auvers in France

Chronology of the Letters

As reconstructed in *The Complete Letters of Vincent van Gogh* by Vincent's Sister-in-law, Johanna van Gogh-Bonger

"Have you kept my epistles? If you have a little time to spare, and they have not perished in the flames, then I say: read them again, although it may seem pretentious to ask such a thing of you. But I did not write them without serious intentions, though I was not afraid to speak my mind freely and to give free rein to my imagination." (Vincent to Rappard, R 5)

Letters to Theo	Month and Year	Places of Origination
1–8	August 1872–May 1873	The Hague, Holland
9–26	June 1873–May 1875	London, England
27–59	May 1875–March 1876	Paris, France
60–83	April–December 1876	Ramsgate, Isleworth, England
84–94	January 1877–April 1877	Dordrecht, Holland
95–122	May 1877–July 1878	Amsterdam, Holland
123–143	July 1878–April 1881	Etten, Holland, The Borinage and Brussels, Belgium
144–165	April 1881–December 1881	Etten, Holland
166–322	December 1881–September 1883	The Hague, Holland
323–343	September 1883–November 1883	Drenthe, Holland
344–435	December 1883–November 1885	Nuenen, Holland
436–458	November 1885–February 1886	Antwerp, Belgium
459–462	March 1886–February 1888	Paris, France
463–590	February 1888–May 1889	Arles, France
591–634	May 1889–May 1890	Saint-Rémy, France
635–652	May 1890–July 1890	Auvers-sur-Oise, France

Letters to Anthon G. A. Ridder van Rappard, a Dutch Painter
R 1–R 58 October 1881–September Etten, The Hague,
 1885 Drenthe, Nuenen

Letters to his youngest sister, Wilhelmina
W 1–W 23 ? 1887–June 1890 Paris, Arles, Saint-Rémy,
 Auvers

Letters to Émile Bernard, a French Painter
B 1–B 21 Summer 1887–December Paris, Arles, Saint-Rémy
 1889

A brief discussion of problems in dating Vincent van Gogh's letters, and a chart detailing Dr. Jan Hulsker's attempt to redate with precision certain of the letters can be found in "The Dating of van Gogh's Letters from Saint-Rémy and Auvers," Appendix 1 of Ronald Pickvance, *Van Gogh in Saint-Rémy and Auvers* (New York: The Metropolitan Museum of Art, 1986), 291–92.

1

A Pilgrim's Progress

Vincent van Gogh found deep, personal meaning in the biblical description of life as pilgrimage, and devoted the first sermon he ever preached to that theme. In November 1876, he mounted the pulpit of a small Methodist church in Richmond, England, and affirmed that "our life is a pilgrim's progress":

> We are pilgrims on the earth and strangers—we have come from afar and we are going far—The journey of our life goes from the loving breast of our Mother on earth to the arms of our Father in heaven. Everything on earth changes—we have no abiding city here—it is the experience of everybody. That it is God's will that we should part with what is dearest on earth—we ourselves change in many respects, we are not what we once were, we shall not remain what we are now.[1]

Vincent, at age twenty-three, convinced that he would follow in his father's footsteps as pastor, missionary, or teacher of the Bible, seems to have drawn together in this one sermon the experiences of his youth and marked out directions his spiritual quest would take during the remaining fourteen years of his life.

A sense of passing through life in loneliness and alienation permeate the sermon, and "pilgrimage" provides a spiritual interpretation for this experience of estrangement. The related theme of impermanence, "we have no abiding city here," endows with religious meaning the bewildering changes of late nineteenth-century Europe and the lonely and often unsympa-

thetic rooming houses and workplaces far from home with which Vincent was forced to cope. The "great storms of life" described further on in the sermon soon become storms in "the heart of man," and Vincent applies the theme of change directly to the self, a description of personal transformation: "we are not what we once were, we shall not remain what we are now." Alienation, impermanence, and transformation become key words within the greater religious drama of pilgrimage toward "the arms of our Father in heaven." Both life's problems and the spiritual resources for interpreting and transforming those problems appear deeply rooted in Vincent van Gogh's recollections of his early years and religious environment.

Vincent's personal pilgrimage would lead him from a Calvinist parsonage in the modest Dutch village of Zundert to some of the great cities of his day: London, Paris, The Hague, Amsterdam, and Antwerp; to a new experience of sun and countryside in the south of France; to a final resting place in the hills of Auvers on the Oise River.

His pilgrimage would take place in the midst of the ongoing turmoil of Europe, where the privilege of birth continued to give way to the power of industry and commerce, and the horse and hoe were being replaced more and more by the machine and conveyor belt. These were the scenes of his pilgrimage, but the most profound level of that pilgrimage took place in the recesses of Vincent's own spirit as he struggled with pangs of guilt and promises of salvation, with the narrow path of divinely appointed tribulations and the wider way of a new literature and a new art.

There is an early description of Vincent by a member of his own family. Elisabeth Huberta van Gogh, one of Vincent's three younger sisters, published a personal recollection of Vincent in 1910, some twenty years after Vincent and his brother Theo had both died. Though the recollection is highly stylized and often rather vague, it does provide a sister's description of Vincent in his teens. Elisabeth pictured herself and her sisters playing in the parsonage garden:

> Turning around, one of them saw approaching their older brother Vincent, a seventeen-year-old boy as square as he was tall, with a slight stoop for he had the bad habit of walking with his head down. His close-cropped red-blond hair was hidden

under a straw hat. He had a strange, not young looking, face, the forehead full of lines, the eyebrows on the large, noble brow drawn together in deepest thought. The eyes, small and deep-set, were now blue, now green, according to the impression of the moment. But in spite of all awkwardness and the ugly exterior, one was conscious of a greatness, through the unmistakable sign of the deep inner life.[2]

Apart from her seeking some sign of Vincent's later "greatness," Elisabeth described Vincent as awkward, unattractive, and given to strange mannerisms. She further recollected that he avoided the "watchful eyes" of villagers and much preferred solitude in nature where he became a "young naturalist," collecting plants and insects, and studying birds in their native habitat.[3]

S. Aertsen-Honcoop, a woman who had worked as a serving-maid in the van Gogh parsonage, had opportunity to observe Vincent as a youngster:

> There was something strange about him. He did not seem like a child and was different from the others. Besides, he had queer manners and was often punished. He was covered with freckles. His hair was red as fire.[4]

Marc Tralbaut, a van Gogh scholar, interviewed Hendrik Hoppenbrouwers, a village schoolmate of Vincent's. Hendrik recalled:

> He was an ugly red-headed boy who liked to go by himself on many long walks across the fields. . . . Vincent was a good pupil and read a great deal. We were beaten from time to time, but on other occasions we also got up to mischief together. All the same, as I said before, Vincent went off on his own for most of the time and wandered for hours together around the village, and quite a long way from it.[5]

These early remembrances of Vincent's ugliness, unattractiveness, strangeness, peculiar mannerisms, and a preference for solitude are expanded to include unusual ascetic practices, nervous habits, sadness and melancholy, and a peculiar voice as later observers describe Vincent's days as bookstore clerk, theology student, and artist.

At age twenty-four, Vincent worked briefly in a bookshop in

the Dutch town of Dordrecht, rooming and boarding with the Rijken family. Mr. Rijken remembered Vincent as "a queer chap, and no mistake," who "shuffled" about in his room all night, purposely missed meals, and responded to their concerned questions with the words, "I don't want food, I don't want a night's rest." According to Mr. Rijken, Vincent wore a blue smock which made him look "like an immigrant," and he was often teased by others. Mr. Rijken noted, "I keep seeing him as a scapegoat."[6]

Vincent shared a room at the Rijken home with Mr. Görlitz, an assistant teacher, who left his impressions of Vincent:

> He was a singular man with a singular appearance into the bargain. He was well made, and had reddish hair which stood up on end; his face was homely and covered with freckles, but changed and brightened wonderfully when he warmed into enthusiasm, which happened often enough. Van Gogh provoked laughter repeatedly by his attitude and behavior—for everything he did and thought and felt, and his way of living, was different from that of others of his age. At table he said lengthy prayers and ate like a penitent friar: for instance, he would take no meat, gravy, etc. And then his face had always an abstracted expression—pondering, deeply serious, melancholy.[7]

At age twenty-five, Vincent lived with an uncle in Amsterdam and was tutored for entry into theological studies by a young Jewish scholar, Mendes da Costa. The tutor not only described Vincent's ascetic practices and attachments to the Bible, but also left this description of Vincent arriving for lessons:

> In my mind's eye I can still see him come stepping across the square from the Nieuwe Herengracht Bridge, without an overcoat as additional self-chastisement; his books under his right arm pressed firmly against his body, and his left hand clasping the bunch of snowdrops to his breast; his head thrust forward a little to the right, and on his face, because of the way his mouth drooped at the corners, a pervading expression of indescribable sadness and despair. And when he had come upstairs, there would sound again that singular, profoundly melancholy, deep voice: "Don't be mad at me, Mendes; I have brought you some little flowers again because you are so good to me."[8]

A Scottish painter named Archibald Hartrick remembered Vincent from his days in Paris—sometime between 1886 and 1888. He wrote:

> I can affirm that to my eye Van Gogh was a rather weedy little man, with pinched features, red hair and beard, and a light blue eye. He had an extraordinary way of pouring out sentences, if he got started, in Dutch, English and French, then glancing back at you over his shoulder, and hissing through his teeth. In fact, when thus excited, he looked more than a little mad; at other times he was apt to be morose, as if suspicious.[9]

Dr. Félix Rey, the resident surgeon at the Arles hospital who had attended Vincent following the mutilation of his ear, told an interviewer:

> First and foremost Vincent was a miserable, pitiful man, small of stature (please get up for a moment! About your size), lean. He always wore a sort of overcoat, smeared all over with colors—he painted with his thumb and then wiped it on his coat—-and an enormous straw hat without a hatband, of the type usually worn by the shepherds of the Camargue as a protection against the scorching sun.[10]

What effect did so simple a factor as personal appearance have upon Vincent van Gogh's relationship to society from boyhood on? Did his contemporaries' impression that he was an "ugly red-headed boy" who grew to become a "homely" young man "hissing" through his teeth estrange him from society and encourage a lifelong sense of alienation which provoked further nervous mannerisms and peculiarities? The evidence suggests exactly that.

That Vincent came to be poignantly aware of the negative impression he made on others becomes clear. At age twenty-nine he confided to Theo:

> I shall have to suffer much, especially from those peculiarities which I *cannot* change. First, my appearance and my way of speaking and my clothes. . . . " (Letter 190)

That he could be deeply hurt by negative references to his person, even by those he loved and trusted, becomes obvious in

his description of a scene which took place in the studio of his family relation, Anton Mauve, an established artist he much admired. In a moving letter of 1882 he reported to Theo:

> Do not be angry with me, Theo, for troubling you with this. But this is the way things have been all winter long, and what have I done to deserve all this trouble? All the anxiety and worry cannot but make me nervous and flurried in speech and manner. When Mauve imitated me, saying, "This is the sort of face you make, this is the way you speak," I answered , My dear friend, if you had spent rainy nights in the streets of London or cold nights in the Borinage—hungry, homeless, feverish— you would also have such ugly lines in your face and perhaps a grating voice too. (Letter 191)

Vincent here emphasized the role of hardship upon his appearance and voice, but hardship seems simply to have intensified the problem of a homely boy with peculiar, nervous mannerisms of speech and posture.

The effects of Vincent's appearance on others may have been further influenced by the public's fascination in his day with physiognomic classification, phrenology, pantomime, and caricature. The increased mobility of large numbers of people had contributed to the growing alienation of urban workers, who no longer knew their neighbors, and had apparently led many to look to some *science* of physical appearance for help in the evaluation of strangers. The population of Paris, for example, had become avid viewers of the caricatures drawn for the daily papers by Daumier, Gavarni, Grandville, and Monnier, who all employed a vocabulary of facial features and postures that were intended to represent the class, temperament, and quality of their characters and, by extension, their counterparts in society. As one of the many popular physiognomic manuals of the day put it: *Le Dedans jugé par le Dehors* ("The Inside judged by the Outside").[11] Vincent's bristling red hair, small deep-set eyes, grating voice, and tendency to hiss and to hang his head may have marked him as a "low class" and suspect person to be avoided.

It is obvious that many crucial factors contributing to Vincent's sense of alienation and pilgrim status lie beyond the narrow focus of "personal appearance." The potential for alienation

resulting from Vincent's birth into a family of Protestant pastors and wealthy art dealers in a predominantly poor, agricultural, Roman Catholic village is hardly to be ignored. Neither is the Calvinist atmosphere of a home in which the pastor-father uttered daily warnings regarding the sinfulness of the outside world, or where parents considered the local school "too rough" and so withdrew their parsonage children. We will broaden our focus to include those factors later, but for now let us maintain our narrower focus and note two fascinating biblical passages which were applied to Vincent's appearance. These two dramatic passages of Scripture seem to have presented themselves to Vincent as ways of interpreting his appearance and the resulting alienation in religious terms. Both passages comment directly upon the relationship between strange or homely appearance and divine purpose.

The first was applied, according to Vincent, by Pastor van Gogh, who sought to contrast his two sons, Vincent and Theo. In a letter to Theo, Vincent reminded him:

> Father used to ponder over the story of Jacob and Esau with regard to you and me—not quite wrongly—but fortunately there is less discord, to mention only *one* point of difference, and in the Bible itself there are plenty of examples of better relations between brothers than existed between the venerable patriarchs mentioned above. (Letter 338)

The Esau-Jacob narratives of Genesis (chapters 25–27) are both poignant and revealing when applied to Vincent, for they focus upon external appearance as revelatory of internal character: *Le Dedans jugé par le Dehors*. According to the narrative, two children struggled within the womb of Rebekah, wife of the patriarch Isaac: "The first came forth red, all his body like a hairy mantle; so they called his name Esau" (25:25). Esau is described as a "man of the field, while Jacob was a quiet man, dwelling in tents" (25:27). Esau is impetuous, unable to curb his appetites, selling his birthright for potage prepared by the "smooth" Jacob (25:34). Though Esau, as firstborn, is rightful heir to father Isaac's blessing and inheritance, Rebekah and Jacob conspire to steal the blessing, and Esau is left alienated, a progenitor of the Edomites rather than of the chosen people. The words Father Isaac spoke

to Esau describe an alienated existence:

> Then Isaac his father answered him:
> Behold, away from the fatness of the earth shall your
> dwellings be, and away from the dew of heaven on high.
> (Genesis 27:39)

Though we must resist pushing the details of the biblical narrative too far, it is a strong likelihood that this imagery suggested by Pastor van Gogh and remembered vividly by Vincent years later had an influence on the artist. Upon his father's death, Vincent renounced his part in the inheritance, sent his father's most precious possession, a Bible, to Theo, and moved out of the parsonage forever (letters 41la and 430).

At the heart of the story of Esau's loss of his father's blessing, is a deception in which hairy animal skins are placed on Jacob's hands so that the blind father Isaac might feel them and believe "the hands are the hands of Esau," coarse and hairy, and so bestow the blessing intended for Esau on Jacob. Vincent, as a struggling artist, believed that people saw him as a coarse animal. He wrote Theo during the winter of 1883:

> In the daytime, in ordinary life, I may sometimes look as
> thick-skinned as a wild boar, and I can understand perfectly
> well that people think me *coarse*. When I was younger I
> thought, much more than now, that things depended on
> chance, on small things or misunderstandings that had no
> reason. But getting older, I feel more and more differently, and
> see deeper motives. (Letter 345)

Certainly there is an element of mystery in Vincent's recollections here that defies our interpretation, but some revelation that the apparent "coarseness" of his person had placed a barrier between himself and society since youth seems obvious.

It was during that very period in 1883 that Vincent was seeking a reconciliation with his father at the Nuenen parsonage, but came to feel that the polite and proper parsonage family viewed him as a disruptive animal:

> They feel the same dread of taking me in the house as they
> would about taking a big rough dog. He would run into the
> room with wet paws—and he is so rough. He will be in every-

body's way. *And he barks so loud.* In short, he is a foul beast. . . .
And then—the dog might bite—he might become rabid,
and the constable would have to come and shoot him. (Letter
346)

Vincent's response, as he mused on that imagery, was to
interpret his "coarseness" as a God-given role, as a way into
nature itself:

I tell you, I consciously choose *the dog's path through life;* I
will remain a *dog,* I shall be *poor,* I shall be a *painter,* I want to
remain human—going *into* nature. (Letter 347)

Vincent came to believe that his own day had so perverted
the truth that proper society was now inhuman, and the dog's
life was the honest way of remaining human in nature.

Vincent's sensitivity regarding his own apparent coarseness,
and his conscious choice of "the dog's path through life," were
to have a significant effect upon his art. He accepted the fact that
he was "unfit. . .to cope with either dealers or art lovers" (letter
257). He made it clear that ". . . I cannot make 'Types of Beauty';
I do my best to make 'Heads of the People'" (letter 252). As
"lowest of the low," he would show "what is in the heart of such
an eccentric, of such a nobody":

This is my ambition, which is, in spite of everything,
founded less on anger than on love, more on serenity than on
passion. It is true that I am often in the greatest misery, but still
there is a calm pure harmony and music inside me. I see draw-
ings and pictures in the poorest huts, in the dirtiest corner. And
my mind is drawn toward these things by an irresistible force.
(Letter 218)

Vincent hoped that his studio would become "a kind of harbor
of refuge" for "a herd of poor people" (letter 278). In his isolation
and poverty he would paint "not only with colors, but with self-
denial and self-renunciation and with a broken heart. . . " (letter
514).

Vincent felt that Parisians and other "civilized" people made
a mistake "in not having a palate for crude things, for Monticellis,
for common earthenware" (letter 520). In his own paintings,

which he knew "people will speak of as unfinished, or ugly" (letter 398), he intensified the irregularities and coarseness of the aged, the labor-worn, the poor and sorrowing: "I have wanted to give the impression of a way of life quite different from that of us civilized people" (letter 404). As he explained of his *Potato Eaters:*

> And it might prove to be a real *peasant picture, I know it is.* But he who prefers to see the peasants in their Sunday-best may do as he likes. I personally am convinced I get better results by painting them in their roughness than by giving them a conventional charm. . . .
> . . . if the field has an odor of ripe corn or potatoes or of guano or manure—that's healthy, especially for city people.
> Such pictures may *teach* them something. But to be perfumed is not what a peasant picture needs." (Letter 404)

Vincent's conviction that the coarse, the underside, the crude, was his given domain, and his satisfaction in that mission, is perhaps best illustrated in a painting-experience he proudly reported to Theo:

> Recently I have also been very busy drawing horses in the street. I would love to have a horse for a model sometime. Yesterday, for instance, I heard someone behind me say, There's a queer sort of painter—he draws the horse's ass instead of drawing it from the front. I rather liked that comment. (Letter 230)

The Genesis narrative regarding Esau, which Vincent heard applied to himself in the parsonage, suggested that external coarseness marked him as alienated from parental blessing and proper society from birth. Vincent accepted that verdict and discovered in it a kinship with the lowly, a mission to the disinherited, the crude, and the ugly. One other biblical passage must be placed alongside the Genesis account as offering an interpretation of ugliness and alienation in terms of spiritual vocation. Vincent himself appears to have selected it as a key to Scripture and as a description of his mission in "imitation of Christ."[12] It is the famous passage known as the "Suffering Servant Song," Isaiah 53.

Months after his father's death in March 1885, Vincent placed his father's Bible on a small table and painted it in a still

life, then sent both the Bible and the painting to his brother Theo. Though we will discuss the full significance of that unusual painting in a later chapter, here we simply note that Vincent purposefully opened the Bible to a passage of his choice, and clearly painted at the top of the Bible's open pages: Esaie LIII, (Isaiah 53.) Familiar to many as a central text utilized in Handel's *Messiah*, biblical scholars view the prophetic passage as a high point in biblical poetry and theology, a "Suffering Servant Song" devoted to the doctrine of sacrifice and vicarious suffering.[13] The originally intended identity of the Suffering Servant is a much argued puzzle, perhaps representing Israel, a remnant of Israel, the Messiah to come, Isaiah himself, or some anonymous prophet.[14] But certainly the Servant is distinguished by his ugliness or deformity, and negative appearance is directly related to his God-given sacrificial mission of suffering and death on behalf of those in distress. The heart of Isaiah 53 reads:

> For he grew up before him like a
> young plant
> and like a root out of dry ground;
> he had no form or comeliness that we
> should look at him
> and no beauty that we should
> desire him.
> He was despised and rejected by
> men;
> a man of sorrows, and acquainted
> with grief;
> and as one from whom men hide
> their faces
> he was despised, and we esteemed
> him not. (Isaiah 53:2–3)

The passage goes on to describe the despised servant as "smitten by God," "wounded for our transgressions" (53:4–5). He is compared to "a lamb that is led to the slaughter," an "offering for our sin" (53:7, 10). As his mission, "he poured out his soul to death"; he "bore the sin of many. . . " (53:12).

A few chapters later, in Isaiah 61:1–2, it may well be the Servant who is describing his own mission in terms of "preaching the gospel to the poor," comforting "all who mourn." The Gospel of Luke presents Jesus at the Nazareth synagogue as opening the

scroll of Isaiah and reading that very passage from Isaiah 61, and announcing: "Today this scripture has been fulfilled in your hearing" (Luke 4:16–21). Early Christians identified Jesus Christ as Isaiah's Suffering Servant, and called upon his followers to imitate his sacrificial suffering.[15]

Vincent clearly followed in this tradition, described his own mission as "preaching the gospel to the poor," and joined in "imitation" of the "man of Sorrows," the "Suffering Servant" of Isaiah 53. While doing religious work in England in 1876, Vincent chose the Isaiah 61 passage regarding "preaching to the poor" as text for a lesson he taught (letter 77), quoted that same Isaiah chapter to Theo (letter 71), and advised Theo to read fifteen chapters of Isaiah, including the "Servant Song" of chapter 53 (letter 82a). In 1878, as an evangelist in Belgium, Vincent described for Theo a sermon he had preached to the miners in which he described Jesus in the words of Isaiah 53 as "the great Man of Sorrows," who set the pattern of humility for humans who ought to live "in imitation of Christ" (letter 127). Vincent could describe his own "worship of sorrow" (letters 295, 320) and the "wound" he carried (letter 313). He also described painters as "isolated, poor, treated like madmen" (letter 514), calling to mind descriptions of the "Servant," and saw in his own sacrifices a preparation for a "green shoot springing from the roots of the old felled trunk":

> The more I am spent, ill, a broken pitcher, by so much more am I an artist—a creative artist—in this great renaissance of art of which we speak. (Letter 514)

Even the Servant's likeness to a sacrificial lamb is echoed in Vincent's description of the choice he believed he and Theo must make in a world of "money-wolves":

> . . . it is better to be a sheep than a wolf, better to be slain than to slay—better to be Abel than Cain. . . .
>
> Suppose that it's not just in our imagination, but that you and I are really like sheep among our fellow creatures. All right—granting the existence of rather hungry and false wolves, it would not be impossible that we should be devoured someday. (Letter 344)

Vincent, in fact, described for Theo a "*motive* for keeping one's

serenity even when one is isolated and misunderstood, and has lost all chance for material happiness." That motive was a sense of mission based on "faith" that one's own sufferings, the "oppressiveness of the hours that precede the thunderstorm," would serve the future, would mean "the following generations will be able to breathe more freely" (letter 451).

Vincent van Gogh's appearance and mannerisms from youth struck many of his contemporaries as ugly and coarse, and seem to have played a role in alienating him from "proper" society. His religious resources provided him with a way toward positive meaning in such "coarseness" and its alienating effects, providing him with the image of life as a "sorrowful yet always rejoicing" pilgrimage through suffering and impermanence. Passages in Genesis and Isaiah led him to interpret his "ugliness" as a kinship with the lowly, a sacrificial mission on behalf of the rejected and disinherited of his time.

As we will see later, Vincent's religious resources were not limited to the Bible, and so we will close this chapter with a moving passage Vincent treasured from a book by Jules Michelet, the French historian and social critic. Almost a dozen of Michelet's books are mentioned in over fifty references in Vincent's letters from 1873 to 1889, a period of seventeen years. According to Vincent, "Michelet even expresses completely and aloud things which the Gospel whispers only the germ of" (letter 161), and Michelet's book *L'Amour* became to him, "a revelation and a Gospel" (letters 19, 20). In *L'Amour*, Michelet asserted that surface beauty, "youthful complexion," was of little consequence compared to the deeper beauties that can be developed in the human soul. An anecdote used at that point in Michelet made a lasting impression on Vincent, an anecdote concerning "Socrates, ugly as a satyr" (letter 572). In 1889 Vincent applied the anecdote to his friend Roulin, but as early as 1883 he made clear that he applied the story directly to himself:

> Socrates was born as a true satyr, but by devotion, work and renouncing frivolous things he changed so completely that on the last day before his judges and in the face of death, there was in him something, I do not know what, of a god, a ray of light from heaven that illuminated the Parthenon. (Letter 306)

Pilgrimage, impermanence, suffering, and sacrifice were linked

by Vincent to the quest for transformation, and he believed that even one "ugly as a satyr" might hope that through devotion and labor something divine would shine through the coarse exterior to illuminate the world's darkest corners.

2

Religious Transformation

Although Vincent apparently had boyhood dreams of becoming a pastor, following in the footsteps of his father and grandfather, two wealthy uncles in the art trade seem to have convinced their less affluent brother, Pastor van Gogh, that Vincent ought to be apprenticed as clerk in the famous art establishment of Goupil and Company. At sixteen Vincent left home for the Goupil galleries in The Hague where he became an obedient and dedicated worker. Four years later, with a raise and positive recommendation, he was transferred to Goupil's London branch. In the very first biographical account of Vincent van Gogh, his sister-in-law, Johanna van Gogh-Bonger, claimed in her memoir that Vincent's second summer at the London branch of Goupil and Company was a time of crisis, a decisive turning point in his life. She pictured the twenty-one-year-old clerk suffering his "first great sorrow," becoming a "different being" who sought "refuge in religion."[1] Almost every biographer since that 1913 memoir has focused on such a crisis, describing its outcome in such terms as "fanatical religious mysticism,"[2] "mystic fervor,"[3] "obsession with religion,"[4] or "a state of religious exultation."[5] What is the evidence for this crisis, and what is the nature of the religious transformation evidenced in Vincent's life and thought?

Vincent in his earliest letters, beginning in August 1872, appears to be a pleasant nineteen-year-old, enjoying living among his mother's friends and relatives in The Hague. He is busy planning a surprise birthday gift for his father, writing to his sister Anna, and corresponding about paintings and the Goupil

15

business with Theo.⁶ The only somber notes sound when Vincent encourages Theo, newly employed at Goupil's Brussels branch, not to "lose heart if it is very difficult at times," and when he reacts with worry and depression because Goupil has transferred him to their London branch (letters 1–5). Early letters from London reveal homesickness but also a will to learn about English art, enjoy nature, and appreciate boarding "with a very amusing family" (letters 9–11). Vincent summed up his life:

> Then I have nature and art and poetry. If that is not enough, what is? Still, I do not forget Holland—especially The Hague and Brabant. (Letter 13)

It is at this point, during Vincent's London stay, that most biographers choose to follow the "Memoir" by Johanna van Gogh-Bonger rather than to focus upon the evidence in the letters. Identifying the "amusing family" of Vincent's boarding-house as the widow Loyer and her daughter, Johanna van Gogh-Bonger posits a crisis of young love thwarted during the summer of 1874:

> He intended to visit Holland in July, and before that time he apparently spoke to Ursula of his love. Alas, it turned out that she was already engaged to the man who boarded with them before Vincent came. He tried everything to make her break this engagement, but he did not succeed.
>
> With this first great sorrow his character changed; when he came home for the holidays he was thin, silent, dejected—a different being.⁷

Pierre Cabanne, in his *Van Gogh,* feels free to elaborate:

> She admitted she had led him on, making fun of him; and as he persisted, continued to plead with her, she burst again into laughter, cutting him to the heart. . . .
>
> In the following months his mystic fervor intensified. He believed his suffering was a sign that he must set himself to redeem, by acts of charity, the offenses for which God was punishing him.⁸

Frank Elgar's work, *Van Gogh,* adds a retreat to Holland:

> . . . he soon fell in love with his landlady's daughter, Ursula . . .

proposed to her, was rejected and became so depressed that he returned to his family in Holland . . . for four months. . . . his disappointment in love had turned his thoughts to a kind of fanatical religious mysticism.[9]

Marc Tralbaut also focuses on the story of Ursula rejecting Vincent, and relates it to psychological problems:

> It was suggested earlier that Vincent may have suffered in his earliest childhood from an unsuspected mental depression; in which case Ursula's refusal may have aroused dormant neurotic tendencies, in particular an inferiority complex in regard to women.[10]

In spite of the fact that the Ursula love story has become pivotal in almost all works on Vincent van Gogh, and seems generally to be considered a sufficient explanation for his turning to "fanatical religious mysticism," the evidence of Vincent's letters leads in another direction. Jan Hulsker's decision is a sound one:

> . . . as there is not a single letter or document from Vincent's time substantiating this romantic incident, I shall not discuss it further.[11]

Hulsker also notes that research has proved the Loyer daughter's name was Eugenie, not Ursula.[12] With this in mind, we might consider the possibility that Vincent had become a homesick admirer of the widowed landlady, Ursula, rather than of her daughter. It may be relevant that among Vincent's favorite passages of literature that summer were two chapters in Jules Michelet's *L'Amour*, one entitled "There Are No Old Women," and the other "Autumnal Aspirations," which argues that the inner beauty of older women far surpasses the shallow attractions of maidenly complexion.[13] In any case, any Loyer romance at all remains problematic, though admittedly possible.

There are others, inclined toward a psychological analysis, who reach back a year prior to Vincent's birth for a significant clue to his crisis. Humberto Nagera, in *Vincent van Gogh: A Psychological Study*, focuses upon the fact that exactly one year before Vincent's birth a first child had been stillborn to Pastor van Gogh

and his wife, and that child had also been named "Vincent." Nagera points out that parents in such cases may become "victims of important psychopathological changes that will profoundly affect and interfere with their relationship to the child whose fate it is to become a substitute for the dead sibling."[14] Idealization of the original child and disappointment and oversolicitous attitudes toward the "substitute" might then become factors in Vincent's conviction of inadequacy and his state of anxiety during the prolonged period away from home in London.[15]

Jean Leymarie's study *Van Gogh,* is less cautious than Nagera:

> ... it is certain that, born as he was to parents in mourning who in effect substituted him for the dead child, his relations with his mother were distorted from the start, and so gave rise ... to the sense of anguish and guilt that grew upon him in later years.[16]

Marc Tralbaut is equally convinced:

> If we read between the lines of the uninterrupted confession which Vincent's letters provide, we find that his life was governed by various processes of repression, and that, moreover, fantasies of guilt caused by the death of the first child frequently appear right up to the end of his life. This feeling of guilt showed itself for the last time, at a subconscious level, in the suicide which liberated him from the world, and indeed was one of the motives for it.[17]

Albert Lubin, in his psychological biography of van Gogh, devotes a full chapter to "The First Vincent and the Sad Mother," interpreting the dynamics of Vincent's being a "replacement for a dead child" as an explanation for his depicting "women bearing burdens" and his preoccupation "with death, illness, and body-mutilation accidents."[18] Fantasies associated with his dead brother as buried body, according to Lubin, led to Vincent's obsession with digging, cultivating, and sowing the earth, and to his paintings of trenches, quarries, bogs and potatoes.[19] Lubin finds that Vincent painted himself as the younger man on the left in *The Potato Eaters,* with a faceless and ethereal child standing between himself and his mother with whom he vainly seeks "to make contact."[20] An unconscious longing for death in order to

reunite with the mother is, according to Lubin, "the latent meaning behind much of Vincent's art. . . ."[21] Lubin concludes the chapter by calling attention to one of Vincent's late works, *Thatched Roof with Man on Top*:

> In a picture sketched just before Vincent killed himself, a man stands on a roof top as a breast-shaped cloud formation awaits him in the sky above.[22]

My own view is that the Ursula love story and the replacement child theory have too often been utilized in place of a careful examination of the artist's own letters, which themselves indicate a complex network of religious tradition, nineteenth-century social forces, and personal concerns that led to his so-called crisis and period of "religious fanaticism." Certainly some romantic considerations played a role when twenty-year-old Vincent pondered what course his life might take; that much he himself tells us.[23] True, there may have been both sadness and over-solicitousness by Vincent's parents in view of the loss of a first child twelve months before Vincent's birth. But the letters themselves indicate that Vincent's reading of Michelet and Renan, his experiencing the deaths of friends and relatives, and his deepening disillusionment with a commercialized art trade played a significant part in his search for an alternative vocation worthy of self-sacrifice. Further, Vincent's sense of guilt, unworthiness, anxiety, and melancholy, shared in part by his brother Theo, had obvious roots in the tradition of his religion, which would not be connected to either the Ursula or the replacement child theory.

A closer look at the primary evidence in Vincent's letters regarding his crisis and consequent "religious obsession" reveals a complex of *triggering* factors among which we might choose. The fact that Michelet's *L'Amour* was to him "both a revelation and a Gospel" (letter 20) may indicate that he was seriously considering the options of young love or self-improvement, particularly as he was struck by Michelet's example of Socrates, who "by the sculpture of reason, virtue, and self-sacrifice," transformed his "ugliness" into a face that shone with divine light.[24] Or perhaps Ernest Renan, whose *The Life of Jesus* he had just read, was his chief inspiration for a new life-direction. A critical letter during this period ends with a significant quotation from Renan:

> To act well in this world one must sacrifice all personal desires.
> The people who become the missionary of a religious thought
> have no other fatherland than this thought.
>
> Man is not on this earth merely to be happy, or even to be
> simply honest. He is there to realize great things for humanity.
> (Letter 26)

In that very same letter written in the spring of 1875, Vincent
inquired about the illness of a young relative in The Hague to
whom he and Theo both felt very close, Annette Haanebeek.
When Vincent was informed of her sudden death, he responded
to Theo: "I am sure you will not forget her or her death, but keep
it to yourself" (letter 28).

The encounter with death may have had increasing effect on
Vincent, for within a period of six months a thirteen-year-old girl
died at his boardinghouse; Annette Haanebeek died and he urged
upon Theo private grief; and he was informed that his uncle Jan
Carbentus and an acquaintance named Weehuizen had died
(letters 25, 28, 35, 36a). In his reply to the letter describing
Weehuizen's death, Vincent, who had only recently been trans-
ferred to Paris, suggested that Theo "not read Michelet any longer
or *any* other book except the Bible" (letter 36a). Vincent opened
his very next letter to Theo with the words:

> Wings, wings over life!
> Wings over grave and death!

and affirmed:

> That is what we want and I am beginning to understand that
> we can get them. Don't you think Father has them? And you
> know how he got them, by prayer and the fruit thereof—pa-
> tience and faith—and from the Bible that was a light unto his
> path and a lamp unto his feet. (Letter 37)

We will see that Vincent's increasing focus on the Bible, multi-
plication of biblical quotations in his letters, and time spent in
seclusion reading the Bible are all chief marks of the larger part
of his period of religious "obsession." The presence of death,
whether in Dostoevsky, Sartre, Bergman's "Seventh Seal," or
Siddhartha Gautama's "Four Sights," has been a key factor in

human crisis and transformation throughout history. Social psychologists C. D. Batson and W. L. Ventis view the consideration of death as so basic to religious concerns that "whatever we as individuals do to come to grips personally with the questions that confront us because we are aware that we and others like us are alive and that we will die" becomes their functional definition of religion for the social-psychological study of religious experience.[25] That Vincent viewed human "limit-situations" as a way to God, and proximity to death a revelation of the true human situation, is made clear in a letter he wrote Theo in 1878. After affirming that scenes of death "must affect everyone who knows and feels that one day we too have to pass through the valley of the shadow of death," he continues:

> It always strikes me, and it is very peculiar, that whenever we see the image of indescribable and unutterable desolation—of loneliness, poverty and misery, the end or extreme of all things, the thought of God comes into our minds. At least it does with me, and doesn't Father also say, 'There is no place I like to speak in better than a churchyard, for we are all standing on equal ground; furthermore, we always *realize* it." (Letter 126)

There is quite another facet to Vincent's stay in London that has been generally overlooked, yet may have played a decisive role in his religious transformation. Why would Vincent at age nineteen be ambitious, proud of his job at Goupil and Company, and immersed in the study of art, yet three years later be so disinterested and careless a worker that "serious complaints" would lead to his being forced to resign (letters 3, 50)? Most biographers blame a depression over Ursula and religious preoccupations for distracting him from his job. Might it not be wiser to view the job itself as the problem? Perhaps it was Goupil and Company that had changed, and not Vincent.

Goupil and Company, with a new generation of family owners, had become Boussod, Valadon and Company, and was vigorously expanding. Vincent's manager at the London branch, a Mr. Obach, was busy making changes apparently designed to increase sales and profits (letter 20). Could it be that Vincent's idealistic picture of the quality art trade of his Uncle Vincent and the old house of Goupil, calling for an expert knowledge of

painting and painters, met in London with a modern art business intent on profits and calling for flattery and salesmanship?

Eight years after working for Mr. Obach in London, Vincent wrote a letter to Theo bemoaning the "triomphe de la mediocrité" in the art trade and art illustration in magazines. He sent the 1882 issue of the *Graphic* as proof of the degeneration, and observed:

> And now everything is gone—once again materialism instead of moral principle. Do you know what I think of the copy I'm sending you? It is like Obach's kind of talk, for instance, the manager of Goupil and Company in London. And it has success, *yes, that has success, yes, that is listened to and that is admired.*

He continued in melancholy fashion:

> But it makes me sad, it takes away my pleasure, it upsets me, and personally I am absolutely at a loss about what to do. What sometimes makes me sad is this: formerly, when I started, I used to think, if only I make so or so much progress, I shall get a job somewhere, and I shall be on a straight road and find my way through life.

Is Vincent not only depressed about his plans as artist, but remembering his deep depression as a clerk at "Obach's kind of talk?" The same letter concludes:

> In short, instead of meeting with an opinion, a sentiment, an aim like Dickens'. . . one is confronted with a philosophy like Obach's. It makes me sad, and then I feel helpless. One can only undertake a thing if one has sympathy and co-operation. (Letter 252)

Could it be that when transferred to London Vincent could no longer in good conscience serve Goupil and Company? Viewing Obach's philosophy as evidence that the once reputable firm had become "Swine and Company," as Zola called the greedy commerce of the day, did Vincent begin to seclude himself with his Bible and look toward his father's profession as his alternate means of serving the world? I believe so.

Let us view a few chronological details regarding the nature

of Vincent's religious transformation that summer of 1874 in London. Did it happen suddenly? Did it result in what might be described as a fanatical religious mysticism? I do not believe the evidence supports the view that there was a single crisis. Neither do I believe there was just one major phase to his new religious orientation that could accurately be described as fanatical religious mysticism.

No significant religious content occurs in any of Vincent's letters until August 1874 (letter 21). Apparently in answer to a question Theo posed about a woman of questionable reputation, Vincent defends the position that, "virginity of soul and impurity of body can go together," quoting two key passages from the Gospel of John against judging others (John 8:7, 15), and citing art works and Luke 7:47 as further evidence. Vincent advises Theo to test his own ideas "with those of Him who dared to say 'I am the truth' or with those of some very human person, Michelet, for instance...." The use of biblical quotations, and the juxtaposition of Christ (John 14:6) and Michelet, are interesting and reflect the beginnings of a new reliance upon the Gospels.

An unusual gap of five months in Vincent's correspondence is then followed by a letter promising Theo copies of *Jesus* by Renan and *Joan of Arc* by Michelet (March 1875, letter 23). Both books seek to impress upon the reader stories of Christian self-sacrifice for humanity. Vincent's last two letters from London tell of the death of the young daughter of his new landlady and cite the Renan passage calling for "sacrifice of all personal desires" (letters 25, 26). Vincent is transferred to Paris in May 1875, and a letter in July informs Theo that a "French Bible and the *Imitation of Christ*" have been sent to him (letter 31). An August letter reports a sermon Vincent heard and advises Theo to "go to church every Sunday. . . "(letter 33).

The reason for giving some details about this period in 1874, during which time, it is claimed by most biographers, Ursula's refusal took place is to make clear that there was no immediate or radical change evident in Vincent's orientation. It appears, rather, that over a period of time a series of interests, including biblical texts, Christ as guide, Renan, Michelet, the Bible, the *Imitation of Christ* and regular church-going, occupy more and more of his time and that gradually they command an increasing amount of his thought.

By autumn 1875 a whole constellation of forces seems to

have directed Vincent to the point where biblical texts, religious prayers and sentiments came to dominate his correspondence. News of the death of cousin Annette Haanebeek in June (letter 28) leads Vincent to observe that such events make one "sorrowful yet always rejoicing," a phrase from Paul's letters (II Cor. 6:10) employed by Bunyan in *Pilgrim's Progress*. In September he is informed of Uncle Jan Carbentus's death, and he places a prayer and biblical text in his reply to Theo (letter 35). Also in September, Theo tells him of the death of Weehuizen, and Vincent's response suggests that Theo read no other book "except the Bible," seek the company of friends, and consider their father's word regarding "sadness" (letter 36).

It is Vincent's next letter, dated September 1875, that marks a critical stage in his resolve to seek a new direction in life. He affirms that he will seek "Wings over grave and death," and describes his father's life as the embodiment of the method by which those "wings" can be gotten:

> And you know how he got them, by prayer and the fruit thereof—patience and faith—and from the Bible (Letter 37)

Vincent's conscious embarkation on a journey of religious transformation is here decided, and it hardly appears to be either "fanatical" or "mystical." Neither does it appear to be the result of one crisis, whether rejection by Ursula or the pressure of guilt regarding the death of the first Vincent.

What are the chief elements of this stage of Vincent's religious transformation? First, the new life focuses upon his father, Pastor van Gogh, as perfect model. Vincent asks no more of life than an outcome patterned on his father's ministry (letters 43, 72, 94). Though previously Vincent believed his wealthy, art-dealer uncles were "pure gold," he now sees that they fall short of his father's perfection (letters 26, 31, 108). We might attempt a hypothetical reconstruction of a critical moment in Vincent's life when at sixteen a family council decided his future. Pastor van Gogh had hoped his boy would study theology, for "there has always been one who preached the gospel in the van Gogh family" (letter 89). Unfortunately, the poor parson had no funds for Vincent's university preparation. There was silence. Finally wealthy and childless Uncle Vincent, ignoring the possibility of

ministerial training, offered to arrange an apprenticeship in art-dealing. Money had won, and Vincent was to spend what he later called six "years of exile" at the "fleshpots of Egypt" before changing course toward his father's original hope (letters 70, 82a).

A second element in this stage of Vincent's religious transformation is its definition as a "narrow path" filled with struggle and suffering, a journey "uphill all the way "(letters 41, 116). Just thirteen days after his "wings over grave and death" decision, Vincent wrote Theo:

> The path is narrow, therefore we must be careful. You know how others have arrived where we want to go; let us take that simple road, too. (Letter 39)

Vincent then quoted the New Testament: "Therefore if any man be in Christ, he is a new creature. . ." (II Corinthians 5: 17) and immediately resolved: "I am going to destroy all my books by Michelet, etc. I wish you would do the same." We are now at a critical point in Vincent's understanding of "narrow path," and hence a critical point in his understanding of religious transformation.

In a letter of September 27 Vincent quoted Jesus' words from Matthew, chapter 7:

> Narrow is the path which leadeth into life, and those that find it are few. Struggle to enter by the narrow gate, for many will seek to enter, and will not be able. (Letter 39b)

In the same letter he described the path as "taking up our cross," being "tried and purified," and receiving from God "a thorn in the flesh." Struggle and suffering accompany the biblical description of the "narrow path," and Vincent sought to understand the implications. His own chief pleasures were nature, art, and literature. Vincent was forced to examine the possibility that the narrow path required elimination of those joys from his life. *The Imitation of Christ*, considered by Vincent a companion to the Bible, preached a world-denying discipline belonging to his own Dutch heritage, and clearly called upon him "to despise the world":

> Strive to withdraw your heart from the love of visible things, and direct your affections to things invisible. . . . Restrain an inordinate desire for knowledge, in which is found much anxiety and deception But there are many matters, knowledge of which brings little or no advantage to the soul. Indeed, a man is unwise if he occupies himself with any things save those that further his salvation.[26]

How was he to interpret this call to withdrawal from the "visible," this single-minded devotion to the things of "salvation?"

Vincent's transformative journey focused on the issue of the nature of religion in personal life: Does religion make an exclusive claim? Can it include the paths of nature, art, and literature? Does a serious spiritual quest enhance or cancel other pathways to meaning? No rapid or easy resolution came. Following his tenure with Goupil in Paris, he would find religious employment in England, work as bookseller in Dordrecht, then settle in Amsterdam to be tutored for entry into theological school. Throughout the remaining seven months in Paris, ten months in England, three in Dordrecht, and fourteen in Amsterdam this issue would remain contested and the battleline would shift first in one direction, then the other.

The struggle between Bible and other literature is so pivotal that we will devote the following chapter, "From *Book* to Books," to it. But here let us illustrate Vincent's struggle over the legitimacy of love of nature and love of art. The letter immediately following his "wings over grave and death" resolution already engaged the issue:

> A feeling, even a keen one, for the beauties of nature is not the same as a religious feeling, though I think these two stand in close relation to one another. Almost everybody has a feeling for nature—some, more; some, less—but a few feel that God is a spirit and whoever worships Him must worship Him in spirit and in truth. Our parents belong to those few. . . . (Letter 38)

Apparently thinking further on the subject, Vincent added a postscript after signing:

> It is the same with the feeling for art. Don't give yourself utterly to that.

The same month he wrote again, perhaps seeking some balance:

> See things as they are, and do not approve of everything for
> yourself. It is possible to deviate, to the right as well as to the
> left. (Letter 39a)

A month later he advised Theo again to destroy his books, but
tempered it with the warning: " . . . nevertheless, take care not to
become narrow-minded." He then quoted Philippians 4:8:

> Whatsoever things are true, whatsoever things are honest,
> whatsoever things are just, whatsoever things are pure, what-
> soever things are lovely . . . think on these things. (Letter 43)

Five months later he returned to the issue of nature, advising:
"Though love of nature is not *everything,* it is still a precious
possession; may we keep it always" (letter 57).

An awareness of Vincent's continuing struggle with the
problem of religion's relationship to love of nature and art ex-
plains numerous puzzling passages in his letters during this
period, and a proper reading of these puzzling passages indicates
the direction his resolution of the problem was taking. A good
example occurs in his letter to Theo on March 28, 1876:

> Yesterday I saw six pictures by Michel, how I wish you
> could have seen them too! Sunken paths through sandy fields
> leading to a mill, or a man going home across the heath with
> gray skies above—so simple and so beautiful. I think the "Men
> of Emmaus" saw nature in the same way as Michel, and I
> always think of them when I see one of his pictures. (Letter 58)

The passage begins with a simple appreciation of the work of an
artist Vincent admires. Vincent's admiration includes his shar-
ing Michel's manner of seeing nature. But Vincent seems to say
to himself, "What am I doing enjoying art and nature to the
exclusion of religion?" He therefore seeks a unification of themes
in Rembrandt's famous *religious* work which pictures the dis-
ciples at Emmaus (Luke 24) sitting at table viewing their host, the
Risen Christ. Vincent notes that their "enlightened eyes" would
see nature just as Michel did. By a somewhat torturous route,

Vincent unifies nature and art within religious vision. Perhaps he even vaguely hints at the equation: seeing the world aright equals seeing the resurrected Christ. If this seems farfetched, one must turn to the end of the "story," where Vincent as artist argues that painting an olive orchard *is* painting Gethsemane, painting a melancholy portrait of Dr. Gachet *is* painting Christ for our times.[27]

Similar puzzles which yield to an understanding of Vincent's search for unity include his equating Dickens and resurrection (letter 111), Rembrandt's etchings and his father speaking of Christ to the dying (letter 110), enjoyment of a starry night, God's love, and Matthew 28: 20 (letter 101a). The striving for unification of paths to meaning may also explain Vincent's attraction to some "second-rate" artists and writers, Ary Sheffer and Erckmann-Chatrian, for example. Their use of biblical subjects and scriptural texts provided him with bridges between religion, art, and literature during this phase of his search, and so, much else could be forgiven them. Vincent's practice of filling the margins of prints he hung in his room with biblical quotations also becomes meaningful as a kind of "baptism" and justification of art within his religious quest.[28]

Late in his career as artist, Vincent would arrive at a far more radical solution in this search for unity: when seen and painted from the depths of the creative soul, even a tree or rock is a living and luminous center of Christification. But we will return to that theme later.

Additional information exists on the nature of Vincent's religious transformation that will better reveal its complexity. These facts go beyond his tenure as a Goupil and Company clerk. It is clear that though the path of his thinking continued to narrow in some regards in Paris, it opened in a surprising manner at the moment he abandoned studies for theological school in Amsterdam. Furthermore, I will argue that Vincent's life of ascetic self-sacrifice among the miners in the Borinage from the winter of 1878 into 1879 was not a dramatization of the narrow path of religious fanaticism, but a conscious experiment in Christian servanthood by one who had already opened himself toward society, art and literature.

Transferred from London to Paris, Vincent moved into a room in Montmartre, and on October 11, 1875, he wrote to Theo in order to describe "in more detail how I spend my time" (letter

42). We learn that he seldom left his room except for work and church-going. Long hours were spent secluded in his room with an eighteen-year-old English employee of Goupil's named Harry Gladwell. Vincent appears to have identified with Gladwell's homesickness and strange appearance, and assumed the role of spiritual guide to the younger man. This responsibility may further explain Vincent's seriousness and religious preoccupation. He wrote Theo:

> Every evening we go home together and eat something in my room; the rest of the evening I read aloud, generally from the Bible. We intend to read it all the way through. (Letter 42)

> I was able to show him a danger that was threatening him.
> He had never been away from home, and though he did not show it, he had an unhealthy (though noble) longing for his father and his home. It was the kind of longing that belongs only to God and to heaven. (Letter 45)

The original reason for Vincent's seclusion from society in Paris might well have been direct advice from his father, whose words Vincent placed alongside Scripture itself during this period. Even six years later, when he was twenty-eight, Vincent was receiving warnings against the infection of French ideas from Pastor van Gogh. In 1881 Vincent complained to Theo:

> When Father sees me with a French book by Michelet or Victor Hugo, he thinks of thieves and murderers, or of "immorality" they bring up a story of a great uncle who was infected with French ideas and took to drink, and so they insinuate that I shall do the same. (Letter 159)

Pastor van Gogh's dealing with his children apparently emphasized human sin and the enormity of the world's evil, and this likely played its role in determining Vincent's attraction for the narrow path. If this deep suspicion of the world were accompanied by the affirmation that the van Gogh elders were "pure gold" and so deserved perfection from their children, one might well expect a heavy burden of guilt and anxiety on Vincent and Theo. Vincent reminded Theo "how Father prayed every morning, 'Deliver us from evil, especially from the evil of sin' " (letter 88), and his mother's prayer, "keep him from the evil" (letter 81).

Vincent could write Theo, "we are still far beneath Father and other people" (letter 43), and could confess, "There is much evil in the world and in ourselves—terrible things; one does not need to be far advanced in life to fear much . . ." (letter 98). Vincent's response to one of Theo's letters is especially revealing in this regard:

> A phrase in your letter struck me: "I wish I were far away from everything; I am the cause of all, and bring only sorrow to everybody; I alone have brought all this misery on myself and others." These words struck me because that same feeling, exactly the same, neither more nor less, is also on my conscience. (Letter 98)

Vincent continued by contrasting the van Gogh elders and their expectations for him with his own poor resources:

> . . . when I think of the many watching me who will know where the fault is if I do not succeed, who will not make trivial reproaches, but as they are well tried and trained in everything that is right and virtuous and pure gold, the expression on their faces will seem to say . . . we have done for you what we could— have you honestly tried? (Letter 98)

Such a level of anxiety and guilt may seem abnormal and exaggerated, or one may be tempted to blame Pastor van Gogh for fostering such feelings in his children, but placed within proper context, the feelings of Vincent and Theo are the logical and planned outcome of John Calvin's interpretation of Scripture and approach to the human condition. Calvin's "program" for humans is clearly laid out in *The Institutes of the Christian Religion,* beginning not with forgiveness, comfort, grace, and salvation, but with "knowledge of the self" without which there can be no "knowledge of God." "Knowledge of the self" is defined at the outset, in book I, chapter I, section 1:

> Each of us must, then, be so stung by the consciousness of his own unhappiness as to attain at least some knowledge of God. Thus, from the feeling of our own ignorance, vanity, poverty, infirmity, and—what is more—depravity and corruption, we recognize that the true light of wisdom, sound virtue, full abundance of every good, and purity of righteousness rest in

the Lord alone. To this extent we are prompted by our own ills to contemplate the good things of God; and we cannot seriously aspire to him before we begin to become displeased with ourselves.[29]

If Vincent's sense of guilt and anxiety appears to have been abnormal, his chief fault was that he took to heart this Calvinist heritage. That others at different times and places did the same, with even greater exaggeration, is clear to any who have read the narrative of witchcraft hysteria among Puritan Calvinists in Salem, or to any who have read the Calvinist sermons preached by Jonathan Edwards a century later.[30]

In view of the focus upon depravity, corruption, and the "promptings of our own ills" in his Calvinist heritage, and his parents' warnings regarding the "evil" in the world and "sin" in human nature, one hardly needs recourse to a "replacement-child theory" to account for an intensifying of guilt and anxiety during Vincent's long months away from home in London followed by a transfer to the "infected" city of Paris. His seclusion in a Montmartre room with his Bible and a disciple, Gladwell, is understandable and in many ways marks the apex of his narrowing path of religious exclusiveness.

But let us follow Vincent's religious transformation through another phase, surprising in its suddenness and unexpected in its timing. Vincent's seclusion in Paris led to unpleasant remarks regarding his eccentricities and finally to the request that he resign from Goupil and Company, effective April 1, 1876.[31] Vincent then took a teaching position at Mr. Stokes's school for boys in England, and by July found a more suitable post at the Reverend Jones's school in Isleworth, where he assisted the Methodist minister both in the school and at several tiny Methodist churches. Vincent now saw himself solidly on course to Christian work allied to his father's profession. On July 5, 1876, he wrote Theo:

> Lately it has seemed to me that there are no professions in the world other than those of schoolmaster and clergyman, with all that lies between these two—such as missionary, especially a London missionary. . . . (Letter 70)

Vincent had found his place in life, with practical work ranging

from weeding the garden, hiking to London to collect fees, teaching the boys Bible history, and leading devotional services at the school and in country churches. Mr. Jones could pay little, but was sensitive to Vincent's needs:

> Mr. Jones has promised me that I shall not have to teach so much in the future, but may work more in his parish, visiting the people, talking with them, etc. May God give it His blessing. (Letter 76)

That autumn of 1876 Vincent preached from the pulpit for the first time, in a little church in Richmond. He sent to Theo, along with a copy of the sermon, this moving report:

> When I was standing in the pulpit, I felt like somebody who, emerging from a dark cave underground, comes back to the friendly daylight. It is a delightful thought that in the future, wherever I go, I shall preach the Gospel; to do that *well*, one must have the Gospel in one's heart. May the Lord give it to me. (Letter 79)

The sermon itself, on the theme "that our life is a pilgrim's progress," gives evidence of thoughtfulness and a will to communicate to ordinary people, a visual appeal to a sketch by Boughton of a theme in *Pilgrim's Progress*, and an effective use of Scripture, poetry, and folk wisdom.[32]

In her notes to *The Complete Letters of Vincent van Gogh*, Johanna van Gogh-Bonger describes Vincent during this period at Isleworth as "too much taken up with religious fanaticism," "despairingly" clinging to religion "as his sole support."[33] Most commentators on Vincent's life seem swayed by that description. It is our view that Vincent's life, far from displaying fanaticism or despair, shows him to be a sincere Methodist lay preacher and teacher, learning his job well, reading, sketching, visiting friends, and working toward the day he might become a missionary to the poor in London.

When Vincent returned to his parents' home for Christmas, as Johanna van Gogh-Bonger explains, "it was decided he would not go back to England as there was no prospect whatever for the future."[34] Attempting to reconstruct what actually happened, I would suggest that Vincent's father and the family elders had decided that doing what to them appeared "odd-jobs" for a

Methodist preacher was hardly a fitting profession for a van Gogh. Already Pastor van Gogh had written Vincent, "Where do Mr. Jones and others get their income?" (letter 81). His question may well have implied that Methodism was not comparable in stability, prestige, or financial support to the Dutch Reformed Church. The family council therefore found a bookseller's job for Vincent among friends in Dordrecht, Holland. Vincent may well be quoting the words of such a council when he explains to Theo his new job:

> Then the salary would certainly be better than at Mr. Jones's, and it is one's duty to think of that because later in life a man needs more. (Letter 83)

Within four months it was reported that Vincent spent all his time in Dordrecht reading the Bible and writing sermons, and belatedly his wealthy uncles offered some of the support Vincent could have used years earlier for studies leading to the university and ministerial preparation.[35]

For approximately a year, May 1877 to July 1878, Vincent boarded in Amsterdam with Uncle Jan van Gogh, Commandant of the Navy Yard, and studied under the supervision of Uncle Stricker, a well-known Dutch Pastor, to prepare for entry examinations to the university. Translating Caesar from Latin, learning Greek verbs, reading geography, history, mathematics and algebra were too far from Vincent's practical interests, too academically narrow. There was not even time for the hours he once devoted to his beloved Bible (letter 96). Vincent found every excuse for leaving his studies to hike in nature, see art, read his Bible, visit bookstores, and draw:

> Now and then when I am writing, I instinctively make a little drawing. . . . (Letter 101)

> There are so many books I should like to read, but I must not. (Letter 102)

> . . . three lithographs after Bosboom and two by J. Weissenbruch; I found them this morning at a bookstall. (Letter 103)

> I wish the days were longer so I could accomplish more, for it is not always easy work, and even continuous plodding gives

but meager satisfaction. (Letter 108)

Besides, I cling to the church for aid and to the bookshops; I invent some errand to go there whenever possible. (Letter 112)

In his letter to Theo on February 18, 1878, though still studying long hours each day, Vincent seemed to have given up hope of the university route: "certainly it is very doubtful that I shall ever succeed, I mean, shall ever pass all the examinations" (letter 119). He was drawing maps of Paul's travels and leaving them as gifts for clergymen: "Even if I fail, I want to leave my mark here and there behind me."

It is at that very moment, as he surrendered the academically respectable route the family council advised, Vincent suddenly and unexpectedly broke away from the narrow path of religious exclusivity and described a new path that saw not threatening distraction but strength in "loving many things." His practical experience in England contrasted with a year of cold, academic plodding exploded in a new confidence, a faith in love, work, and the wisdom of the ordinary. Vincent's search for the unification of nature, art, literature, religion, and practical service among the poor realized itself in a new phase of his religious transformation. He wrote Theo on April 3, 1878:

As to being "an interior and spiritual person," couldn't that be developed by a knowledge of history in general and of particular individuals from all eras—especially from the history of the Bible to that of the Revolution and from the Odyssey to the books of Dickens and Michelet? And couldn't one learn something from the works of such as Rembrandt and from Breton's "Mauvaises Herbes," or "The Four Hours of the Day" by Millet, or "Bénédicté" by De Groux? . . . (Letter 121)

Haunting anxiety and guilt regarding the judgment of his elders seemed to fade in the dawn of his new creed:

If only we try to live sincerely, it will go well with us, even though we are certain to experience real sorrow, and great disappointments, and shall also probably commit great errors and do wrong things; but it certainly is true that it is better to be high-spirited, even though one makes more mistakes, than to be narrow-minded and overprudent. It is good to love many

things, for therein lies true strength; whosoever loves much, performs and can accomplish much, and what is done in love is well done. (Letter 121)

The following year, which includes Vincent's radically self-sacrificial service in the Borinage, is almost universally viewed as the apex of his narrow religious fanaticism. But when those months are viewed in the light of his new creed, they prove to be a demonstration of new confidence in a personal, experiential religion that refused to conform to narrower religious proprieties:

> This is the creed which all good men have expressed in their works, all who have thought somewhat more deeply and looked for more and worked more and loved more than others—who have dived into the depths of the sea of life. We must cast ourselves into the depths, if we want to catch something, and if at times we must work throughout the night without catching anything, it is good not to give in, but to cast the net again in the morning. (Letter 121)

Abandoning his studies in Amsterdam in the summer of 1878, Vincent attended the Training School for Evangelists in Brussels, went to the Belgian mining district, the Borinage, and finally received a probationary appointment as an evangelist. Stubbornly following his own intuition, casting himself "into the depths," he refused to tailor his service to the warnings and advice of narrower evangelists, the supervising Synodal Board of Evangelization, or his father, who apparently argued that he must submit to the church authorities and their wishes. Vincent's views on the narrowing of the academic approach to religion become clear in his letters from the Borinage:

> Not permissible aye, just as Frank the Evangelist thought it reprehensible of me to assert that the sermons of the Reverend Mr. John Andry are only a little more evangelical than those of a Roman Catholic priest. (Letter 132)
> I must tell you that with evangelists it is the same as with artists. There is an old academic school, often detestable, tyrannical, the accumulation of horrors, men who wear a cuirass, a steel armour, of prejudices and conventions; when these people are in charge of affairs, they dispose of positions,

and by a system of red tape they try to keep their protégés in their places and to exclude the other man. Their God is like the God of Shakespeare's drunken Falstaff, *the inside of a church.* . . . (Letter 133)

After only a six-month probationary period, the Synodal Board terminated Vincent's appointment. Their official record acknowledges his self-sacrifice for "the sick and wounded," faults his speaking ability, and concludes:

> Undoubtedly it would be unreasonable to demand extraordinary talents. But it is evident that the absence of certain qualities may render the exercise of an evangelist's principal function wholly impossible.
> Unfortunately this is the case with Mr. van Gogh. Therefore, the probationary period—some months—having expired, it has been necessary to abandon the idea of retaining him any longer.[36]

At this point Vincent refused to abandon the Borinage, against his father's explicit wishes, admitting that he had become "a kind of impossible and suspect personage in the family" (letter 133). He "hid" himself through a painful "molting time," sketching the "poor oppressed" among whom he felt at home, and emerged as an artist committed to the poor, the laborers, the disinherited (letters 130, 133).

Emerging from his molting time, Vincent describes yet another phase of his transformation, no less religious yet promising to unify his love of art, nature, and the poor. This mission of artist will have its own narrow path of suffering, but it will embrace the broad concerns of love and active labor:

> Well, even in that deep misery I felt my energy revive, and I said to myself, in spite of everything I shall rise again: I will take up my pencil, which I have forsaken in my great discouragement, and I will go on with my drawing. . . .
> The miners and the weavers still constitute a race apart from other laborers and artisans, and I feel a great sympathy for them. I should be very happy if someday I could draw them, so that those unknown or little known types would be brought before the eyes of the people. The man from the depth of the abyss *de profundis*

. . . . Wait, perhaps someday you will see that I too am an artist. I do not know what I can do, but I hope I shall be able to make some drawings with something human in them. But first I must draw the Bargues (exercises) and do other more or less difficult things. The path is narrow, the door is narrow, and there are few who find it. (Letter 136)

3

From *Book* to Books

In the previous chapter I challenge the popular view that Vincent's life was shattered during his early twenties by either a thwarted love or a replacement-child's anxiety attack that triggered a period of religious fanaticism. I also reject the description of his increasing religious concerns as mere fanaticism. Vincent's own letters reveal a far more complex picture than this, for they show his concern with books he was reading, disappointment with the art trade, encounter with the death of loved ones, and periods of general self-examination in response to his Calvinist upbringing, all of which contributed to intensifying his religious focus.

Vincent's religious development clearly reflected an attitude that narrowed and broadened as he sought how to unify his experiences of nature, art, literature, and religion. By focusing on the transformation of his attitude toward the Bible and toward the literature of his day, it is possible to follow how he resolved his search for unity, the manner in which for him the Bible and literature, and hence art and nature as well, could be creatively linked.

His spiritual development is nowhere more dramatically revealed than in his transformation from a man of one book, the Bible, to a man of many books, the literature of his age. Further, no other change in Vincent's perspective is so clearly demonstrated in his paintings as is this transformation. The trail of evidence begins with a Vincent who, as devoted student of the Bible, vows to destroy all his other books and leads to a Vincent,

who as avid reader of novels by Zola, Hugo, Dickens, Eliot and others, defends his voracious reading by arguing "the love of books is as sacred as the love of Rembrandt" (letters 39, 133). If Vincent's spiritual quest is a key to the deepest meaning of his life and work, then his transformation from a Bible-centered pietist to a radical evangelist for contemporary literature deserves our attention.

That Vincent's turning from Goupil's art trade toward the religious tradition of his father was also a turning to the Bible is clear enough. This isn't hard to understand, for his first sixteen years in his parent's Zundert parsonage were lived in the presence of the Bible. As in the Dutch Reformed Church generally, the Bible as "Word of God" dominated the worship services over which father van Gogh presided and in which his family participated. Funerals, baptisms, special seasonal celebrations, church school and Bible classes would have made Vincent's life a constant round of events focused upon Scriptural texts and their exposition or dramatization. Further, Pastor van Gogh apparently had prayers for the family in the parsonage each morning: ". . . remember how Father prayed every morning, 'Deliver us from evil, especially the evil of sin . . .' " (letter 88). Certainly these devotionals involved reading from the family Bible.

In the Calvinist tradition the Bible was the chief source of inspiration and guidance. The centrality of the Bible in the thought of John Calvin is obvious and its importance to Calvinist doctrine is clearly stated. The Geneva Confession of Calvin and Farel, in use by 1536, had as its opening article:

> First we affirm that we desire to follow Scripture alone as rule of faith and religion, without mixing with it any other thing which might be devised by the opinion of man apart from the Word of God. . . .[1]

For Calvin, neither nature, nor art, nor philosophy could lead anyone to God, for human sin had obscured God's invisible presence in all save the "mirror of Scripture" and the sacraments as interpreted by Scripture.[2] Scripture was the "sole authority in the life of the Church," and Calvinist preachers had but one chief duty, "expounding the Scripture in the midst of the worshipping Church."[3] In fact, if Scripture maintained silence on a subject, that silence should act as "bridle to the waywardness of man's

curiosity."[4] Calvin wrote in the *Institutes:*

> On the whole subject of religion one rule of modesty and soberness is to be observed; and it is this—in obscure matters not to speak or think, or even long to know, more than the Word of God has delivered.[5]

Such views make Vincent's concern over the status of his interests in nature, art, and literature understandable and might well explain his decision, at one point, to burn all his books save the Bible.

By the nineteenth century, Calvinism in Holland had split into a number of Reformed Church movements with differing emphases. Locating the particular brand of Calvinism to which Pastor van Gogh subscribed could be of importance in indicating the strictness or liberality with which he interpreted Calvin's views. As a result of his research, Marc Tralbaut finds that the Groningen party, or Evangelical movement, to which Vincent's father belonged was "centered between the two extreme wings, the orthodox on the right and the modernists on the left."[6] I believe, however, that there is sufficient evidence to indicate that the Groningen party was generally quite liberal, emphasizing innate human religious feelings and seeking accommodation with a local culture. Nevertheless, it placed high value on the New Testament, trust in Christ, and the call to Christian discipleship.[7] And there are further complications: Pastor van Gogh was hardly looked upon favorably by the Groningen authorities; he was forced to wait an unusually long time for an appointment; and then he was "exiled" to a tiny parish in the southern Brabant region, which was dominated by Roman Catholicism.[8] In the midst of a Catholic majority and a pious Protestant minority, the need to stress Calvinist emphases over against Roman Catholicism may well have made Pastor van Gogh a more conservative Calvinist in comparison to many of his colleagues. In such a situation the lines of differences could not be allowed to get blurred.

Vincent's focus on the Bible becomes obvious in the letter of September 12, 1875, from Paris, in which he seeks "wings over grave and death" (letter 37). In it he affirms that his father had those "wings," and got them by prayer "and from the Bible that was a light unto his path and a lamp unto his feet." Thirteen days

later he decided to destroy all his other books (letter 39), and by
September 27 he wrote a letter that contains a pastiche of thirty
lines from the Bible, drawing largely upon words of Jesus from
the four Gospels and Paul's Corinthian letters. The number of
scriptural references in his correspondence reaches another peak
in December 1876, some weeks after he had preached his first
sermon (letter 82a). That rambling letter includes reminiscences,
poems, hymns, and biblical references to Ecclesiastes, Psalms,
Isaiah, Jeremiah, Paul's letters, and the Gospels. It concludes with
a solid string of biblical quotations including two from the
Gospels, six from Isaiah, and one each from Jeremiah, Ezekiel,
Proverbs, and Revelation.

During his brief period as a bookseller's clerk in Dordrecht in
1877, it was reported:

> . . . whenever anyone looked at what he was doing, it was
> found that instead of working, he was translating the Bible
> into French, German and English, in four columns, with the
> Dutch text in addition.[9]

This may have had more purpose than at first appears, for
Vincent hoped that one day he would become a London mission-
ary ministering to foreigners from many lands.[10] This same tech-
nique of repetition until one internalizes, until one "knows by
heart," will be applied to the drawing of peasant figures once
Vincent becomes an artist.[11] During the Dordrecht period, Vin-
cent tried to communicate to Theo his deep attachment to the
Bible:

> You do not know how I am drawn to the Bible; I read it
> daily, but I should like to know it by heart and to view life in
> the light of that phrase, "Thy word is a light unto my path and
> a lamp unto my feet." (Letter 88)

The close relationship between Vincent's hope to follow in
his father's footsteps and his study of the Bible is clarified in
another letter from Dordrecht:

> I have such a longing to possess the treasure of the Bible, to
> study thoroughly and lovingly all those old stories, and espe-
> cially to find out what is known about Christ. As far as one can
> remember, in our family, which is a Christian family in every

sense, there has always been, from generation to generation, one who preached the Gospel. (Letter 89)

The manner in which Vincent mixes verses of Scripture from diverse sources, seldom cites the book used, and quotes rather freely and not without error, make analysis of his biblical use somewhat difficult, but it is clear that he favors the Gospel of John, generally favors words attributed to Jesus, has a liking for the Psalms and terse sayings from the "wisdom" tradition, as in Proverbs and Ecclesiastes, selects Isaiah and Jeremiah among the prophets, and avoids apocalyptic images of violent vengeance or world catastrophe, such as one would find in Revelation. His two favorite texts of the entire Bible appear to have been the Pauline phrase "sorrowful yet always rejoicing" (2 Corinthians 6: 10) and the story of the Prodigal Son from the Gospel of Luke, each referred to numerous times in his letters. It may be Bunyan's use of the Pauline phrase as the name of a spiritual guide in *Pilgrim's Progress*, and Boughton's illustration of the scene, unifying Bible, literature, and art, that sealed the Corinthian passage in his mind. The Prodigal Son story seemed personally applicable to Vincent, who felt unworthy of the religious heritage and example of his parents. He was also familiar with the motif in art, especially in Rembrandt's work.

Vincent's earlier creed, stated during his theological studies in Amsterdam, placed parents and God on the same side, watching him critically as he in resignation sought to live the parental version of the Bible:

It is so, it is true, there is a God Who is alive, He is with our parents, and *His eye is also upon us;* and I am sure that He plans our life and that we do not quite belong to ourselves, as it were. This God is no other than Christ, who we read about in our Bible and Whose word and history is also deep in our hearts. (Letter 98)

When Vincent was dismissed from his appointment as evangelist in the Borinage, July 1879, after just six months of service, he reported to Theo that the narrowness of the old academic group of evangelists and church authorities was behind his dismissal (letters 132, 133). He vowed that he would no longer follow the cold and unfeeling system of resignation of "unbeliev-

ing and hard-hearted" clergymen, and noted that his own father not only had sided with such men against him but was himself a follower of that cold, academic way (letters 155, 161, 164). Vincent did not reject the Bible, but he did reject its "academic school" of interpreters; he himself now looked at the Bible in a new way. He would open his life to love, even the earthly love of women the clergy abhorred, and he would reject pharisaic and restrictive interpretations of Christ's way:

> The clergymen call us sinners, conceived and born in sin, bah! What dreadful nonsense that is. Is it a *sin to* love, not to be able to live without love? . . .
> If I repent anything, it is the time when mystical and theological notions induced me to lead too secluded a life. (Letter 164)

Once Vincent had learned by his own experience and had examined "dessous des cartes" the "morality and religious system of ordained clergy," he confidently affirmed the new creed he had offered more reticently when he abandoned his Amsterdam studies:

> But I always think that the best way to know God is to love many things. Love a friend, a wife, something—whatever you like—you will be on the way to knowing more about Him; that is what I say to myself. But one must love with a lofty and serious intimate sympathy, with strength, with intelligence; and one must always try to know deeper, better and more. That leads to God, that leads to unwavering faith. (Letter 133; cf. letter 121)

He lists Rembrandt, the history of the French Revolution, and the "great university of misery" as ways to God: "one man wrote or told it in a book; another, in a picture" (letter 133). He concludes the passage with the admonition: "We know how to read—well then, let us read!"

Certainly Vincent did not exclude the Bible in spite of its history of misuse. But human involvement in love opens one to literature, art, and "the great university of misery," unifying all paths to meaning within the human heart. Vincent later restated his new creed in even starker form for a fellow Dutch artist, Anton van Rappard:

And as regards the doctrine I preach, this doctrine of mine—
"My friends, let us love what we love"—is based upon an
axiom. I thought it superfluous to mention this axiom, but for
clarity's sake I will add it. That axiom is: "My friends, we love."
(Letter R 6)

On the very same day he wrote Rappard, November 23, 1881,
Vincent expressed the same conviction in a letter to Theo:

> . . . the truth is, there is no real independence, no real liberty,
> no steady self-reliance, except through Love. I say, our sense of
> duty is sharpened and our work becomes clear to us through
> Love; and in loving and fulfilling the duties of love we perform
> God's will. (Letter 161)

For Vincent, love is the force that can effectively transform all
aspects of his experience, thus providing the answer to his search
for a principle of unification.

But let us return to specifics regarding Vincent's view of the
Bible and the literature of his time. For example, how did he view
the relationship of Zola's novels to the Truth of the Bible? If we
look closely at his *Still Life with Open Bible and Zola Novel,* painted
in October 1885 at Nuenen,[12] we discover that Vincent has
provided us with a visual demonstration of his views.

By the time Vincent painted *Still Life with Open Bible and Zola
Novel,* he had, in his unsettled life, been through a number of
remarkable experiences. He had already sketched the miners and
done drawing exercises in the Borinage, then traveled to Brussels
to make contact with other artists (1880). He had returned to his
parents' parsonage at Etten in the spring of 1881, but the follow-
ing Christmas he was ordered out of the house after a violent ar-
gument with his father. Having moved to The Hague, he studied
art briefly with Anton Mauve, took in a pregnant prostitute and
her children during 1882, and in September 1883, depressed by
his family's negative views of his life-style and deep in debt, he
wandered in the desolate Drenthe region. Discouraged and
penniless, he returned to his parents, now in a parish at the
Dutch town of Nuenen. There Vincent set up a studio and
painted the peasants and weavers for almost fifteen months
when suddenly and unexpectedly his father died on March 27,
1885. Following the event, Vincent arranged on a table a still life

of his father's Bible (which he was about to send to Theo), a candlestick with the stub of an extinguished candle, and a much worn paperback novel.

Though Vincent's letters often tell a good deal about the intent of his paintings,[13] in this case he simply tells Theo:

> . . . I send you a still life of an open—so a broken white— Bible, bound in leather against a black background with a yellow-brown foreground, with a touch of citron yellow.
> I painted that *in one rush,* on one day. (Letter 429)

The subject matter and its arrangement, however, indicate that the painting is far more than an experiment in color. The snuffed candle and his father's ponderous Bible standing together against the black background certainly speak of his father's profession and of death. The "touch of citron yellow" seems an intrusion, a cheap and worn Parisian novel, with its authorship and title clearly in view, "Émile Zola, *La Joie de vivre (The Joy of Living)*." Over against the ponderous Bible, claimed as an immovable and restrictive authority by "unbelieving and hard-hearted" clergy, lies close at hand a bit of yellow light bearing the title *La Joie de vivre,* a novel barely one year off the press, a product of Vincent's newly discovered world.

The entire painting appears in some sense to be Vincent's visualization of two opposing generations exemplified in his father's refusal of the new literature in the name of the eternal Truth of the Bible. The very arrangement of the still life recreates a scene we have already reported happening between Vincent and his father in the parsonage. Just one month before Christmas (1881), when his father was to order him out of the house, Vincent wrote to Theo:

> When Father sees me with a French book by Michelet or Victor Hugo, he thinks of thieves and murderers, or of "immorality"; but it is too ridiculous, and of course I don't let myself be disturbed by such opinions. So often I have said to Father, then just read it, even a few pages of such a book, and you will be impressed yourself; but Father obstinately refuses. (Letter 159)

Vincent represents what he views as an essential conflict between the closed mind that claims all Truth for the Bible and the mind that accepts the possibility that Truth can be found in other

books as well.

Even though battles with his father deeply grieved Vincent, ever since the Borinage he insisted that he must actively stand up against the "cold academic view," against his parents' misunderstanding of the times, literature and art; "neither do they understand the Bible" (letter 164). While troubled by arguments with his father at Etten, Vincent had explained to Theo, ". . . of course I love Father," but

> Father cannot understand or sympathize with me, and I cannot be reconciled to Father's system—it oppresses me, it would choke me. I too read the Bible occasionally just as I read Michelet or Balzac or Eliot; but I see quite different things in the Bible than Father does, and I cannot find at all what Father draws from it in his academic way. (Letter 164)

Vincent's painting, even as it memorializes his father's death, does not give an inch to the older generation's outmoded and repressive ideas. Vincent felt civilization itself was at a critical juncture where a new and revolutionary generation must stand against the entrenched prejudices of class, power, money, and privilege:

> We are full-grown men now and are standing like soldiers in the rank and file of our generation. We do not belong to the same one as Father and Mother and Uncle Stricker; we must be more faithful to the modern than to the old one—to look back toward the old one is fatal. (Letter 160)

But there is something more to Vincent's painting of the Bible and Zola's novel. Though the Bible belonged to his father, his father had not truly understood the Book. Vincent opened the Bible neither to restrictive commandments nor to the warnings of evil his father stressed. He also rejected what had once been a favorite passage of his own, the parable of the Prodigal Son. Vincent no longer saw himself as a prodigal in relation to his father. What Vincent consciously chose was to open the Bible to his own experiment in biblical living, the mission of the Suffering Servant he had wholeheartedly taken on in the Borinage. The song of the Suffering Servant in Isaiah, chapter 53, is clearly marked by the French word "ISAIE" at the top of the right-hand page (he was sending both the Bible and his painting of it to

Paris), and by the Roman numerals LIII.[14] That chapter of Isaiah, already discussed, describes the mission of God's disfigured and misunderstood servant who bears the griefs and sorrows of others:

> He was despised and rejected by men;
> a man of sorrows, and acquainted with grief. . . .
> Surely he has borne our griefs and carried our sorrows;
> Yet we esteemed him stricken,
> smitten by God, and afflicted. (Isaiah 53: 3, 4)

Vincent had actually suggested to Theo, while their father was still alive, that he could have helped his father discover other facets to the Bible, but his father refused:

> So I do not consider Father an enemy, but a friend who would be even more my friend if he were less afraid that I might "infect" him with French "errors."(?) I think if Father understood my real intentions, I could often be some use to him, even with his sermons, because I sometimes see a text in quite a different light. But Father thinks my opinion entirely wrong, considers it contraband, and systematically rejects it.(Letter 161)

Vincent now had that opportunity his father once denied him. He opened the Bible to a text which interprets the Scripture's intent accurately, and he allowed a modern novel its rightful place beside the Bible.

One detail is less clear in the painting of the Bible itself. It appears that Vincent painted the roman numeral XX as a marking to indicate that the Bible was opened to verse twenty, but there is no twentieth verse in chapters 52, 53, or 54 of Isaiah. My own guess is that Vincent intended to write XII, but was careless. However, I have at least considered the possibility that, by using verse twenty in a chapter with only twelve verses, Vincent might have been intimating the story of the Suffering Servant continues to be written.

One other level of significance in Vincent's painting of *Still Life with Open Bible and Zola Novel,* is discernible to those who, like Vincent himself, have read Zola's novel with care. That level has been missed by most interpreters. Hulsker, in *The Complete van Gogh,* finds stark contrast between the Bible opened to Isaiah

and the novel's title, *La Joie de vivre*.[15] Graetz, in *The Symbolic Language of Vincent Van Gogh,* similarly places all the emphasis upon contrast:

> The little novel in front of the weighty Bible symbolizes the opposition between the modern way of life and the strong religious tradition with the condemnation in Isaiah of joy in living—of *joie de vivre*.[16]

A double error of interpretation is involved in such views. First, Isaiah is misinterpreted. Far from being a dour prophet, he is known as the prophet of singing, celebration, and rejoicing. Because God provides a servant who carries the suffering of others, a vicarious sacrifice, humanity is invited to "break forth into singing" (Isaiah 54:1), to "come, buy wine and milk without money and without price" (Isaiah 55:1). Isaiah, in fact, announcing that humanity is healed by the servant, specifically calls his message "good tidings" or "gospel" (Isaiah 61:1). In addition, Zola's novel is misinterpreted. *La Joie de vivre* is hardly a contrast to Isaiah, and would not have been intended so by Vincent. In fact, we suggest that Vincent chose the novel precisely because it communicated to him the Servant Song of Isaiah in modern dress.

At one level it appears that Vincent painted what has the external appearance of a contrast: the virtuous and sturdy Bible over against a garish and flimsy novel. That would be the shallow level at which Vincent's father, clergymen and their disciples of the cold academic approach would have made their judgment. But at a more profound level, the painting affirms that significant novels express the truths of the Bible for a contemporary audience. In a single painting, Vincent has revealed the misunderstanding of the old generation, the new generation's attraction to the novel, and his own theory regarding the relationship of modern novels to the Bible's Truth. It is possible to test the theory by first viewing the plot of *La Joie de vivre* and then by referring to Vincent's own words regarding the relationship of novels to the Bible.

Zola's *La Joie de vivre* pictures a bourgeois family that is as miserable as one can imagine. There is Mr. Chanteau whose gout makes every movement painful, reducing him finally to a grotesque stub of a body. His wife is a self-centered and greedy

woman. Lazare, their son, is a weakling who runs from every challenge and is reduced to misery by thoughts of dying. Pauline Quenu, an orphan, is put in their charge, and though they steal her money, betray her, and misuse her love, she remains a ray of light in the household and an angel of charity in their poor fishing village. Finally, she saves the life of the newborn child of Lazare, the man she had once hoped to marry, and his new wife, a shallow and ill-tempered temptress. The apathy of the new parents leaves the child to her care. Zola makes no secret of his drama of light shining in darkness. The first line of chapter two reads:

> From the first week Pauline's presence in the house proved a source of joy and pleasure to the family.[17]

The end of the book makes clear that the darkness could not put out that light:

> She would remain unmarried in order to be able to work for the universal deliverance. And she was, indeed, the incarnation of renunciation, of love for others and kindly charity for erring humanity. . . . She had stripped herself of everything, but happiness rang out in her clear laugh.[18]

Vincent saw both the Servant in Isaiah and Pauline Quenu as incarnations of renunciation, sacrifice, and charity. But it was fitting that Zola expressed the Servant mission for a new age in the form of a new body, a joyful young girl, and projected its hope into the future in the form of the child she vowed to raise in the midst of darkness and death. Vincent knew his literature, and books were not mere props or disembodied titles in his work, they were messages demanding an "art of words" equivalent to the art of painting itself. As he wrote his colleague, Émile Bernard, who was struggling to write sonnets:

> There are so many people, especially among our comrades, who imagine that words are nothing—on the contrary, isn't it true that saying a thing well is as interesting and as difficult as painting it? There is the art of lines and colors, but the art of words is there nonetheless, and will remain. (Letter B 4)

But Vincent can be far more specific regarding the relationship

of the contemporary "art of words" and the "eternal" Truth of the Bible. In 1881, while at the parsonage in Etten, he recommended that Theo read the works of "Michelet and Beecher Stowe, Carlyle and George Eliot and so many others," and continued:

> It is true the Bible is eternal and everlasting, but Michelet gives such practical and clear hints, so directly applicable to this hurried and feverish modern life in which you and I find ourselves, that he helps us to progress rapidly; we cannot do without him. The Bible consists of different parts and there is growth from one to the next; for instance, there is a difference between Moses and Noah on the one hand, and Jesus and Paul on the other. Now take Michelet and Beecher Stowe: they don't tell you the Gospel is no longer of any value, but they show how it may be applied in our time, in this our life, by you and me, for instance. Michelet even expresses completely and aloud things which the Gospel whispers only the germ of. (Letter 161)

Vincent indicates that the Bible itself incorporates development over time and so obviously allows for change and application. Modern writers participate in that development, and make pointed application of the Bible to modern life, even to expressing aloud what the "Gospel whispers only the germ of."

Vincent's thoughts about the relationship between modern literature and the Bible didn't end there. Six years later, assuming the role of adviser to his youngest sister, Wilhelmina, he defined his position more radically. After recommending that "Wil" read Guy de Maupassant, Rabelais, Henri Rochefort, Voltaire's *Candide,* books by the de Goncourts (*Germinie Lacerteux* and *La Fille Eliza*), Zola's *L'assommoir* and *La Joie de vivre,* and works by Richepin, Daudet, and Huysmans, he asks:

> Is the Bible enough for us?
> In these days, I believe, Jesus himself would say to those who sit down in a state of melancholy, It is not here, get up and go forth. Why do you seek the living among the dead?
> If the spoken or written word is to remain the light of the world, then it is our right and our duty to acknowledge that we are living in a period when it should be spoken and written in *such* a way that—in order to find something equally great, equally good, and equally original, and equally powerful to revolutionize the whole of society—we may compare it with a clear conscience to the old revolt of the Kristians.

To be certain his point is properly understood, Vincent continues from a more personal perspective:

> I myself am always glad that I have read the Bible more thoroughly than many people nowadays, because it eases my mind somewhat to know that there were once such lofty ideas. But because of the very fact that I think the old things so beautiful, I must think the new things beautiful *à plus forte raison*. *À plus forte raison,* seeing that we can act in our own time, and the past as well as the future concern us only indirectly. (Letter W 1)

Vincent had now left the Bible to the past, and turned his attention to the only Bible applicable to his own day, those "new things" that revolutionize the present. His use of the question originally addressed to those who sought Christ at the tomb, "Why do you seek the living among the dead?" makes clear his sense of the dynamic nature and continuing incarnation of Truth, never locked in the past, always to be discovered in the present act. Those who remained attached to the ancient Bible were faithless in their supposed faithfulness.

In 1887, the same year Vincent wrote about his radical view of the Bible and modern literature to sister Wil, he demonstrated the new outlook in his painting *Romans Parisiens (Paris Novels)*. Twenty or more paperback novels, most of them bright yellow, are piled extravagantly on the table of his Paris apartment with a glass and stem of roses. The novel directly in front of the viewer is open. Vincent here celebrated modern literature and expressed gratitude for books, which saved and revolutionized his life in time of despair, leading him to take up that same mission, though in lines and color. The novel opened in the foreground invites and challenges: "We know how to read—well then, let us read!" (Letter 133)

Books play a role in numerous other works by Vincent, who admired paintings of readers by other artists.[19] During the winter of 1887 he had done a painting of three novels on the oval panel of a tea chest, painted the famous *Romans Parisiens* and a still life with plaster statuette, rose, and two novels—one by Guy de Maupassant (*Bel-Ami*) and the other by the de Goncourts (*Germinie Lacerteux*).[20] In Arles, he painted an almond branch beside

a book, books beside a jar with oleander branches, one version of *The Arlésienne* with two books, and a woman reading a novel.[21] In December 1888, there are novels in *Gauguin's Chair*, and in January 1889, Raspail's volume, *Annuaire de la Santé* is placed along with onions and other objects on a tabletop.[22] His *Arlésienne* from a drawing by Gauguin has on the table in front of her Harriet Beecher Stowe's *Uncle Tom's Cabin* and Dickens's *Christmas Carol*.[23] Finally, one of his portraits of Dr. Gachet from Auvers, which he painted in 1890, has the novels *Germinie Lacerteux* and *Manette Salomon* by the de Goncourts on the table.[24] Further, novels, even when not pictured directly, often inspired Vincent to paint specific subjects or wrestle with particular issues.[25]

Books obviously played an important role in Vincent's life, perhaps as important as the role the Bible had once claimed for itself. One reason, generally overlooked by critics, is that Vincent's personal peculiarities, his alienation as a wandering foreigner, his "strange" profession, and his isolation during periods of painting from dawn to dusk in the countryside, left him with few human contacts apart from literature. His books were his bridge to society, to human feelings and motives, currents of thought, and even to trivia and gossip. Further, it is often overlooked how important a role Vincent had given illustrators in the world of art, and how highly he regarded those who created pictures specifically to go with words, as in novels and magazine articles, or created pictures that carried captions, as in much of the work of Daumier and Gavarni, for example. Pages carrying the work of these men, often from *The Graphic, L'Illustration,* or *Harpers,* were gathered by Vincent who spoke of the collection as his Bible.[26] His own early use of captions, as in the lithograph *Sorrow* which carried lines from Michelet on its lower margin, continued through the occasional presence of book titles in his paintings and the regular commentary carried in his letters.

Vincent's constant search for unification of his life and the variety of ways to meaning, led to a constant attempt to find equations which might unify the worlds of nature, art, and literature. He compared scenes in nature to paintings, descriptions in books to nature and to art works, and regularly sought equivalences between writers and painters. For example:

There is something of Rembrandt in Shakespeare, and of

> Correggio in Michelet, and of Delacroix in Victor Hugo; and
> then there is something of Rembrandt in the Gospel, or some-
> thing of the Gospel in Rembrandt. . . . If now you can forgive
> a man for making a thorough study of pictures, admit also that
> the love of books is as sacred as the love of Rembrandt—I even
> think the two complement each other. (Letter 133)

For Vincent, *word* and *image* were two ways it was possible to
express one meaning.

Vincent's transformation to a man of many books allowed
him a more critical stance toward the Bible of old. In letters to
Émile Bernard, the young painter who was struggling with his
deep feelings for Roman Catholic tradition and piety, Vincent
was most willing to discuss the Bible.[27] In a letter from Arles in
1888, before Gauguin's visit, Vincent expressed his feelings on
the Bible in response to Bernard's announcement that he was
studying Scripture. Vincent, who always had favored the New
Testament, now had scathing criticism of the Old Testament,
intensifying his sense of development in the Bible:

> How petty that story is! My God, only think. So there are
> only Jews in the world, who begin by declaring everything
> which is not themselves impure.
> Why don't the other peoples under the great sun of those
> parts—the Egyptians, the Indians, the Ethiopians, Babylon,
> Nineveh—why don't they have their annals, written with the
> same care!

Vincent's own search for unity and inclusiveness here seems
offended by the Old Testament's exclusivity. He continues:

> But the consolation of that saddening Bible which arouses our
> indignation—which distresses us once and for all because we
> are outraged by its pettiness and contagious folly—the conso-
> lation which is contained in it, like a kernel in a hard shell, a
> bitter pulp, is Christ. (Letter B 8)

A new criticism of the Bible and its layers of diverse traditions
was certainly not foreign to Vincent's day. Manuscript discover-
ies encouraged the development of "lower criticism" and Dar-
win-inspired evolutionary views, comparative religion, histori-
cal and literary studies advanced "higher criticism" of both Old

and New Testaments. Julius Wellhausen's *Prolegomena to the History of Israel*, published in 1883, detailed cultural influences and layers of tradition in Hebrew Scripture, while the Tübingen school questioned the divinity and even the historicity of the Jesus figure.[28] That a critical view was taken of the Bible was not unusual, *but*, that an artist had studied the Bible for himself and thought seriously about its claims of Truth in relation to modern literature and art, this *was* unusual.

An enormous issue arising at the point where Bible and art intersect soon became the focus of discussion as Vincent, the Dutch Calvinist in search of a deeper unity, and Émile Bernard, rediscovering his heritage of Catholic piety, continued their correspondence. The critical issue, deserving of a volume in itself, focuses upon the problem of doing "religious art" in the modern age. Specifically, if contemporary literature is the Bible-making of this age, is there any longer a justification for painting archaic biblical scenes and themes? If there is not, how does one distinguish Christian religious art from any other art? What art ought churches commission and utilize? Bernard was so moved by Vincent's letters on this subject, though hardly in agreement, that he sought to have them published soon after the Dutchman's death. Few have studied this correspondence or sought to understand Vincent's impassioned arguments, and little or no progress seems to have been made on the issues involved since Vincent and Bernard's original statements

Vincent lived during the "Age of Disbelief," the "Generation of Materialism" looking toward science and scientific methodology for salvation. The naturalism of the de Goncourts and Zola was a study of the objective facts of human heredity and environment that sought to understand human nature. Vincent's own attraction to *Germinie Lacerteux* was no doubt partly a response to the book's preface, in which the Goncourts defined the mission of this new literature:

> Today, when the Novel is growing broader and larger, when it is beginning to be the great and serious form, passionate and alive, of literary study and social inquiry, when by analysis and psychological research it is becoming the moral history of our time, today when the Novel has subjected itself to the study and discipline of science, it can claim the freedom and rights of science. And may it aim at Art and Truth; may it

portray sufferings worthy of not being forgotten by the fortu-
nate in Paris; may it show society people what Sisters of Charity
have the courage to see, what queens of long ago made their
children look at in hospices—human suffering, present and
alive which inculcates charity; may the Novel have that reli-
gion which the last century called by the broad and compre-
hensive name—Humanity. [29]

Similarly, the new and revolutionary approach to painting
had discarded the Academy's tradition of canvases depicting
ancient mythological subjects, coronations of kings and deaths
of generals, countless canvases of *Hagar in the Wilderness* and
Jesus in Gethsemane. Realists, as the writings of Champfleury and
paintings of Courbet demonstrated, studied the facts of their
own time and sought to give "impartial representation" of the
real world. Within the movement, Social Realists showed society
its own hidden underside. De Groux, Daumier, and Gavarni
pictured the slums and alleys, Millet had studied the peasant, and
Vincent's favorites of The Hague School, Mauve, the Maris broth-
ers, Isräels, and others, showed the hard life of fishing villages,
peat cutters and peasants.[30]

But already in Vincent's lifetime, dissatisfaction with Real-
ism led such painters and writers as Maurice Denis, Charles Fil-
iger, Serusier, Paul Verlaine, Huysmans, Paul Claudel and many
others either to return to the safety of the Church or respond to
the call to become priests of a new aesthetic elite, as Carlyle
seemed to advocate:

> Highest of all Symbols are those wherein the Artist or Poet
> has risen into Prophet, and all men can recognize a present
> God, and worship the same. . . . A Hierarch therefore, and
> Pontiff of the World will we call him, the Poet and inspired
> Maker. . . .[31]

What direction would Gauguin and Bernard take? In 1888,
Gauguin had painted *Vision after the Sermon: Jacob Wrestling with
the Angel*, signaling for many the founding of symbolism as a
school of art. He appeared to be following the advice he had given
to one of his disciples: "Art is an abstraction; extract it from
nature while dreaming before it. . . ."[32] Gauguin's imaginative,
mysterious dreaming was conjuring biblical images and primi-

tive faith. In 1899 he added a *Calvary, Yellow Christ, Joan of Arc, Self-Portrait as Christ in Gethsemane*, and *Self-Portrait with Yellow Christ*. Bernard had painted an *Adoration of the Shepherds* in 1887, and by 1889 sent photographs to Vincent, now at Saint-Rémy, of several religious paintings including an *Adoration of the Magi, Annunciation, Christ in the Garden of Olives*, and *Christ Carrying His Cross*. If Bernard had expected a positive response, he was mistaken. Vincent, after viewing the photographs, wrote to Theo:

> The thing is that this month I have been working in the olive groves, because their Christs in the Garden, with nothing really observed, have gotten on my nerves. Of course with me there is no question of doing anything from the Bible—and I have written to Bernard and Gauguin too that I consider that our job is thinking, not dreaming, so that when looking at their work I was astonished at their letting themselves go like that. (Letter 615)

In his response to Bernard's photographs, Vincent was even more direct:

> Now look here, I am too charmed by the landscape in the *Adoration of the Magi* to venture to criticize, but it is nevertheless too much of an impossibility to imagine a confinement like that, right on the road, the mother starting to pray instead of giving suck; then there are those fat ecclesiastical frogs kneeling down as though in a fit of epilepsy, God knows how, and why!

Vincent attacks the "dreaming" before nature that avoids hard observation of reality; he attacks empty religious posturing that has forgotten the realist's responsibility for contemporary life. In a sense, he is repeating again the words spoken at the tomb: "Why do you seek the living among the dead?"

Continuing his critique, Vincent provided a positive model for Bernard's consideration:

> No, I can't think such a thing sound, but personally, *if* I am capable of spiritual ecstasy, I adore Truth, the possible, and therefore I bow down before that study—powerful enough to make a Millet tremble—of peasants carrying home to the farm a calf which has been born in the fields. Now this, my friend,

all people have felt from France to America; and after that are
you going to revive medieval tapestries for us?

Vincent here calls to Bernard's attention Millet's work depicting
peasants carrying a newborn calf to their home where mother
and children wait to care for it. "Dreaming" a medieval religious
scene detaches one from the struggle to discover the sacredness
of such life-events. A fantasy world of archaic religious symbols
robs everyday life, even the birth of a calf, of its holiness.

Vincent's critique of Bernard's other religious paintings is
equally harsh: "An 'Annunciation' of what? . . . that nightmare
of a 'Christ in the Garden of Olives,' good Lord I mourn over it.
. . . 'The Christ Carrying His Cross' is appalling" (letter B 21). Vin-
cent again presents positive counter-examples, describing two
paintings he has done at the asylum, one contrasting a tree struck
by lightning and a fading rose, the other "the sun rising over a
field of young wheat." He explains:

> I am telling you about these two canvases, especially about
> the first one, to remind you that one can try to give an impres-
> sion of anguish without aiming straight at the historic Garden
> of Gethsemane; that it is not necessary to portray the charac-
> ters of the Sermon on the Mount in order to produce a consol-
> ing and gentle motif. (Letter B 21)

For Vincent, "seeing nature through one's temperament" is no
simple copying task, but involves a struggle, a conversation with
reality that releases truth: "I see that nature has told me some-
thing . . . " (letter 228).

Vincent was forced to acknowledge that some of his favorite
artists, including Rembrandt and Delacroix, had sometimes
painted biblical scenes. But he emphasized that it was not often,
and that such masters had still allowed "modern sensations
common to us all," to "predominate" (letter B 21). Vincent's only
personal attempts at a biblical scene, *Christ in Gethsemane,* he had
scraped off and never attempted again (letters 505 and 540). His
copies of biblical themes by Delacroix and Rembrandt had quite
another motive than doing his own biblical subjects in art. They
were experiments in "translating" or "playing" compositions
created by masters (letters 607, 613).

Gauguin's biblical paintings may have caused an added

problem for Vincent, especially as they depicted contemporary Breton women or Gauguin himself in biblical settings or worshipping at actual shrines. Nevertheless, Vincent still objected to a return to religious mannerisms and fantasies.[33] Poignantly, an unfinished letter found among Vincent's papers was intended to continue the discussion with Gauguin:

> Meanwhile, I have a portrait of Dr. Gachet with the heartbroken expression of our time. *If you like,* something like what you said of your *Christ in the Garden of Olives,* not meant to be understood, but anyhow I follow you there, and my brother grasped that nuance absolutely. (Letter 643)

Perhaps Vincent here admitted the possibility that Gauguin's personal involvement in the Gethsemane painting saved it from empty posturing. However, I am more inclined to believe that he sought to convince Gauguin that a radically modern portrait, as in his own painting of Dr. Gachet, would be more *responsible* and *effective.*

The debate of Bernard, Gauguin, and van Gogh regarding the possibility of religious art in the modern world was never completed. Bernard's "medieval tapestry" approach is still in evidence and some experiments have involved Gauguin's mix of ancient, modern, and the self, but Vincent's radical allegiance to the "sacred present" seems not to have been understood by the religious community or its favored artists.

A fascinating chapter in a book Vincent valued highly, Victor Hugo's *Notre Dame de Paris,* provides a further context for Vincent's conversion from one book, the Bible, to the literature of his day. The Hugo chapter, entitled "This Will Kill That," depicts Dom Claude Frollo, the tormented archdeacon of Notre Dame, in a secret meeting with King Louis XI and his physician. Dom Claude Frollo is described by Hugo as making a mysterious prediction:

> . . . extending his right hand, with a sigh, toward the printed book which lay open on the table, and his left hand toward Notre Dame, and turning a sad glance from the book to the church,—"Alas," he said, "this will kill that."[34]

Victor Hugo devoted an entire chapter to the interpretation of

that single sentence, uncovering layer after layer of meaning: "The book will kill the edifice, . . . the press will kill the church, . . . all civilization begins in Theocracy and ends in democracy, . . . the invention of printing . . . is the mother of revolution."[35]

Vincent was in agreement with Hugo's sweeping view of the revolutionary power of the printing press to liberate the minds of a new generation of workers from the "academies" of privilege and oppression. The de Goncourts, Zola, and Harriet Beecher Stowe would uncover the realities of slavery, poverty, greed, and abuse. Hugo would move readers toward the great unifying possibilities of freedom and love, George Eliot would demonstrate the power of independent thought and depth of feeling in moral regeneration, Dickens would celebrate the potential for personal conversion to childlike simplicity and community.

In a Dickens story Vincent reread every Christmas, Scrooge stood as a parable of Vincent's hopes: the miserly self-centeredness of the old age could be inspired to "rebirth" by the spirits of novels revealing the meaning of past, future, and present.[36] Like Scrooge, the old age would not be reborn to Institutional Christianity, but to loving service, to community with the needy, to healing Tiny Tim. Vincent saw the power of novels to work transformations for the good, and even the power of illustrations accompanying those words, but the problem was, how were painters to pursue this same mission to the people. "Falling back" to the biblical images used for so long to bolster the power of an academic, priestly caste was not the answer. And although Vincent appreciated Carlyle's message that work itself is revelatory, he rejected the view that writers and painters ought to make claim to a new priesthood, accepting adoration and guarding some esoteric symbolism.[37] His response to Aurier's enthusiastic review of his paintings, while expressing gratitude to the critic, honestly refused adoration, and even cautioned the critic that "sectarian spirit" among artists was "preposterousness."[38]

Vincent's own plan for contributing to the liberation of the minds of the new generation, explained in detail to Theo, was worked out in The Hague in 1882 as he experimented with lithography. Artists also had a press, and they too could serve the new age:

> As it is useful and necessary that Dutch drawings be made, printed, and distributed which are destined for workmen's

houses and for farms, in a word, for every working man, a number of persons should unite in order to use their full strength toward this end. (Letter 249)

Vincent described the goal as "making figures *from the people for the people* . . . not commercially but as a matter of public service and duty . . . " (letter 251). When workmen actually asked for a copy of Vincent's lithograph of an almshouse man, he was deeply moved: "No result of my work could please me better than that ordinary working people would hang such prints in their room or workshop" (letter 245). Vincent himself lacked the money to continue his experiments in lithography. Friends did not come forward to serve in the enterprise, and it died.

Other plans and experiments followed. Vincent discussed with Theo the possibility of marketing rapid sketches inexpensively, or mounting studies on cheap gilt Bristol for the market (letter 399). Vincent's "Yellow House" in Arles was another experiment on behalf of artists, who could live and work together like monks for a common cause (letters 468, 493). When Gauguin abandoned the Yellow House, that dream too was shattered. From the asylum at Saint-Rémy Vincent continued to struggle with the issue:

Oh, we must invent a more expeditious method of painting, less expensive than oil, and yet lasting. A picture . . . that will end by becoming as commonplace as a sermon, and a painter will be like a creature left over from the last century. (Letter 615)

No invention has quite answered Vincent's search. Oil paintings continue to be thought of as the province of museums and the wealthy, and prints are numbered and kept artificially scarce.

In spite of his poverty, disappointments, illness, and isolation, Vincent did not live a joyless life. His own favorite bit of Scripture probably expressed it best: "Sorrowful, yet always rejoicing." Among his greatest joys were books, including the poetry of Jules Breton, Christina Rossetti, Longfellow, Keats, and Whitman, the dramas of Shakespeare, or novels of Zola, Dickens, Eliot, Daudet, Loti, and many others. Vincent could speak of a "something indescribable" that communicates through nature, God, paintings, and "a book by Victor Hugo," and this brought

a deep sense of happiness:

> At times there is something indescribable in those aspects—all nature seems to speak; and going home, one has the same feeling as when one has finished a book by Victor Hugo, for instance. As for me, I cannot understand why everybody does not see it and feel it; nature or God does it for everyone who has eyes and ears and a heart to understand. (Letter 248)

Again, Vincent continually wanted to bring together all his experience to a cohesive meaning that would be made possible by the unifying force that he sought.

From the asylum in Saint-Rémy, Vincent wrote Theo of one beautiful sight in Paris he hoped to paint someday. As he never got that opportunity, we have only his picture in words, perhaps the most beautiful tribute ever made to a bookstore, by a true lover of books:

> I still have it in my heart someday to paint a bookshop with the front yellow and pink, in the evening, and the black passers-by—it is such an essentially modern subject. Because it seems to the imagination such a rich source of light—say, there would be a subject that would go well between an olive grove and a wheat field, the sowing season of books and prints. I have a great longing to do it like a light in the midst of darkness, Yes, there is a way of seeing Paris beautiful. (Letter 615)

4

The Vulnerability of God

Vincent van Gogh lived his brief life at the juncture of two ages, the age of religious certainty, which was dying and defensive, and the age of scientific certainty, which was young and aggressive. Belief in God was under devastating attack by some, considered irrelevant by many, and undergoing radical reformulation by a few. Friedrich Nietzsche, the German philosopher who announced "God is dead, and we have killed him," was placed in an asylum the very year (1889) that Vincent voluntarily entered the asylum at Saint-Rémy. Martin Buber, the Jewish philosopher deeply influenced by Nietzsche, was born the year Vincent spent in Amsterdam preparing for theological school (1878). Buber would later write *Ich und Du* (*I and Thou*), distinguishing the "living God of personal engagement" from intellectual constructions of God. Paul Tillich, the German-American philosopher and theologian, was born the year Vincent lived in Paris with Theo (1886). Tillich read Nietzsche while serving as an army chaplain in World War I, agreed that the old concept of God was dead, and used existential insights in a search for the "God beyond God."

Vincent, though aware of much of the European art and literature of his day, gave no indication of direct knowledge of the works of Nietzsche, Kierkegaard, Freud, Schleiermacher, Marx, Albrecht Ritschl, and other seminal thinkers whose explorations had monumental impact on religious belief and concepts of God in the latter half of the nineteenth century. Neither do Vincent's writings indicate any knowledge of Ferdinand Chris-

tian Baur's application of Hegelianism to New Testament studies. Vincent's own attraction to Thomas à Kempis's *Imitation of Christ,* Bunyan's *Pilgrim's Progress,* Ernest Renan's naturalistic *Life of Jesus,* hints of Tolstoy and Dostoevsky, Victor Hugo's religious musings, Millet's "peasant faith" as depicted in the biography by Alfred Sensier, and the art works of Rembrandt and many others were unusual sources for theological inspiration. This, no doubt, contributed both to the uniqueness of his religious thought and to its being ignored by theologians and scholars of religion ever since.

Vincent's early religious thought reveals a pietistic acceptance of the faith taught in his parsonage home and preached in the churches pastored by his grandfather, father, and uncle Stricker. His concept of God demonstrates an early trust in established authority, his Calvinist heritage, his parents, and the Bible. In the striving to find a mission within the church from 1874 to 1878, Vincent sought to learn and to submit himself to the views of the middle-class Calvinism of his day and to the manner of life of his parents.

Vincent's first sermon, preached in November 1876 in the village of Richmond, England, allows us an effective review of his belief in God during this period of religious striving through accepted institutional channels. The text he chose is revealing, Psalm 119:19: "I am a stranger on the earth, hide not thy commandments from me." It agrees in emphasis with the texts he cited as his special preference in a letter to Theo in 1875:

> . . . I prefer:
> "Fear God, and keep his commandments: for this is the whole duty of man," and "Thy will be done," and "Lead us not into temptation but deliver us from evil." (Letter 34)

The theme of God as Lawgiver, charting a disciplined, narrow path for those wishing to be certain of their progress and blameless in their behavior appears to have been central. No better text, in that case, could have been chosen than Psalm 119. The terms "law, testimonies, precepts, statutes, commandments, and ordinances," occur a total of 128 times in that single Psalm, promising to answer the question, "How can a young man keep his way pure?" (Psalm 119:9). The Psalm's blessing is clearly upon "Those whose way is blameless, who walk in the law of the Lord . . ."

(Psalm 119: 1). The passage was obviously well known to Vincent, as it contains a text he quoted in two letters focusing on the centrality of the Bible in his father's life and in his own aspirations: "Thy word is a lamp to my feet and a light to my path" (Psalm 119: 105). Two of Vincent's most cherished books, *The Imitation of Christ* with its demanding requirements and *Pilgrim's Progress* with its journey through terrifying obstacles, present a similar picture of God as transcendent authority whose requirements are to be painstakingly met.

Along with the theme of God as Lawgiver charting a narrow way, Vincent's sermon placed great emphasis upon the debt of gratitude owed to mother and father. The sermon describes the mother's anguish in childbearing, her "loving breast," the "golden hours of our early days at home," and the Christian "lives of my parents." Parents and God stand together as demanding authorities, and it is sometimes difficult to determine which was primarily in Vincent's mind, as when midway through the sermon he asserts, " . . . we want a Father, a Father's love and a Father's approval." [1]

Another aspect of Vincent's concept of God is emphasized numerous times in his first sermon and throughout his period of traditional religious piety: the close relationship, perhaps identity, of God and Christ. Without explanation, barely eight lines into the sermon, Vincent affirmed:

> The end of our pilgrimage is the entering in Our Father's house, where are many mansions, where He has gone before us to prepare a place for us. [2]

The "He" who "has gone before us" appears to refer back to "Our Father," but obviously refers as well to Christ, as the quotation from Jesus' words in John 14: 2 indicates.

> In my Father's house are many mansions. If it were not so, would I have told you that I go to prepare a place for you?

Though Vincent provided no explanation for his use of the terms, when he uses "God" he seems to be emphasizing the sense of "Transcendent Lawgiver" and when he uses "Jesus Christ" he seems to be focusing on the promise of peace, resurrection, light, rebirth, and love. The sermon, for example, contains twelve clear

references to Christ or words of Christ, six from the Gospel of John, one from the Synoptic tradition, four from Paul's letters, and one general affirmation. Christ, who is described as "resurrection and life" and "light in darkness," teaches the commandments of love, comforts us in the storm, brings "peace," and asks the question, "Dost thou love me?" Apart from these references within the sermon, God and Christ seem to merge most completely for Vincent in one of his favorite texts of this period, the parable of the Prodigal Son (Luke 15:11–32), where the father as described by Jesus brings comfort and peace to the prodigal.

Vincent's concept of God, its close relationship to authority, parents, and Bible, and its identification of God with Christ, was reaffirmed a year later during his studies in Amsterdam, in a personal creed we cited earlier:

> . . there is a God who is alive, He is with our parents, and *His eye is also upon us;* and I am sure that he plans our life and that we do not quite belong to ourselves as it were. This God is no other than Christ, whom we read about in our Bible and whose word and history is also deep in our hearts. (Letter 98)

The same letter from Amsterdam which carried the above creed also emphasized the overwhelming reality of Vincent's (and Theo's) anxiety regarding the heavy requirements placed on them, "the many watching . . . the fear of failure, of disgrace . . ." (letter 98). The heavy requirements of God as Lawgiver seem to have been an overwhelming reality for Vincent during this period, while the identification with Christ and the image of the accepting father of the prodigal were merely a fond hope.

Vincent's religious transformation occurred at the very moment he gave up the family sponsored academic route toward Christian service and opened his search to include the domains of nature, literature, and art. His new creed, which had cast aside anxieties regarding disgrace and failure, is expressed in terms of love:

> . . . it certainly is true that it is better to be high-spirited, even though one makes more mistakes, then to be narrow-minded and overprudent. It is good to love many things, for therein lies true strength; whosoever loves much, performs and can accomplish much, and what is done in love is well done. (Letter 121)

In the light of this new creed, Vincent's work as evangelist in the Borinage during 1879 appears as an open and personal experiment in acting out Christ's "Suffering Servant" mission among people in need, a mission Vincent appears to have conducted in his own manner without anxiety regarding the opinions of those in authority. His interpretation of God's nature may be indicated in these rather stylized remembrances by a neighbor of Esther Denis, the wife of the baker with whom Vincent boarded in the Borinage for a time:

> To Esther (Madame Denis, who expostulated with him for tearing up his linen so that he could take it to families where there were sufferers from firelamp burns):
>
> "Oh Esther, the Good Samaritan did more than that! Why not apply in life what one admires in the pages of the Bible?"
>
> To the same, who expostulated with him for dashing out of the house in the morning to the unfortunate victims, without taking the time to wash himself or to lace his shoes:
>
> "Oh Esther, don't worry about such details, there is nothing for hèaven in them."
>
> To the same, who expostulated with him for leaving her hospitable home to go and sleep on a miserable pallet in the hovel of a needy family:
>
> "Esther, one should do like the good God; from time to time one should go and live among His own."[3]

Without regard for social convention, Vincent incorporated the message of Jesus' parables, practical acts of compassion, and an emphasis upon God as incarnating himself to "live among his own" within his daily ministry. This is in agreement with his report to Theo of the sermons he preached to the miners in the Borinage:

> Among other things, I spoke about the parable of the mustard seed, the barren fig tree, the man born blind. On Christmas, of course, about the stable in Bethlehem and peace on earth. (Letter 127)

In the same letter to Theo, Vincent relates the substance of one of his sermons that focused on Christ as "the Great Man of Sorrows who knows our ills" and recommended that the hearers live in "imitation of Christ."

Criticized by other evangelists and by his father, and dismissed by the Synodal Board of Evangelization in July 1879, Vincent spent a year in pain and poverty, reading voraciously, hiking from town to town, unsuccessfully seeking employment, sketching and returning to the Borinage. This difficult "molting time" is described in a poignant letter of July 1880, to Theo:

> As molting time—when they change their feathers—is for birds, so adversity or misfortune is the difficult time for us human beings. One can stay in it—in that time of molting— one can also emerge renewed; but anyhow it must not be done in public, and it is not at all amusing, therefore the only thing to do is to hide oneself. (Letter 133)

Vincent went on to describe his "irresistible passion for books," his neglected and "shocking" appearance, and his disgust with the "old academic school" of evangelists, those whose God is like "the inside of a church."

Though putting behind him his earlier respect for traditional church practices, approved interpretations of the Bible, and his father's authoritarian certainties, Vincent was not finished with God. Rather, he saw himself as struggling in God's presence for an answer to his questions:

> How can I be of use in the world? Can't I serve some purpose and be of any good? How can I learn more and study certain subjects profoundly? . . . And one exclaims, "How long, my God!" (Letter 133)

Even in this dark struggle, Vincent clearly reaffirmed for Theo the new breadth of his creed which refused to exclude any "good thing" from the path to God:

> In the same way I think that everything which is really good and beautiful—of inner moral, spiritual, and sublime beauty in men and their works—comes from God, and that all which is bad and wrong in men and their works is not of God and God does not approve of it. . . .

Vincent refused the old route to knowledge of God through traditional authority; rather, he turned to the personal experience of "loving many things":

> But I think that the best way to know God is to love many things. Love a friend, a wife, something—whatever you like—you will be on the way to knowing more about Him; that is what I say to myself. But one must love with a lofty and serious intimate sympathy, with strength, with intelligence; and one must always try to know deeper, better and more. That leads to God, that leads to unwavering faith. (Letter 133)

Love with its deeper knowledge and faith was, for Vincent, a way to open prison doors. He described his own sense of imprisonment to Theo: " . . . one feels certain barriers, certain gates, certain walls," and one is led to cry, "My God! is it for long, is it forever, is it for eternity?" He confided to Theo that it is "being brothers, love, that is what opens the prison."

A letter two months later, announcing that he would become an artist, makes it clear that he believed the finding of one's mission could also open prisons:

> . . . I said to myself, in spite of everything I shall rise again: I will take up my pencil. . . . From that moment everything has seemed transformed for me. . . . (Letter 136)

His mission and love as the experiential way, became Vincent's path to meaning and to God for the remaining ten years of his life. During those ten years his musings on God assume a new poetic and parabolic form, an openness to experimentation and creative variation.

Vincent, having left behind the narrowness of the religious establishment and embarked upon the broader way of "loving many things," pledged himself to the mission of artist by 1880. He began the arduous discipline of drawing exercises in the Borinage and then in Brussels, returning to his parents' parsonage in Etten in April 1881 to ease expenses. In Etten, he fell in love with his widowed cousin, Kee Vos, daughter of the Reverend Stricker. Serious family discord resulted from Vincent's unwillingness to accept her refusal of his love. Vincent saw Kee Vos as living in "a kind of prison" created by "The Jesuitism of clergymen and pious

ladies" with their system of "resignation, and sin, and God." His description of her religious situation, once his own, reveals a critical facet of his new orientation:

> And she never realizes, I fear, that God perhaps really begins when we say the word with which Multatuli finishes his Prayer of an Unbeliever: "O God, there is no God!" For me that God of the clergymen is as dead as a doornail. But am I an atheist for all that? The clergymen consider me so. . . . (Letter 164)

Utilizing a line from Eduard Douwes Dekker, a Dutch author who wrote under the pseudonym Multatuli, Vincent proclaimed the death of the "God of the clergymen," yet acknowledged the reality of a God he could relate to directly, "O God." This is not unlike Nietzsche's *death of God* theme, Buber's distinction between an intellectual construction and a living *I-Thou* relationship, and Tillich's search for the *God beyond God*.

Vincent's affirmation that "The God of the clergymen is as dead as a doornail," his unwillingness to resign himself any longer to the narrow views of his father and misdirected prayers for "Christian resignation" of his mother, and his critical stance toward "that saddening Bible which arouses our despair and our indignation" raises the question: Is the God he addresses "O God" also subject to criticism? God, Bible, parents, and clergy had been closely related in Vincent's mind. Did his new critical stance include criticism of God, even the God beyond that of the clergy?

It may surprise many that the answer is yes. In 1888, Vincent had left Theo's apartment in Paris in order to travel to Arles and paint in the sunshine of southern France. Hearing that Theo had become ill and was worried by a diagnosis of possible heart trouble, Vincent wrote to reassure his brother. Expressing sympathy and concern, Vincent went on to muse about the flawed nature of human existence on earth:

> I feel more and more that we must not judge of God from this world, it's just a study that didn't come off. What can you do with a study that has gone wrong?—if you are fond of the artist, you do not find much to criticize—you hold your tongue. But you have a right to ask for something better. We should have to see other works by the same hand though; this

world was evidently slapped together in a hurry on one of his
bad days, when the artist didn't know what he was doing or
didn't have his wits about him. (Letter 490)

Certainly Vincent intended some humor to cheer his anx-
ious brother, but there is also an element of serious experimen-
tation liberated from scruples about obligations owed to God as
the authoritative lawgiver. Biblical theologians would be quick
to classify Vincent's thought as one more example of the anthro-
pomorphic approach to deity, as in the Yahwist account in the
Torah where God is described as "walking in the Garden in the
cool of the day," or calling out, "Adam, where are you?"[4] A careful
analysis of Vincent's approach, however, indicates a type of
anthropomorphism that is unique and warrants a name of its
own. An appropriate term for it is *idiomorphism.*

Vincent does not simply ascribe to God human attributes, as
though God were a giant human being. Rather, Vincent sees God
specifically in his own innermost experience of frustration, fail-
ure, and striving as an artist. Vincent experiences God in the
concreteness of his own most intense and significant personal
history. Because as an artist Vincent experiences life in its profun-
dity, he not only experiences God "as if" God were an artist, he
experiences God's "failed sketch" in his own failed sketches. So
a mother would experience God not simply "as if" God were a
mother, but would experience God's mothering in her concrete
acts of child-care. A farmer would experience God not simply "as
if" God were a farmer, but would experience God in the concrete
acts of sowing and planting. Vincent's idiomorphism strains the
requirements of Buber's I-Thou description of relationship with
the Divine. Vincent, unlike Buber, seems unconcerned that the
gulf between Creator and creature disappears in the intensity of
personal experience viewed as Divine experience.

Vincent's approach to God emerges more clearly in his letter
to Theo as he expresses his regard of God's "study that has gone
wrong":

... the study is ruined in so many ways. It is only a master
who can make such a blunder, and perhaps that is the best
consolation we can have out of it, since in that case we have a
right to hope that we'll see the same creative hand get even
with itself. And this life of ours, so much criticized, and for

> such good and even exalted reasons, we must not take for anything but what it is, and go on hoping that in some other life we'll see something better than this. (Letter 490)

Vincent's own new creed, practicing the "high-spirited" path which is free to risk "mistakes," reveals the manner of God's own artistry, an artistry whose daring makes possible such a blunder as the creation of this flawed world. For Vincent, mistakes, blunders, and imperfections, are the location of hope. Blunders are the assurance that God acts with a Self-forgetfulness that attempts more than can be reasonably expected or accomplished in the present. This confirms God's mastery and promises the success of his total "oeuvre."

In spite of differences in language, Vincent's viewpoint here has interesting parallels with the "New Theism" based upon Whiteheadian "Process Philosophy." The process theologian, Shubert Ogden, for example, asserts:

> So far from being the wholly absolute and immutable Being of the classical philosophers, God must really be conceived as the eminently relative One, whose openness to change contingently on the actions of others is literally boundless.[5]

Vincent's linking of God's daring "blunder" with the hope that the Divine "creative hand" would "get even with itself" clearly proceeds from his own experience and faith as an artist. An example is provided in his response to the Dutch artist Rappard who in 1885 refused to accept Vincent's lithograph *Potato Eaters* as a serious work, detailing its many flaws (letter R 51a). Vincent accepted the fact of flaws, but rejected the conclusion that the work therefore lacked "seriousness." He explained: "I do things wrong before I manage to do them better" (letter R 54). "I am always doing *what I can't do yet* in order to learn how to do it . . . (letter R 57). He then insisted, as he did throughout his artistic career:

> . . . people cannot be justified, or speaking in good faith, when they judge my work otherwise than as a whole and in a broader way, taking into account my purpose and endeavor. . . . (Letter R 57)

God, therefore, must not be judged "from this world," for its flawed and unfinished nature is our hope that the total work, the "complete oeuvre," has yet to be seen by us.

This expectation of "something better" to come, which emerges precisely from the fact of failure and imperfection, becomes for Vincent a kind of "proof" that there must be a more complete version of life than the "sketch" we experience, there must be a life after death with more favorable circumstances, and finally, there must be a God. With an engaging humor and imagination, Vincent described the hope of a more "complete" life, a "spherical" life, to Émile Bernard:

> For look here: the earth has been thought to be flat. It was true, so it still is today, for instance between Paris and Asnières. Which, however, does not prevent science from proving that the earth is principally round. Which no one contradicts nowadays.
>
> But notwithstanding this they persist nowadays in believing that *life is flat* and runs from birth to death. However, life too is probably round, and very superior in expanse and capacity to the hemisphere we know at present. (Letter B 8)

Our fragmented view, a few sketches and studies, shows life to be flat, from birth to death, but a view of the whole work would reveal a completed sphere where death must come round to life again.

Death itself can be seen positively as the "flaw" that promises a complete work, a locomotion toward something better. Vincent wrote Theo:

> Why, I ask myself, shouldn't the shining dots of the sky be as accessible as the black dots on the map of France? Just as we take the train to get to Tarascon or Rouen, we take death to reach a star. . . .
>
> So to me it seems possible that cholera, gravel, tuberculosis and cancer are the celestial means of locomotion, just as steamboats, buses and railways are the terrestrial means. To die quietly of old age would be to go there on foot. (Letter 506)

Vincent described the promise held for artists in God's further works, the stars and planets, in a letter which he sent from Arles to Émile Bernard in 1888:

But seeing that nothing opposes it—supposing that there are also lines and forms as well as colors on the other innumerable planets and suns—it would remain praiseworthy for us to maintain a certain serenity with regard to the possibilities of painting under superior and changed conditions of existence. . . .

The existence of the painter-butterfly would have for its field of action one of the innumerable heavenly bodies, which would perhaps be no more inaccessible to us, after death, than the black dots which symbolize towns and villages on geographical maps are in our terrestrial existence.

Vincent's idiomorphic view of God as struggling Artist might well suggest that Jesus would be described as artist as well. That, in fact, is the case, though it is interesting that while Vincent focused on God's "blunders," he idealized Jesus' artistry. In the same letter to Émile Bernard he wrote:

Christ . . . lived serenely, *as a greater artist than all other artists,* despising marble and clay as well as color, working in living flesh.

Christ is further described as working in *living men* and in *the spoken word,* as unifying image and word in his art of the parable. Jesus' "words," according to Vincent

are one of the highest summits—the very highest summit—reached by art, which becomes a creative force there, a pure creative power. (Letter B 8)

Perhaps this idealization of Jesus without reference to struggle or failure seemed appropriate to Vincent, because he viewed the entire life of "The Man of Sorrows" as an incarnation of the daring way of failure. It was the ecclesiastical concept of God, conceived as a cold, academic perfection that invited Vincent's criticism and correction.

The death of an uncle to whom he had once been close, moved Vincent in 1888 to further musings regarding death. In these musings there is revealed a dynamic in Vincent's thought that moves from human frailty and death to life's delicate beginnings, to the mystery of life's journey which is beyond human knowledge:

Then I shall find that not only the Arts but everything else were only dreams, that one was nothing at all oneself. If we are *as flimsy as that*, so much the better for us, for then there is nothing to be said against the unlimited possibility of future existence. Whence comes it that in the present instance of our uncle's death, the face of the deceased was calm, peaceful, and grave, whereas it is a fact that he was rarely that way while living, either in youth or age? . . .

And in the same way a child in the cradle, if you watch it at leisure, has the infinite in its eyes. In short, I know *nothing* about it, but it is just this feeling of *not knowing* that makes the real life we are actually living now like a one-way journey on a train. You go fast, but cannot distinguish any object very clearly, and above all you do not see the engine. (Letter 518)

The very flimsiness of life and our "not knowing" continue the theme of failure and incompleteness as the foundation of hope. Now, however, rather than emphasizing the radical concreteness of God experienced in one's own life-struggle, Vincent's thought moves in the opposite direction, toward the vagueness and mystery of the Divine. Martin Buber's description of the need for balance in "a conceptual apprehension of the Divine" is relevant here, though its elements are in reverse order to the manner in which we have been dealing with Vincent's concept:

The more abstract the concept, the more does it need to be balanced by the evidence of living experience, with which it is intimately bound up rather than linked in an intellectual system. The further removed a concept seems from anthropomorphism, the more it must be organically completed by an expression of that immediacy and, as it were, bodily nearness which overwhelm man in his encounters with the divine. . . .[6]

Vincent moved as far in the direction of mystery as he did in the direction of concreteness. While on the one hand he contrasted the radical immediacy of the idiomorphic God to the "abstractions" of the cold, academic viewpoint, on the other hand he contrasted a mystery beyond our knowing to the detailed knowledge of God's requirements claimed by the clergy.

Vincent was impressed by the simple faith of peasants, and was moved by Sensier's description of the influence of a peasant upbringing on the painter Millet's beliefs.[7] In a letter of 1883 he wrote Theo:

> I see that Millet believed more and more firmly in "Something on High." He spoke of it in a way quite different than, for instance, Father does. He left it more vague, but for all that, I see more in Millet's vagueness than in what Father says. I find the same quality of Millet's in Rembrandt, in Corot—in short, in the work of many, though I must not and cannot expatiate on this. (Letter 337)

Leaving one's belief in "Something on High" vague, was a quality that showed itself in painting, and Vincent sought that quality in his own work by emphasizing only the essentials in a subject:

> And I even *do my best not to give details*—for then the dreaminess goes out of it. And when Tersteeg and my brother, and others, say, "What is this, is it grass or cabbage?"—then I answer, "*Delighted* that *you* can't make it out." (Letter R 37)

The contrasting directions of Vincent's belief in God, concrete personal experience and vague mystery, are the very directions he could describe as nourishing or inspiring his art. Rejecting an art based upon human technique as the same sort of academicism he rejected in religion, Vincent wrote the Dutch artist Rappard:

> . . . art is something which, although produced by human hands, is not created by these hands alone, but something which wells up from a deeper source in our souls; and that with regard to adroitness and technical skill in art I see something that reminds me of what in religion may be called self-righteousness. (Letter R 43)

But "depth" within is only one way of describing God. Writing Theo from Saint-Rémy in 1890, Vincent explained:

> You need a certain dose of inspiration, a ray from on high, that is not in ourselves, in order to do beautiful things. (Letter 625)

Years earlier, in 1883, under the influence of the desolate landscape of Drenthe, Vincent had expressed the intimately deep and the vaguely mysterious directions of God and artistic inspiration together in a poetic musing, as he sought to convince Theo to join him in painting:

... I will take the risk, I will push off to the open sea. And you will immediately get a certain somber earnestness—something mighty serious will rise up within you—one looks at the quiet coast, all right, it is pretty enough—but the secret of the depth, the intimate, serious charm of the Ocean of an artist's life—with Something on High over it—will take hold of you. (Letter 339)

For Vincent, the ocean-depth of the soul and the transcendent mystery above were the only environment for an honest and inspired art.

Vincent's attraction to the simple faith of "peasants" and "grandmothers" led him to avoid aristocratic esotericism in art and religion on the one hand, and a "decadent" aestheticism on the other. Though his favored writers Dickens and Hugo followed the vogue for mesmerism and seances, and the de Goncourt brothers and Loti became collectors of aesthetic oddities and celebrated their hypersensitive tastes, Vincent's balance of "depth" of soul and "Something on High" saved him from such fashionable byways of art. Such byways would claim Émile Bernard and feed such movements as the Nabis, "the prophets."

Vincent's life was a quest for unification, a search for how to integrate the ideas in religion, art, literature, and nature that motivated him. The solution must also bring together his experience of depth and height, intimate experience and vague mystery. From his early days of religious orthodoxy he seemed drawn to a word which promised such unity, a word central to the Gospel of John: love. Liberated in his new creed from anxieties regarding failure, Vincent turned to that word:

It is good to love many things, for therein lies true strength; whosoever loves much, performs and can accomplish much, and what is done in love is well done. (Letter 121)

Three years later, in 1881, Vincent was living at home in Etten, and had fallen in love with Kee Vos. He wrote to Theo emphasizing the relationship between a mature belief in God and the ability to love:

You must not be astonished when, even at the risk of your taking me for a fanatic, I tell you that in order to love, I think

it absolutely necessary to believe in God. To believe in God (that does not mean that you should believe all the sermons of the clergymen and the arguments and Jesuitism of the bigoted genteel prudes, far from it); to me, to believe in God is to feel that there is a God, not dead or stuffed but alive, urging us to love again with irresistible force—that is my opinion. (Letter 161)

Experience led Vincent to deepen and simplify his understanding of the unifying power of love, as in the creed he shared with the painter Rappard, a creed that made clear that love is beyond language and beyond conceptualization, residing in act:

I want to be silent—and yet, because I *must* speak—well then—as it seems to me: to love and to be lovable—to live—to give life, to renew it, to restore it, to preserve it—and to work, giving a spark for a spark, and above all to be good, to be useful, to be helpful in something, for instance lighting a fire, giving a slice of bread and butter to a child, a glass of water to a sufferer. (Letter R 4)

Love is creative and life-giving for Vincent. He wrote to his sister Wil: "What the germinating force is in a grain of wheat, love is in us." The intimacy and simplicity of love give it a seriousness and holiness beyond the most profound of abstract ideas. To Rappard he explained that this love is not simply feeling, it moves humans to act: "I believe the more one loves, the more one will act; for love that is only a feeling I would never recognize as love" (letter R 34).

Certainly there is concreteness and specificity in acts of love: lighting a fire, giving a glass of water to a sufferer. But love also moves in the direction of mystery and has no fixed form. As Vincent wrote Theo:

What a mystery life is, and love is a mystery within a mystery. It certainly never remains the same in a literal sense, but the changes are like the ebb and flow of the tide, which leaves the sea unchanged. (Letter 265)

Vincent's thought relating love, life, mystery, and God is revealing. In a discussion with Theo quoted earlier, Vincent had cited the words, "O God, there is no God" and asked Theo, "But

am I an atheist for all that?" His discussion continued:

> . . . but I love, and how could I feel love if I did not live and others did not live; and then if we live, there is something mysterious in that. Now call it God or human nature or whatever you like, but there is something which I cannot define systematically though it is very much alive and very real, and see that is God, or as good as God. (Letter 164)

For Vincent, it is love that proves we are alive: I love therefore I live. The mystery of such life predicated on love is undefinable, but one may call that mystery God. If, however, ecclesiastical misuse has rendered the word God misleading, then one might say the mystery is "as good as God."

For Vincent, "God" is the name we might use for the mystery of love's presence in life. "Acts of love" are the concreteness of God's presence in life. Both "God" and "love" locate themselves not primarily in religions, which pass away, or even in works of literature and art, which can lose their relevance over time, but in the simplicity of life, in the germinating power of the family, the cradle. This, for Vincent, is the democratic nature of love and so of God, available in the home of every peasant and laborer. He wrote Theo:

> When one is in a somber mood, how good it is to walk on the barren beach and look at the grayish-green sea with the long white streaks of the waves. But if one feels the need of something grand, something infinite, something that makes one feel aware of God, one need not go far to find it. I think I see something deeper, more infinite, more eternal than the ocean in the expression of the eyes of a little baby when it wakes in the morning, and coos and laughs because it sees the sun shining on its cradle. If there is a "ray from on high," perhaps one can find it there. (Letter 242)

New life at its simplest, without power or pretense, is a visual, experiential proof of life, love, and so of God's presence. God is in no way limited to "religion." As Vincent quoted approvingly from Victor Hugo: "Religions pass away, God remains" (letter 411). Where does God remain? For Vincent, God remains in the fullest possible Incarnation among humans, an Incarnation that will endure as long as there are families, as long as there are

persons who love, as long as there are new lives.

Once again, it was Vincent's personal experience that led him to select the child in a cradle as best evidence for God. All too little attention has been given the months Vincent spent beside a cradle in a home of his own in The Hague. Ordered out of the parsonage at Etten in December 1881, Vincent had rented a simple studio in The Hague and taken in a seriously ill and pregnant prostitute and her young daughter. No doubt influenced by stories of women in distress in Dickens, Eliot, and the Bible, he sought to save the life of "Sien" and the yet unborn child fathered by one of her clients. Hospitalization and a difficult birth were successful, and Vincent cared for the mother, her daughter, and the new baby boy in his cradle. Theo's widow, apparently in agreement with Theo's opinion, described the woman harshly in her "Memoir of Vincent Van Gogh":

> . . . a coarse, uneducated woman, marked by smallpox, who spoke in a vulgar accent and had a spiteful character, who was addicted to liquor and smoked cigars, . . . who drew him into all kinds of intrigues with her family. . . .[8]

Vincent's own explanation to Theo had been a simple one: "Which is the more delicate, refined, manly—to desert a woman or to stand by a forsaken woman?" (letter 192).

Vincent's letters to Theo which argue the case for remaining with Sien and marrying her, focus on the sacred nature of the cradle:

> I cannot look at this last piece of furniture without emotion, for it is a strong and powerful emotion which grips a man when he sits beside the woman he loves with a baby in a cradle near them. And though it was only a hospital where she was lying and where I sat near her, it is always the eternal poetry of the Christmas night with the baby in the stable—as the old Dutch painters saw it, and Millet and Breton—a light in the darkness, a star in the dark night. (Letter 213)

Later in the same letter he returned to the cradle theme:

> You see, a cradle is not like anything else—there is no fooling with it—. . . . And just listen, between us—without preaching a sermon, it may be true there is no God here, but there must

be one not far off, and at such a moment one feels his presence. Which is the same as saying, and I readily give this sincere profession of faith: I believe in God, and that it is his will that man does not live alone, but with a wife and a child, when everything is normal.

If there is room for Black theologies and Feminist theologies, as there is, Vincent would have added a theology of the child, a theology of the family cradle. In the cradle, the God who is located directly in our most profound experiences is present. God's presence in the cradle is presence as the germinating force of humanity, as love. In the child, interdependence and transformation intersect. The cradle is the meeting place of Divine and human, of vulnerability and love.

I believe that Vincent counted his leaving Sien the greatest of his failings and the deepest of his disappointments, even if Sien herself did not favor the continuing of the relationship. I believe he grieved for that strange family for the remaining eight years of his life. He expressed his feelings to Theo from Drenthe:

> . . . the fate of the woman and the fate of my poor little boy
> and the other child cut my heart to shreds. (Letter 328)

In 1888, during an attack of his illness, perhaps a result of absinthe-poisoning or epilepsy, Vincent cut off a portion of his ear. I believe it is less important to try solving the question of why he cut his ear than to note that it was Christmas eve, that he was perhaps thinking of the cradle he had once tended for Sien, and that he wrapped the severed ear, a portion of himself, and left it as a gift to a prostitute who had befriended him.

Vincent gave himself passionately to his art; his last letter to Theo declared, "my own work, I am risking my life for it and my reason has half foundered because of it . . ." (letter 652). Nevertheless, Vincent firmly believed that art was secondary to life, for life founded on love held the mystery of God's presence. No painting could reveal God's presence as surely as the naturalness of a baby in a cradle or the act of "giving a slice of bread and butter to a child." As Vincent wrote to his sister Wil:

> Why is religion or justice or art so very holy?
> It may well be that people who do nothing but fall in love
> are more serious and holier than those who sacrifice their love

and their hearts for an idea. (Letter W 1)

Just months before his death, Vincent wrote his mother:

> Last year I read in some book or other that writing a book or painting a picture was like having a child. This I will not accept as applicable to me—I have always thought that the latter was more natural and best. . . .(Letter 641a)

Nevertheless, accepting the sacrifices his mission in art required of him, Vincent gratefully acknowledged:

> . . . one must content oneself with painting pictures. It is not really living at all, but what is one to do? And indeed, this artistic life, which we know is not *the* real life, seems to me so vital, one would be ungrateful not to be content with it. (Letter 480)

During the Christmas season of 1888, the time of Vincent's first nervous attack and mutilation of his ear, he was at work on a canvas that places the viewer at the very location of God's incarnation, the intersection of love and creativity: "I think I have told you . . . I have a canvas of 'La Berceuse' the very one I was working on when my illness interrupted me" (Letter 574).[9] In his own description:

> It is a woman in a green dress. . . .
> The hair is quite orange and in plaits. The complexion is chrome yellow. . . .
> The hands holding the rope of the cradle the same. (Letter 571a)

He explained the painting's intent to Theo:

> . . . the idea came to me to paint a picture in such a way that sailors, who are at once children and martyrs, seeing it in the cabin of their Icelandic fishing boat, would feel the old sense of being rocked come over them and remember their own lullabys. (Letter 574)

Seeing the housewife-mother seated before one, and recognizing the end of the cradle-rope in her hand, each viewer since

that Christmas of 1888 has been placed by Vincent directly in the cradle of their childhood. That location was for Vincent the most moving evidence of God's presence, the meeting place of divine vulnerability and the germinating power of love: "If there is a 'ray from on high,' perhaps one can find it there" (letter 242).

5

The Oriental Connection

In September 1883 Vincent wandered alone and penniless in the remote region of peat bogs and meadowlands, marshes and sod huts, called Drenthe. During the few months he spent there, he revealed a significant aspect of his spiritual quest. In a letter he sent that September to his parents, he provides us with an important juxtaposition of images: hearth and cradle, fields of corn and the lines of alder bushes:

> I think there is no better place for meditation than by a rustic hearth and an old cradle with a baby in it, with the window overlooking a delicate green cornfield and the waving of the alder bushes. (Letter 334)

Vincent's view through the window of his ideal home, his favored location for meditation, is a field of growing grain and bushes moving with the wind. As Vincent saw it, nature offered itself both to be worked by human hands and to be viewed and enjoyed as a presence. As a companion it assisted him to meaning, to spiritual healing, and to God. For Vincent, the child in the cradle and the young grain in the field are intimately related to each other and to the great pattern of the universe with its dynamic of germination. This idea of interrelatedness brings us also to the heart of a difficulty with Vincent's symbolism. It is this aspect of his art that is often misunderstood by the public and distorted by the critics. In his own descriptions he suggests that in his manner of seeing he recognizes how all forms of nature resonate with human life.

Sometimes I have such a longing to do landscape, just as I crave a long walk to refresh myself; and in all nature, for instance in trees, I see expression and soul, so to speak. A row of pollard willows sometimes resembles a procession of almshouse men. Young corn has something inexpressibly pure and tender about it, which awakens the same emotion as the expression of a sleeping baby, for instance. (Letter 242)

While hiking in Drenthe among hamlets with such names as Driftsand and Blacksheep, Vincent thought about the best possible life one might live, and he wrote to Theo:

What life I think best, oh, without the least shadow of a doubt it is a life consisting of long years of intercourse with nature in the country—and Something on High—inconceivable, "awefully unnamable"—for it is impossible to find a name for that which is higher than nature. Be a peasant—be, if it could be considered possible nowadays, a village clergyman or a schoolmaster—be—... a painter, and as a human being, after a number of years of living in the country and having a handicraft, as a human being you will in the course of these years gradually become something better and deeper in the end. (Letter 339a)

The combination of life in the country, Something on High, and one's service to others constituted for Vincent the best of lives.

One of the unresolved struggles in Vincent's life was his concern for the oppressed of the newly industrialized cities, yet his love and need for the rural countryside of his childhood memories. Would he choose the new city or the old countryside? Would he paint the cities of Dickens and the Goncourt brothers or become a peasant painter like Millet? Perhaps his life was too brief to reach a resolution, but most often he maintained a suspicion of the city as an environment unsuited for profound thought, and chose the countryside for recuperation and labor.[1] He advised Theo, "... in order to grow, one must be rooted in the earth.... don't wither on the sidewalk" (letter 336). He could affirm:

One must not be a city man but a country man, however civilized one may be. I cannot express it exactly. There must be a "je ne sais quoi" in a man which keeps his mouth shut and makes him active—a certain aloofness even when he speaks

—I repeat, an inner silence which leads to action. (Letter 333)

Vincent found the necessary "inner silence" in Drenthe, a silence that allowed nature and God to speak to him:

> ... just *now* I find myself in surroundings which so entirely engross me, which so order, fix, regulate, renew, enlarge my thoughts, that I am quite wrapped up in them. And that I can write you, full of what those silent, desolate moors tell me. (Letter 333)

Specifically, Vincent heard the desolate moors tell him to attempt persuading Theo to leave the art trade in Paris and to join him as a painter in the country, in spite of the financial disaster such a move might cause them both. But more generally, Vincent felt on the moors the absolute claim of God, casting aside compromises, rejecting the *better* in favor of the *best*. Using a powerful image found in Victor Hugo's novel *Ninety-Three*, the focus of a chapter entitled "The Two Poles of Truth," Vincent accepted the claim of the "White Ray" from on High which is merciful goodness and rejected the "Black Ray" which is self-righteous goodness:

> ... with an unutterable feeling I see God, Who is the White Ray of Light, and Who has the last word; what is not good through and through is not good at all, and will not last—He, in whose eyes even the Black Ray will have no plausible meaning. (Letter 337)

Such deep thoughts and spiritual searchings Vincent felt were available through solitude in nature. He continued: "Look, I see all these things here on the silent moor, where I feel God high above you and me" (letter 337).

At its most intense, the experience of nature in Drenthe could be described by Vincent as a wordless music, a symphony in which even the "self" was finally lost. He reported to Theo a trip across the heath to Zweeloo, where even a leaf dropping to earth could be heard, a place of "quietness, a mystery, a peace." He continued:

> When one has walked through that country for hours and hours, one feels that there is really nothing but that infinite

earth—that green mold of corn or heather, that infinite sky. Horses and men seem no larger than fleas. One is not aware of anything, be it ever so large in itself; one only knows that there is earth and sky. However, in one's quality of a little speck noticing other little specks—leaving the infinite apart—one finds every little speck to be a Millet. (Letter 340)

Vincent's trip to Zweeloo ended as he hiked past a shepherd returning with sheep to the sheepfold at twilight:

That coming home of the flock in the twilight was the finale of the symphony I heard yesterday.

That day passed like a dream, all day I was so absorbed in that poignant music that I literally forgot even food and drink —I had taken a piece of brown bread and a cup of coffee in the little inn where I drew the spinning wheel. The day was over, and from dawn to twilight, or rather from one night till the other, I had lost myself in that symphony. (Letter 340)

Without money or painting supplies, Vincent returned to his parents at the Nuenen parsonage in December 1883. There he worked at becoming a peasant-painter of the Brabant country-side, spending his evenings at the huts of "weavers and farmers, musing by the fire . . . " (letter 400). He painted *The Potato Eaters* during this period, emphasizing:

. . . that those people, eating their potatoes in the lamp-light, have dug the earth with those very hands they put in the dish. . . . (Letter 404)

Vincent hoped such country paintings would teach the city dweller:

. . . if a stable smells of dung—all right that belongs to a stable; if the field has an odor of ripe corn or potatoes or of guano or manure—that's healthy, especially for city people.

Such pictures may *teach* them something. (Letter 404)

He also painted a *Peasant's Cemetery* in the shadow of a ruined church tower. It was to teach:

. . . how those ruins show that *for ages* the peasants have been laid to rest in the very fields which they dug up when alive

—I wanted to express what a simple thing death and burial is, just as simple as the falling of an autumn leaf — just a bit of earth dug up—a wooden cross. . . .

And now those ruins tell me how a faith and a religion moldered away—strongly founded though they were—but how the life and death of the peasants remain forever the same, budding and withering regularly, like the grass and the flowers growing there in that churchyard.

"Religions pass away, God remains," is a saying of Victor Hugo's. . . (Letter 411).

Vincent's sense of the profound lessons of the countryside remained firm, and nature's pattern of the seasons resonated with the peasants' seedtime and harvest and life's birth and death. Even religions have their seasons, though God remains.

When Pastor van Gogh died in March 1885, Vincent painted a still life of his father's Bible, as we described earlier. When he left Brabant, never to return, he travelled first to Antwerp where he continued to paint, visited museums, and studied briefly at the Academy of Art. Antwerp is of special importance to our study, for it was from Antwerp that Vincent first wrote of a new interest he was developing, an interest that we believe has great relevance to his spiritual search through nature.[2]

In a letter of November 1885, Vincent reported to Theo that he had "pinned a lot of little Japanese prints on the wall" of his studio, "little women's figures in gardens, or on the beach, horsemen, flowers, knotty thorn branches." He further noted that "one of de Goncourt's sayings was 'Japonaiserie forever'" (letter 437). The de Goncourt brothers, among Vincent's favorite novelists, had become collectors of Japanese art, newly available in Europe since Admiral Perry had opened Japan to Western trade in 1853, the very year Vincent was born. The de Goncourts employed their knowledge of Japanese art in a novel on the Parisian art scene, *Manette Salomon,* published in 1867. The novel includes an entire chapter of Oriental images inspired by albums of Japanese woodcuts, plus an experiment with techniques of Japanese painting by Coriolis, hero of the story.[3] Vincent was apparently impressed by what he read, perhaps by remembrances of Japanese art he had seen in Holland, and certainly by the reference in Sensier's biography of Millet that both Rousseau and Millet had been attracted to examples of Japanese art.

Vincent left Antwerp on February 27, 1886, and travelled to Paris, where he moved into the apartment of brother Theo, now manager of the Goupil Gallery in Montmartre. In Paris Vincent experimented with the bright colors of the impressionists, painted briefly at Cormon's studio, talked in the cafés and studios with Toulouse-Lautrec, Gauguin, Pissaro, Signac, and Émile Bernard.

During this same period, Vincent's enthusiasm for Japanese prints was encouraged to grow by his access in Paris to perhaps the largest collection of Japanese prints in Europe, at the shop of S. Bing. Later, from Arles in 1888, Vincent described for Theo the hours he had spent in Bing's shop while he was in Paris:

> There is an attic in Bing's house with millions of prints piled up, landscape and figures, and old prints too. He will let you choose for yourself some Sunday, so take plenty of old prints as well.[4] (Letter 510)

In the same letter, Vincent reminded Theo that "the prints we have at our place are beautiful," and advised him, when visiting Bing's, "to take the 300 Hokusai views of the holy mountain, as well as the pictures of Japanese life." He also made reference to "the exhibition of prints that I had at the Tambourin," its influence on Anquetin and Bernard, and his own wish while in Paris "to have a showroom of my own at a café. . . ." Vincent not only searched through the huge stacks of Japanese prints in Bing's inventory, but he and Theo collected hundreds of the least expensive nineteenth-century prints generally classified as "ukiyo-e," pictures of "the floating world" portraying scenes from everyday Japanese life. Though wealthy collectors looked down on these cheap, bright, "later" prints intended more for the Japanese populace than for aristocrats, Vincent insisted on their beauty and value, "even when I am told 'you must get out of the habit of that'" (letter 511). Vincent hung Japanese prints in his room in Antwerp, chose a collection of hundreds of prints in Paris, and later would have Theo send a "package of Japanese stuff" to be hung in his Yellow House in Arles (letter 540). Japanese prints would also be on the walls of the tiny room where he would die in Auvers.[5]

Certainly Vincent did not collect hundreds of Japanese prints through an urge to own or invest. Bing's shop was a

schoolhouse for him, a place to study and to enjoy the Japanese manner of viewing nature, everyday life, and the human figure:

> Lord, I could not do there as I liked, for I was as enthusiastic over that heap of 10,000 prints to rummage in as Thoré was over the sale of Dutch pictures, with interesting ones among them. . . .
>
> I learned there myself, and I made Anquetin and Bernard learn there too. Now there is still something *to learn* at Bing's and that is why I strongly advise you to hang on to our stock and our right to inspect the attic and cellars, and you will see how far I am from seeing it as a speculation. (Letter 511)[6]

Vincent's enthusiasm for Japanese prints and his willingness to learn from Japanese artists led him to experiment. The Rijksmuseum Vincent van Gogh in Amsterdam now displays three van Gogh oil paintings which are his careful copies of Japanese prints. Two he copied from works of Hiroshige, now recognized as one of Japan's masters of all time. Vincent's copy of *Flowering Plum Tree at Kaimeido* almost certainly inspired his own later *Branches of an Almond Tree in Blossom*. Vincent's third copy, a courtesan by Eisen, was taken from the cover of the May 1886 *Paris illustré*, with an added border of lily pads, storks, and frogs copied from other prints in his collection.[7]

After spending two years in Paris with brother Theo, Vincent took a train in February 1888, following the "route of the sun" toward the Mediterranean, to Arles in Provence. His earlier suspicions regarding city life seem to have proven true. He left Paris suffering from the cold, exhausted by life in the city, perhaps an alcoholic, and disgusted with the divisiveness among the city artists. Vincent was returning to nature and its powers of physical and spiritual healing, a favorable setting for profound thought and creative work.

But Vincent was also traveling to where two significant themes, nature and Japan, were to converge for him. Vincent's trip south was a pilgrimage to nature as the Japanese saw it in full sunshine, in clarity of atmosphere, and brilliance of color. In Vincent's mind, Provence was to be his Japanese landscape, with blossoming trees, flowers, cultivated fields, and mountains under starry skies. Even in his first letter to Theo from Arles, dated February 21, 1888, he noted "the landscapes . . . were just like the winter landscapes that the Japanese have painted" (letter

463). Six letters later he affirmed to Theo:

> But, old boy, you know, I feel as though I were in Japan—
> I say no more than that, and mind, I haven't seen anything in
> its usual splendor yet. (Letter 469)

By June, Vincent was certain he would stay in his own equivalent
of Japan, and paint with an eye "more Japanese":

> About this staying on in the South, even if it is more
> expensive, consider: we like Japanese painting, we have felt its
> influence, all the impressionists have that in common; then
> why not go to Japan, that is to say to the equivalent of Japan,
> the South? . . .
> I wish you could spend some time here, you would feel it
> after a while, one's sight changes: you see things with an eye
> more Japanese, you feel color differently. The Japanese draw
> quickly, very quickly, like a lightning flash, because their
> nerves are finer, their feeling simpler. I am convinced that I
> shall set my individuality free simply by staying on here.
> I have only been here a few months, but tell me this—
> could I, in Paris, have done the drawing of the boats *in an hour?*
> (Letter 500)

Vincent was convinced that nature, along with the lessons he
had learned from the Japanese prints at Bing's and the sun-
drenched *Japanese* atmosphere of Provence, would heal and lib-
erate him and his painting.

Vincent was nearly correct when he reminded Theo that "all
the impressionists," had felt the positive influence of Japanese
art, for most of them had. Chapters in art-critical and historical
works on "Japonisme" are devoted to its influences on Manet,
Whistler, Degas, Gauguin, Seurat, Signac, Mary Cassatt, Vallot-
ton, Vuillard, Odilon Redon, and others.[8] But it was Claude
Monet and Vincent van Gogh who sought a profound liberation
through a unity of nature and the Japanese perspective. Monet
was successful enough in selling his work that he could retire
from the intrigues of Paris to a country home in the rolling hills
of Giverny, and have gardeners construct flower beds, a lotus
pond, and even a Japanese humpback bridge. Monet focused on
that personal corner of Japan, contemplating, sketching, photo-
graphing, and painting the ever-changing surface of the pond

where water lilies reflected the changing colors of the sky and light, and breezes played on the water's surface.[9] Monet could afford both the time and money to build his own corner of Japan at Giverny. He covered the walls of his home with Japanese prints.[10] Gardeners tended his Japanese landscape and waterscape. He entertained Western and Oriental visitors. But Vincent had little time and little money. To find a Japanese landscape he was required to become a stranger and a pilgrim once more, traveling to the only Japan he could afford, sunny Provence. There he spent his days in the fields and orchards, and hiked far into the hills. Apart from a two-month visit by Gauguin, he spent his time alone in nature, from sunrise to sunset. During rain and winter storms he painted in homes, cafés, or his studio that was hung with Japanese prints.

Vincent described the impressionists as "the Japanese of France," counting himself among their number, and he claimed, with some exaggeration, ". . . all of my work is founded on Japanese art . . ." (letters 511, 510). It is relevant, then, to ask how well Vincent knew Japanese art and the Japanese view of nature. Answering this question with precision or certainty is impossible in view of the scarcity of clear evidence. First, we must note that Vincent's profound feeling for nature as a route to meaning predated his tacking Japanese prints on his walls in Antwerp or traveling to his *Japan* in the south of France. Much of his interest in Japanese artists came as a sense of confirmation of his own feeling for nature, a sense that he had discovered like-minded "companions," much as in his discovery of novelists who shared his concerns and viewpoint. Nevertheless, like-minded companions generally share with each other insights and techniques. Determining Vincent's sources of information on the Japanese artist's approach to nature ought to help us understand the intent of his own work in Provence and the role the trip south played in his spiritual quest.

Three clear sources of information emerge from a reading of Vincent's letters. The first is the collection of Japanese art at Bing's shop in Paris, especially the thousands of affordable nineteenth-century "ukiyo-e" prints. The second source is the first issue of an elaborate new publication sponsored by S. Bing, *Le Japon Artistique* (May 1888). The third source is a novel by Loti entitled *Madame Chrysanthème* describing Japanese life while recounting the author's adventures in Japan.

Ukiyo-e Prints

Vincent's reference to an exhibition of Japanese prints he arranged at the Tambourin Café and its influence on Bernard and Anquetin indicates he likely learned much through conversations with other artists and collectors, and likely from those who bought and sold Japanese art at Bing's shop, but our hard evidence focuses upon his own collection of bright, nineteenth-century ukiyo-e prints. That collection is now housed at the Rijksmuseum Vincent van Gogh in Amsterdam, and is carefully described in one of its publications, *Japanese Prints Collected by Vincent van Gogh* (see n. 2). Vincent was a keen visual learner, and he no doubt absorbed much of his knowledge directly from the prints in his collection, including geisha and courtesans pictured against backgrounds of blossoming trees, series of Hiroshige landscapes from the "Fifty-three stations along the Tokaido," a page from Yoshimaru's "A New Book of Insects," landscapes in snow and rain, evening scenes under the moon from "Pictures of Famous Places in Edo," a series of "Birds and Flowers" by Hiroshige, iris borders, bare branches, bridges, portraits of actors, laborers at work, and crepe prints of nature, the entire collection representing fifty or more Japanese artists. Vincent saw earlier Japanese art, often more austere, that he could not afford, but his own attraction to bright ukiyo-e, his selection of Hiroshige landscapes, and his advice to Theo to add a selection of Hokusai nature scenes are all sound judgments vindicated by time.

"Ukiyo-e" contains the Buddhist terms for "floating world," an emphasis upon the ephemeral quality of ordinary life on its journey from place to place and season to season. Earlier Zen aesthetics preferred stark black ink (sumi-e) sketches, often done by aristocratic Zen masters, but ukiyo-e came to celebrate the Zen formula, "samsara (everyday life) is nirvana (enlightened liberation)." [11] Printed in large quantities and easily available to the Japanese public, these prints suited Vincent's democratic sense as well as his feeling for color. Their broad spontaneous strokes, daring perspectives from above and below, intimate feeling for details of nature, all seem to have attracted, taught, and led Vincent toward Provence.

Le Japon Artistique

The second source of Vincent's knowledge of Japanese art is also

available to us. In 1888 S. Bing launched an elaborate periodical entitled *Le Japon Artistique* with carefully reproduced drawings from Hokusai's *Manga,* plates of Hiroshige and Hokusai landscapes, Zen drawings of Bodhidharma, and much more. At the end of the summer of 1888, Vincent received from Theo a "package of Japanese stuff and other things." Apparently the package contained at least the May issue of *Le Japon Artistique.* Vincent read the text which he considered "rather dry," noted that he would "put the Japanese things downstairs in the studio," and wrote Theo " . . . the blade of grass, the carnations and the Hokusai in Bing's reproductions are admirable" (letter 542). By the spring of 1889, hospitalized in Arles and ready to move to the asylum in Saint-Rémy, Vincent wrote:

> In my room I have . . . a *Tangerine* by Monorobu [Moronobu] (the big plate in Bing's sketchbook) the *Blade of Grass* (from the same book), the *Pietà* and the *Good Samaritan* by Delacroix. . . . (Letter 590)

The *Tangerine* is a double-page portrait of a woman in kimono by Kaigetsudo, a pupil of Moronobu. *The Blade of Grass,* a favorite of Vincent's, is by an anonymous Japanese artist. Both came from Bing's new journal.

Although Vincent thought Bing's text dry, we know he read the opening essay by Bing, which includes Bing's view of the relationship of the Japanese artist to nature. Vincent likely paid close attention to this statement, and it appears that he was in general agreement with its contents. Bing wrote of the Japanese artist:

> . . . the constant guide whose indications he follows is called "Nature"; she is his sole, his revered teacher, and her precepts form the inexhaustible source of his inspiration. To Nature he surrenders himself with a frank fervour which expresses itself in all his works, and invests them with touching sincerity. The Japanese is drawn toward this pure ideal by a twofold characteristic of his temperament. He is at once an enthusiastic poet, moved by the spectacles of Nature, and an attentive and minute observer of the intricate mysteries which lurk in the infinitely little. . . . In a word, he is convinced that Nature contains the primordial elements of all things, and, according to him, nothing exists in creation, be it only a blade of

grass, that is not worthy of a place in the loftiest conceptions of Art.[12]

Madame Chrysanthème

One further source of information Vincent used is a rather strange novel then popular in France, Pierre Loti's *Madame Chrysanthème*. Loti, actually the French naval officer Julien Marie Viaud, fed the nineteenth-century taste for adventures to exotic places. The novel tells of Loti's *marriage* to a young Japanese girl he *rented* during his ship's stay in Nagasaki Bay. Though his Western scorn for "the hereditary insignificance and incurable monkeyishness" of the Japanese is the antithesis of Vincent's idealization of Japan, Loti was a good observer of cultural detail and Vincent was apparently fascinated by the novel's glimpses into Buddhist temples and homes. Mentioning the novel almost a dozen times in his letters, Vincent was particularly struck by its descriptions of the barenness of Japanese rooms and their openness to nature. That in itself taught him something about Japanese art:

> That is how you must look at Japanese art, in a very bright room, quite bare, and open to the country. (Letter 509)

There is no doubt that Vincent's trip to Arles in Provence had as its intention the painting of nature from a perspective informed by Japanese art. The question remains, did Vincent interpret this "Japanese" approach to nature as a new phase of his spiritual quest?

Vincent answered this question in a letter to Theo as his first summer in Provence was drawing toward its close. He wrote:

> If we study Japanese art, we see a man who is undoubtedly wise, philosophic and intelligent, who spends his time doing what? In studying the distance between the earth and the moon? No. In studying Bismark's policy? No. He studies a single blade of grass.
>
> But this blade of grass leads him to draw every plant and then the seasons, the wide aspects of the countryside, the animals, then the human figure. So he passes his life, and life is too short to do the whole.
>
> Come now, isn't it almost a true religion which these

simple Japanese teach us, who live in nature as though they themselves were flowers?

And you cannot study Japanese art, it seems to me, without becoming more joyful and happier, and we must return to nature in spite of our education and our work in a world of convention. (Letter 542)

The context of Vincent's approach to the Japanese artist is revealing. He was not discussing artistic technique or painting traditions, but religion, personal spiritual search. The paragraph immediately preceding his discussion of Japanese art reads:

It seems that in the book *My Religion,* Tolstoi implies that whatever happens in the way of violent revolution, there will be a private and secret revolution in men, from which a new religion will be born, or rather something altogether new, which will have no name, but which will have the same effect of comforting, of making life possible, which the Christian religion used to have. (Letter 542)

Vincent then voiced his belief that "we shall want to live more musically," and his sense that we should "be able to feel that kind of foreshadowing," the hint of the coming of the new way of life. Immediately Vincent's mind turned to Japanese art, suggesting an aesthetic approach to religion that does not simply replace Christian dogma with science (studying the distance between earth and moon) or political-historical remedies (studying Bismark's policy). "No. He studies a single blade of grass." Attending to what Bing described as "the intricate mysteries which lurk in the infinitely little," the artist discovers the "primordial elements of all things" in the lowliest corner of nature. Nature in its lively and simplest varieties is the gateway to a new spirituality, not mediated by discursive thought, but directly apprehended by the senses, the aesthetic route. Religion, or its new unnameable successor, will best fit the paradigm of art. The new spirituality is the art of life in its wholeness, the awareness and celebration of the shared life from the blade of grass to plants, to the seasons, to the countryside, to animals, to the human figure. Even Vincent's ordering of this list, including seasonality as a dynamic and the "wide countryside" as humanity and earth in cooperation is significant.

Buddhism

Did Vincent realize that Buddhism played a pervasive role in the Japanese perspective? Did he have any realization that he was opening his own Christian background and devotion to Christ as artist toward a meeting with another world religion, one focused on the Buddha? In a letter to sister Wil from Arles, Vincent mentioned "a new portrait of myself, as a study, in which I look like a Japanese" (W 7). His description of the same portrait in a letter to Gauguin, whom he was attempting to bring to Arles, is more precise:

> I have a portrait of myself, all ash-colored. . . . But as I also exaggerate my personality I have in the first place aimed at the character of a simple bonze worshiping the Eternal Buddha. (Letter 544a)

Vincent not only saw himself as a monk worshiping Buddha, he saw his Yellow House as a "refuge for many," a Buddhist monastery under the direction of an abbot. His candidate for the position of abbot was Gauguin (letters 544a, 544). Both the idea that he, Gauguin, and others should exchange portraits and the plan that the studio should be like a Buddhist monastery for artists derived from his idealized view of the standard set by Japanese artists:

> For a long time I have thought it touching that the Japanese artists used to exchange works among themselves very often. . . . they were really living in some sort of fraternal community, quite naturally and not in intrigues. (B 18)

This monastery, of course, was to be simply a home base for *artist monks* who lived and worked in nature:

> . . . it is a damned useful thing to see the South— where so much more of life is spent in the open air—in order to understand the Japanese better. (B 19)

What is the spiritual dynamic of the Japanese artist's approach to nature? Does an acquaintance with the traditional Japanese aesthetic aid us in understanding Vincent's life and work, his spiritual quest, in Arles and Saint-Rémy in Provence?

It is remarkable that of the more than two-thousand surviv-

ing paintings and drawings Vincent produced in Holland, Belgium, Paris, Arles, Saint-Rémy and Auvers, it is specifically the works done on his trip to the "equivalent of Japan" that have continued to grow in popularity with people of many cultures, around the globe. It is the sunflowers, blossoming orchards, iris, wheatfields, cypresses, olive orchards, mountains and starry skies of Arles and Saint-Rémy that have profoundly moved most viewers most often. The lessons Vincent learned in the south he apparently carried north to the rolling hills of Auvers; there he painted the thatched roofs, cultivated fields, flowers and insects, and stormy skies to create a similar effect.

Is there a new element present in these late works focused on nature which emerged through Vincent's Oriental connection? Chisaburoh Yamada of Tokyo, in his study of art influences between East and West, wrote:

> . . . Japanese ukiyo-e prints showed Europeans a different apprehension of the physical world and hinted at a way out of the impasse into which realism had led European art. The revelation was one of an entirely new type of beauty and of a new approach to nature. . . .[13]

Bernard Dorival, in an essay entitled "Ukiyo-e and European Painting," attempted a closer definition of that "new approach to nature." He found the key in the fact that ukiyo-e represents an Oriental tradition in the Japanese aesthetic that is "a stranger to the anthropocentric prejudice of Western humanistic art."[14]

Is the absence of an "anthropocentric prejudice" a critical element in the Japanese aesthetic and in the Zen Buddhist philosophy which is generally viewed as pervading the culture's art? A seminal essay by a leading scholar of Buddhist philosophy and Japanese culture, Abe Masao, makes clear the role of "non-man-centrism" in Buddhism:

> . . . Buddhism develops its non-man-centered nature to its outermost limits. . . . It is this most radical non-man-centered and cosmological dimension that provides the genuine basis for the salvation of man in Buddhism.[15]

D. T. Suzuki, who held that "Zen has entered internally into every phase of the cultural life" of Japan, applied the "non-man-centered" element directly to the act of painting:

> To become bamboo and to forget that you are one with it
> while drawing it—this is the Zen of the bamboo, this is the
> moving with the "rhythmic movement of the spirit" which
> resides in the bamboo as well as in the artist himself.[16]

Many Japanese would select the seventeenth-century haiku
poet (also a painter), Matsuo Basho, as the greatest of Japan's
artists. Basho, who had studied with a Zen master, viewed all the
arts of Japan as having one thing in common:

> Saigyo in traditional poetry, Sogi in linked verse, Sesshu in
> painting, Rikyu in tea ceremony, and indeed all who have
> achieved real excellence in any art, possess one thing in
> common, that is, a mind to obey nature, to be one with nature,
> throughout the four seasons of the year.... The first lesson for
> the artist is, therefore, to learn how ... to follow nature, to be
> one with nature.[17]

Basho made this "first lesson for the artist" more specific in a
passage often viewed as a "classic" statement by both painters
and poets of Japan:

> Go to the pine if you want to learn about the pine, or to the
> bamboo if you want to learn about the bamboo. And in doing
> so, you must leave your subjective preoccupation with your-
> self. Otherwise you impose yourself on the object and do not
> learn. Your poetry issues of its own accord when you and the
> object have become one—when you have plunged deep
> enough into the object to see something like a hidden glim-
> mering there. However well phrased your poetry may be, if
> your feeling is not natural—if the object and yourself are
> separate—then your poetry is not true poetry but merely your
> subjective counterfeit.[18]

Vincent's entire life seems to have been a preparation for this
Japanese approach to nature. A lifetime of failures and disap-
pointments in human relationships and societal expectations
had loosened the hold of any Western anthropocentric preju-
dice. Even during his youth in Holland, alienation had caused
him to turn to nature. From The Hague in 1882, Vincent had
reminded Theo of their unusual love for nature from childhood:

> ... Has everybody also been thoughtful as a child, has everyone

who has seen them really *loved* the heath, fields, meadows, woods, and the snow and the rain and the storm? *Not* everybody has done this the way you and I have. . . .(Letter 251)

Earlier that same year, working in the dunes, Vincent had described his sense of intimate communication with nature through painting:

I see that nature has told me something, has spoken to me, and that I have put it down in shorthand. In my shorthand there may be words that cannot be deciphered, there may be mistakes or gaps; but there is something of what wood or beach or figure has told me in it, and it is not the tame or conventional language derived from a studied manner or a system rather than from nature itself. (Letter 228)

From childhood, Vincent had deep feelings for nature, and his painting at The Hague, Etten, Nuenen, and Drenthe always included heartfelt painting of nature, though "heads of the people" often took precedence and may have seemed more important for his career.

In Arles, however, his preferred pattern of life consciously responded to a Japanese precedent:

Here my life will become more and more like a Japanese painter's, living close to nature like a petty tradesman. (Letter 540)

Vincent himself noted a new spontaneity and speed of execution, a concentration and naturalness:

I must warn you that everyone will think that I work too fast. Don't you believe a word of it.
Is it not emotion, the sincerity of one's feeling for nature that draws us, and if the emotions are sometimes so strong that one works without knowing one works, when sometimes the strokes come with a continuity and a coherence like words in a speech or a letter, then one must remember that it has not always been so. . . . (Letter 504)

Vincent felt that in the presence of nature he was developing the Japanese stroke like a "lightning flash" (letter 500); "as simple as

breathing. . . in a few sure strokes. . . . " (letter 542). Vincent also felt a sense that old plans, ambitions, and even expectations regarding this or that particular painting were shucked off in long concentration before nature:

> . . . if you work diligently from nature without saying to yourself beforehand—"I want to do this or that," if you work as if you were making a pair of shoes, without artistic preoccupations, you will not always do well, but the days you least expect it, you find a subject which holds its own. . . . So slow, long work is the only way, and all ambition and keenness to make a good thing of it, false. (Letter 615)

Even the sense of self melted away in the intensity of such work:

> I have a terrible lucidity at moments, these days when nature is so beautiful, I am not conscious of myself any more, and the picture comes to me as in a dream. (Letter 543)

From the asylum at Saint-Rémy, Vincent made clear that while he had given up hope for a family, he had found his proper place of comfort and restoration:

> Well, do you know what I hope for, once I let myself begin to hope? It is that a family will be for you what nature, the clods of earth, the grass, the yellow wheat, the peasant are for me, that is to say, that you may find in your love for people something *not only to work for*, but to comfort and restore you when there is need for it. (Letter 604)

Even Vincent's ideas, the exciting chain of thoughts that filled hundreds of letters to Theo, seemed to leave him:

> Only I have no news to tell you, for the days are all the same, I have no ideas, except to think that a field of wheat or a cypress is well worth the trouble of looking at closeup. . . . (Letter 596)

From the asylum he also wrote his youngest sister Wil and was about to convince her to read Shakespeare, but instead:

> Did you ever read *King Lear*? But never mind, I think I am not going to urge you too much to read books or dramas, seeing

that I myself, after reading them for some time, feel obliged to go out and look at a blade of grass, the branch of a fir tree, an ear of wheat, in order to calm down. So if you want to do as the artists do, go look at the red and white poppies with their bluish leaves, their buds swaying on graceful bent stems. (Letter W 13)

Vincent's descriptions of listening to nature and giving himself up to her language, without human preoccupations or system, could easily be mistaken for the words of a Zen master or Japanese artist, while Basho's advice that one learn from the pine and bamboo need only be altered to "learn from the sunflower, olive, wheatfield, and cypress" to become a perfect description of Vincent's maturing manner of doing art. The new "transparency" of Vincent's work in nature and the dynamism of trees, fields, and sky through his "lightning" strokes are more readily available in his paintings than in his correspondence, as words gave way along with ego. His springtime became the almond branch, blossoming trees, sprouting grain, and wildflowers, summer became ripe grain and reapers, autumn the falling leaves and ripened sunflowers.

Vincent's search moved to more profound levels. He struggled with old notions regarding the nature of his art, even as struggling with nature swept him to a new level of the spiritual quest. The direction his work was taking puzzled even Vincent himself. He wrote to Bernard:

I myself have done two studies of the fall of leaves in an avenue of poplars, and a third study of the whole avenue, entirely yellow.

I must say I cannot understand why I don't do studies after the figure, seeing that it is often difficult for me to imagine the painting of the future theoretically as otherwise than a new succession of powerful portraitists comprehensible to the general public. (B 19a)

Vincent himself would never resolve in his mind the conflict between his lingering sense that his mission was to paint "heads of the people," and the powerful hold nature had upon him throughout the last twenty-nine months of his life. Those months, through all his illness and turmoil, would be given overwhelmingly to the painting of nature. Perhaps even the

luminous portraits of that period reveal a new orientation toward human beings, a fuller understanding of the place of persons within the dynamic cycle of nature.

Vincent's Western religious heritage had taught him that egocentricity was sin, that he was called to join humanity in the body of Christ, to become a servant of human need. The question remained, can one truly break the bonds of egocentricity while languishing in the anthropocentrism of the Judeo-Christian tradition? Is hyperreflection upon the self any different, qualitatively, than the West's hyperreflection upon humanity? Can one find liberation from self while maintaining the narrow privilege which sees humanity's mission as subduing the earth and enforcing dominion over the non-anthropomorphic universe?

Vincent had transcended one narrowing barrier after another, from worldly acceptance and success, to religious institutionalism and authority, to a suffering servant's task for humanity. In Provence his lifelong love for nature was rekindled and intensified by a search for the secret of the Japanese artist, and the most subtle form of egocentricity, anthropocentrism, gave way in a surrender to nature. Vincent confessed to Bernard in October 1888, regarding his new work in nature:

> You will see that all this isn't in the least impressionistic; dear me, all the worse then. I am doing what I am doing, surrendering myself to nature, without thinking of this and that. (B 19)

A year later, writing to Bernard for the very last time, from the asylum at Saint-Rémy, it is clear his surrender had become a new way of life:

> I have let myself be saturated with the air of the little mountains and the orchards; this much gained, I shall wait and see. My ambition is limited to a few clods of earth, sprouting wheat, an olive grove, a cypress—. . . . (Letter B 21)

It is poignant that even the most desperate of times during his illness, shut away for weeks in his asylum room, did not shake Vincent's deepening sense of companionship with nature. He wrote to Theo in May 1889:

> Through the iron-barred window I see a square field of wheat in an enclosure, a perspective like Van Goyen, above which I

see the morning sun rising in all its glory. (Letter 592)

And in another letter, soon after, he told Theo:

> This morning I saw the country from my window a long time before sunrise, with nothing but the morning star, which looked very big. Daubigny and Rousseau have done just that, expressing all that it has of intimacy, all that vast peace and majesty, but at the same time adding a feeling so individual, so heart-breaking. (Letter 593)

Vincent's attacks of illness continued, the seasons alternated, but nature remained constant for him in its change:

> Oh, while I was ill there was a fall of damp and melting snow. I got up in the night to look at the country. Never, never had nature seemed to me so touching and so full of feeling. (Letter 620)

In spite of the poignant quality of Vincent's experience of nature during his discovery period of the Japanese, one might still raise the question whether breaking through the anthropocentric prejudice is a sufficiently significant departure from Western philosophy and tradition to warrant its being viewed as opening a new and profound level of Vincent's spiritual search, or providing an adequate explanation for the new luminosity, force, and primal appeal of his painting. Fortunately, we have a superb record of the pilgrimage of another Western religionist and artist who was a trained philosopher, an expert in Kantian studies; someone who witnessed to the crucial role "conversion" from anthropocentrism played in his own transcending of Western philosophy's limitations.

Albert Schweitzer (1875–1965) was raised in a parsonage in Alsace, became a renowned biblical scholar, world-acclaimed organist, and Bach scholar, and a medical missionary to the Congo. While working in the natural setting provided by Equatorial Africa, Schweitzer continued to puzzle over a sense of inadequacy he found in Western philosophy and tradition. He described the very moment in nature when the puzzle was resolved during an African river voyage:

> Lost in thought I sat on the deck of the barge struggling to

find the elementary and universal conception of the ethical which I had not discovered in any philosophy. Sheet after sheet I covered with disconnected sentences merely to keep myself concentrated on the problem. Late on the third day, at the very moment when, at sunset, we were making our way through a herd of hippopotamuses, there flashed upon my mind, unforeseen and unsought, the phrase, "Reverence for Life." The iron door had yielded: the path in the thicket had become visible. Now I had found my way to the idea in which affirmation of the world and ethics are contained side by side.[19]

Schweitzer himself defined "reverence for life" in terms of breaking through the anthropocentric "fault":

The great fault of all ethics hitherto has been that they believed themselves to have to deal only with the relations of man to man. In reality, however, the question is what is his attitude to the world and all life that comes within his reach. A man is ethical only when life, as such, is sacred to him, that of plants and animals as that of his fellow men, and when he devotes himself helpfully to all life that is in need of help. Only the universal ethic of the feeling of responsibility in an ever-widening sphere for all that lives - - only that ethic can be founded in thought. The ethic of the relation of man to man is not something apart by itself: it is only a particular relation which results from the universal one.

The ethic of Reverence for Life, therefore, comprehends within itself everything that can be described as love, devotion, and sympathy whether in suffering, joy, or effort.[20]

The words of a contemporary American poet harmonize with Schweitzer's discovery and demonstrate the contemporary relevance of the move beyond anthropocentrism. Gary Snyder left his "Beat Generation" companions in California in order to enter a Zen monastery in Kyoto, Japan. Since his return he has focused his poetry and essays on the sacramental nature of earth and its relation to the personal spiritual quest:

The biological ecological sciences have been laying out (implicitly) a spiritual dimension. We must find our way to seeing the mineral cycles, the water cycles, air cycles, nutrient cycles, as sacramental and we must incorporate that insight into our own personal spiritual quest and integrate it with all

the wisdom teaching we have received from the nearer past.[21]

Vincent's own journey beyond the anthropocentric limitation through his search for the secret of Japanese art led him to his own realization of reverence for it all, his own awareness of the spiritual dimension of earth's cycles as sacramental. That discovery in itself explains much regarding the primal appeal and spirituality of his paintings from Arles, Saint-Rémy, and Auvers. Listening to nature, he painted without the imposition of the anthropocentric bias, his work more and more allowed sunflower and wheat, blossom and peasant to speak their own language, to gaze out at the viewer on their own terms.

But we have not yet entered the profound center of the Zen-inspired Oriental philosophy of nature, nor have we yet fully appreciated Vincent's experiential probing of that Oriental connection. The Zen artist does not discover a romantic communion with the Eternal in nature, but rather awakens to the one field of force which expresses itself momentarily here as sunflower or blossoming tree, there as cicada or peasant, the one field of force which Zen names *sunyata*, "emptiness," or "nothingness." Rather than discovering an Eternity beyond change, a completion beyond the fleeting moment, Zen finds the only cosmic unity to be change itself. The final mutual interpenetration of all things is founded on, and in, impermanence itself.

In their transiency, impermanence, transformation, all things interpenetrate, finding their center in each other. Only through the discovery of that shared center can the human being *wake up* or find salvation. In unity with all things as impermanent, humans find their center in everything, and find the center of everything mirrored in their own impermanence. Abe Masao expresses it thus:

> Buddhist salvation is thus nothing other than awakening to reality through the death of ego, i.e., the existential realization of the transiency common to all things in the universe, seeing the universe really *as it is*. In this realization one is liberated from undue attachment to things and ego-self, to humanity and world, and is then able to live and work creatively in the world. "Awakening" in Buddhism is never for a single instant ever in the slightest something other than, or separated from, the realization of universal transitoriness.[22]

In Zen-inspired philosophy, poetry, and painting, this impermanence is experienced in the cycles of nature, in seasonality itself. The Zen scholar, Heinrich Dumoulin, describes this theme as central to the work of Japan's chief religious thinker and saint, the thirteenth-century Zen Master Dogen:

> This philosophy rests upon a genuine experience of nature. As his nature poems reflect, Dogen was deeply touched by the change of natural phenomena of the four seasons: "Life is a stage of time, and death is a stage of time, like, for example, winter and spring."[23]

Essentially all the hundreds of ukiyo-e prints Vincent studied were seasonal, representing young courtesans under cherry blossoms, the melancholy contrast of aging persons viewing plum blossoms, a lonely figure under bare branches, trees and humans bent by wind or disappearing in the snow. Pictures of the "floating world" saw all things swept along by the current of time, yet celebrating their seasonality. As Basho, the genius of the "poetry of seasons" affirmed in a passage quoted earlier:

> . . .all who have achieved real excellence in any art, possess one thing in common, that is, a mind to obey nature, to be with nature, throughout the four seasons of the year.[24]

Vincent detected the role of the seasons and its "religious" import in Japanese art. As noted earlier in this chapter, he described the Japanese artist as a philosopher who studied a "blade of grass," and that study "leads him to draw every plant and then the seasons. . . ." He continued:

> Come now, isn't it almost a true religion which these simple Japanese teach us, who live in nature as though they themselves were flowers? (Letter 542)

From his arrival in Arles in February 1888, Vincent was absorbed in painting the seasons. He began by bringing blossoming almond twigs indoors for study, but soon reported:

> I'm up to my ears in work, for the trees are in blossom and I want to paint a Provençal orchard of astounding gaiety. It is

very difficult to write collectedly. (Letter 473)

He explained to Theo that he and other artists must work toward doing for "this lovely country. . . what the Japanese have done for theirs" (letter 483). Soon painting grainfields, meadows of buttercups, irises and willows, he described the springtime fields as being "like a Japanese dream" (letter 487), and he described how his drawings should be used to "make sketchbooks. . . like those of original Japanese drawings" (letter 492).

Vincent's vision of his work in Provence was both Japanese and thoroughly seasonal:

> The wheatfields have been a reason for working, just like the orchards in bloom. And I only just have time to get ready for the next campaign, that of the vineyards. . . .
> The orchards meant pink and white; the wheatfields, yellow; and the marines blue. . . . There's the autumn, and that will give the whole scale of the lyre. (Letter 504)

Vincent saw good reason for settling in Provence to enter more deeply into nature as its seasonal cycle turned:

> Why move about much? When I see the orchards again, shan't I be in a better condition, and won't it be something new, a renewed attack on a new season, on the same subject. And the same for the whole year, for harvesttime, and the vineyards, for everything. (Letter 505)

The passing of the seasons and their influence upon those who study the continuity of change itself remained on his mind:

> Will my work really be worse because, by staying in the same place, I shall see the seasons pass and repass over the same subjects, seeing again the same orchards in the spring, the same fields of wheat in summer? . . . it will mean work of a deeper calm at the end of a certain time. (Letter 535)

Early in his painting career Vincent had declared himself a "peasant painter" and now in Provence he found himself responding to the same seasonal changes, and often following the same dawn to dusk rhythm as the peasants. He "plowed" his

canvases with rhythmic strokes and prepared for long hours in the fields during wheat harvest or in the vineyards once the grapes ripened. As he wrote his mother from Saint-Rémy, "I keep looking more or less like a peasant. . . and sometimes imagine I also feel and think like them. . ." (letter 612).

In August 1889 the Dutch painter and critic, J. J. Isaäcson, wrote a favorable notice regarding Vincent "who reveals anew our domain, our earth, our heritage; who restores happiness by revealing the divine in matter. . . . "[25] While appreciative, Vincent felt a "mental weariness of Paris," something "unhealthy," in Isaäcson's review (letter 611). From his response to Isaäcson, it appears that Vincent detected an urban anthropocentrism willing to be moved by a nature scene but unable to fathom nature's transformations or the special character of the "dweller in nature." Avoiding discussion of artistic technique, Vincent described for Isaäcson the seasonality of a real olive tree through its color changes:

> At times the whole is a pure all-pervading blue, namely when the tree bears its pale flowers, and the big blue flies, emerald rose beetles and cicadas in great numbers are hovering around it. Then, as the bronzed leaves are getting riper in tone, the sky is brilliant and radiant with green and orange, or, more often even, in autumn, when the leaves acquire something of violet tinges of the ripe fig. . . .

Vincent not only described the changing tree and its interdependence with sky, sun, and insects, but went on to describe the women working among the trees, and posed this question to Isaäcson:

> Who are the human beings that actually live among the olive, the orange, the lemon orchards?
> The peasant there is different from the inhabitant of Millet's wide wheatfields. But Millet has reawakened our thoughts so that we can see the dweller in nature. . . . But when Chavannes or someone else shows us that human being, we shall be reminded of those words, ancient but with a blissfully new significance, Blessed are the poor in spirit, blessed are the pure in heart, words that have such a wide purport that we, educated in the old, confused and battered cities of the North, are compelled to stop at a great distance from the threshold of those dwellings. (Letter 614a)

Vincent sought to convince Isaäcson that more than happiness through colorful nature canvases was at stake. Humanity was being called upon to respond to the vitality available in nature, and to recognize the effects of nature upon that human life integrated with its cycle of change. As Millet had been "the voice of the wheat," so many voices must speak the comfort, simplicity, and healing available when humans celebrate the transformative power of nature. Jesus' own blessings rested upon the dwellings of those who abandoned ego and anthropocentric prejudices for poverty and purity in mutual interpenetration with earth's varied life cycles. To Vincent, looking at a "wheatfield, even in the form of a picture," offered more to suffering humans than abstract thought seeking abstract answers "on the other side of life" (letter 597). His own laborious copying of Millet's prints depicting the rhythm of the peasant's life and work in nature was no self-indulgent exercise, but was intended as a collection to be given to some school where such scenes of humans integrated with nature could serve youth (letter 610).

It was during this very period that Bernard and Gauguin wrote Vincent regarding their new canvases utilizing traditional religious subjects, *The Nativity* and *Christ in the Garden of Gethsemane*. Vincent made it clear that he was "not an admirer" of their biblical subjects, for in returning to such "dreams" and "abstractions," Gauguin and Bernard were "avoiding getting the least idea of the possible, or the reality of things," and this gave Vincent "a powerful feeling of collapse instead of progress" (letters 614, 615). His own response was to work from morning to evening in the olive orchards:

> . . . I shall not try to paint *Christ in the Garden of Olives*, but the glowing of the olives as you still see it, giving nevertheless the exact proportions of the human figure in it, perhaps that would make people think. (Letter 614)

But his work within nature's seasonal change carried Vincent's own thought even further. Old abstractions and absolutes, dualities of good and bad, happiness and sorrow, life and death gave way as he experienced the impermanence that pervaded all things. He shared with Theo his intensifying feeling that "life is so short and goes so fast" (letter 498), "how like smoke" (letter 516):

> Life passes like this, time does not return, but I am dead set
> on my work, for just this very reason, that I know the oppor-
> tunities of working do not return. (Letter 605)

He worked rapidly, seeking the "lightning" stroke of the Japanese
(letter 500), as the very flowers he painted were fading before him
(letter 526).

But impermanence did not mean the obliteration of life;
rather, it meant a sharing in the transformative power of the
universe. Vincent found nature's metamorphosis especially
applicable to the life of the artist and thus to his own situation.
Writing from Arles in 1888 to his young colleague Bernard,
Vincent discussed Christ's nature-parables as art, the broader
context of painting within "the art of creating life," and finally
the transformative possibilities available even to the struggling
painter:

> . . . it would remain praiseworthy of us to maintain a cer-
> tain serenity with regard to the possibilities of painting under
> superior and changed conditions of existence, an existence
> changed by a phenomenon no queerer and no more surprising
> than the transformation of a caterpillar into a butterfly, or of
> a white grub into a cockchafer. (Letter B 8)

Similarly, in a letter to sister Wil written from Arles during that
same period, Vincent considered the wider context of life and
death in terms of natural metamorphosis, again utilizing the
common garden grub that eats lettuce roots and is transformed
into a cockchafer or scarablike beetle:

> We are as little able to judge of our own metamorphoses with-
> out bias and prematureness as the white salad grubs can of
> theirs, for the very cogent reason that the salad worms ought
> to eat salad roots in the very interest of their higher develop-
> ment.
> In the same way I think that a painter ought to paint
> pictures; possibly something else may come after that. (W 2)

This sense of an inner creative power that transforms natu-
rally as one responds to the tasks at hand may well relate to the
"awfully unnameable" Vincent had experienced on the heath
in Drenthe and felt under the sun and in the fields and orchards

of Provence. Perhaps such profound power revealed through one's life task was a more accurate description of the divine than the word "God":

> Oh, my dear brother, sometimes I know so well what I want. I can very well do without God both in my life and in my painting, but I cannot, ill as I am, do without something which is greater than I, which is my life—the power to create. (Letter 531)

Most often Vincent's sense of profound meaning came while he was busy among blossoming trees, in the olive orchards, in the presence of the cypress, and in the grain fields at planting or harvest. In Saint-Rémy, with the grain fields visible through his barred window, Vincent pulled together his deepest insights which might well have been written by a Zen Master who had moved beyond abstract dualistic thought to an experience of impermanence as liberation:

> I feel so strongly that it is the same with people as it is with wheat, if you are not sown in the earth to germinate there, what does it matter?—in the end you are ground between the millstones to become bread.
> The differences between happiness and unhappiness! Both are necessary and useful, as well as death or disappearance—it is so relative—and life is the same.
> Even faced with an illness that breaks me up and frightens me, that belief is unshaken. (Letter 607)

Vincent's attacks of illness at Saint-Rémy during the early months of 1890 became more severe, leading him to believe that the atmosphere of the asylum itself might be a negative influence. He therefore had Theo arrange his release in May, returning north to visit Theo and his family for a few days, then settling in an inn in the village of Auvers, under the observation of a Doctor Gachet who was fond of artists. Vincent's chief regrets upon leaving Provence were two: First, his last round of illness had made him miss the blossoming season in early spring: "Now the trees in blossom are almost over, really I have no luck" (letter 629). Second, he had not been able to get on canvas all the voices of nature he had heard:

> Oh, if I could have worked without this accursed disease—
> what things I might have done, isolated from others, following
> what the country said to me. (Letter 630)

Vincent's consolations in moving north were that he would be closer to Theo, would meet Theo's wife and their child, his namesake, Vincent. But also: "I am looking forward so much to seeing the exhibition of Japanese prints again" (letter 633).

Theo's wife described the moving scene when Vincent arrived from Saint-Rémy on a May morning of 1890 at the Paris apartment and saw his godchild for the first time:

> Then Theo drew him into the room where our little boy's cradle was; he had been named after Vincent. Silently the two brothers looked at the quietly sleeping baby—both had tears in their eyes. Then Vincent turned smiling to me and said, pointing to the simple crocheted cover on the cradle, "Do not cover him too much with lace, little sister." [26]

Vincent's faith in the cradle as focus of God's vulnerability and the germinating force of human love must have been infinitely deepened by the realization that this cradle held the hope for the future of Theo, Jo, and himself. Not far from the cradle hung his gift to the child, the Saint-Rémy painting of almond branches in bloom, the Japanese-style promise of a new season of growth.

The confusion of the city and the urge to return to painting nature led Vincent to leave Paris in three days for the nearby village of Auvers. There he introduced himself to Dr. Gachet, and settled in a stuffy, inexpensive attic-room at the Ravoux Inn. Within a day or two he had written Theo and Jo that he was already absorbed in painting the village homes and the new crops in the fields:

> Now I have one study of old thatched roofs with a field of peas in flower in the foreground and some wheat. . . . (Letter 636)

Painting the young, green wheat, Vincent was also absorbed in concern for the health of his godchild:

> I often think of you, Jo, and the little one, and I notice that the children here in the healthy open air look well. And yet even here it is difficult enough to bring them up, therefore it must

be all the more terrible at times to keep them safe and sound in Paris on a fourth floor. (Letter 638)

On the last day of June, Vincent received the frightening news that Theo and Jo's child was ill, and reacted as emotionally as the parents apparently had:

> . . . I should be even more powerless than you in the present state of anxiety. But I feel how dreadful it must be and I wish I could help you. (Letter 646)

He had deep sympathy for his brother and sister-in-law who "probably hardly sleep," and noted his concern that Jo was having difficulty nursing the child. Though worried that he might futher confuse things in their household, Vincent himself visited Paris within a few days, and found things even worse than he had feared:

> Jo, believe me—if ever you happen, as I hope, to have more children—don't get them in the city. . . . At present it seems to me that while the child is only six months old, your milk is already drying up, already—like Theo— you are too tired. I do not mean to say exhausted, but anyway worries are looming too large, and are too numerous, and you are sowing among thorns. . . .
> I always foresee that the child will suffer later on for being brought up in the city. (Letter 648)

Anxieties suddenly seemed to have multiplied. Vincent himself was exhausted and perhaps felt another attack of illness coming. He wanted to see Dr. Gachet, but could not locate him: "I think we must not count on Dr. Gachet *at all.*" Further, Theo had reported that financial difficulties were coming, and was contemplating giving up his job and trying to make it on his own if he could find the necessary funds. Vincent was reassured by a letter from Johanna, but apparently saw himself as a "burden," perhaps "a thing to be dreaded." He was thinking of ". . . the little one. I think it is certainly better to bring up children than to give all your nervous energy to making pictures. . . " (letter 649).

Vincent's first paintings in Auvers had included the young, green wheat of May. In June and early July he had been "absorbed in the immense plain with wheatfields against the hills, bound-

less as the sea, delicate yellow. . . " (letter 650). As July moved toward its close, he began painting the mature grain under stormy skies, and finally a harvested field with golden sheaves of wheat standing in the sun. It is likely that in that very field, where he was last painting, Vincent carried his easel, paints, and a pistol he had borrowed from the innkeeper. There was a rightness and consistency to his shooting himself in a harvested field, an exhausted and ill adult-dependent making way for a godchild who needed all his parents' resources if he were to survive.

That this sacrifice was foremost in Vincent's mind is clear in the letter Theo found among Vincent's possessions:

> Your reassuring me as to the peacefulness of your household was hardly worth the trouble, I think, having seen the weal and woe of it for myself. And I quite agree with you that rearing a boy on a fourth floor is a hell of a job for you as well as Jo. (Letter 652)

That a suffering servant should give up his life for another was scriptural; that the "other" should be a child in a cradle was in harmony with Vincent's deepest beliefs in the meeting of the human and Divine; that it occurred in the midst of painting fields of grain and golden harvests resonates with his profound sense of a shared impermanence with nature. As he had written in his last letter from Auvers to sister Wil:

> I am working a good deal and quickly these days; by doing this I seek to find an expression for the desperately swift passing away of things in modern life. (Letter W 23)

When Vincent fired the borrowed pistol into his side, in the very shadow of the wheat-sheaves of a harvested field, the relevance of his words quoted earlier is too powerful to ignore:

> I feel so strongly that it is the same with people as it is with wheat, if you are not sown in the earth to germinate there, what does it matter? —in the end you are ground between the millstones to become bread.
>
> The difference between happiness and unhappiness! Both are necessary and useful, as well as death or disappearance. . . . (Letter 607)

6

Symbolism

Paul Tillich, the philosopher-theologian, was fascinated by the arts and their significance in expressing symbolically humanity's "ultimate concern." He wrote:

> All arts create symbols for a level of reality which cannot be reached in any other way. A picture and a poem reveal elements of reality which cannot be approached scientifically. In the creative work of art we encounter reality in a dimension which is closed for us without such works.[1]

He noted further that such use of symbols :

> . . . not only opens dimensions and elements of reality which otherwise would remain unapproachable but also unlocks dimensions and elements of our soul which correspond to the dimensions and elements of reality.[2]

Carl Jung, the Swiss psychologist, was similarly convinced of the power of symbolism to open otherwise inaccessible levels of meaning. He thus defined symbolism in terms of its directing us toward the unknown and hidden:

> What we call a symbol is a term, a name, or even a picture that may be familiar in daily life, yet that possesses specific connotations in addition to its conventional and obvious meaning. It implies something vague, unknown, or hidden from us.[3]

Jung emphasized the "virtually unexplored" part of the mind "from which symbols are produced," and sought the "archaic remnants," "archetypes," or "primordial images" derived from the unconscious contents of the human psyche:

> Whatever the unconscious may be, it is a natural phenomenon producing symbols that prove to be meaningful.[4]

Eric Neumann, an analytic psychologist who studied with Jung, has focused even more pointedly on the role of the artist and symbolism in art in the modern world. Neumann has pointed out the loss of efficacy of "symbol-creating collective forces of myth and religious rites and festivals. . . " and the resulting "crisis of modern man":

> With the dissolution of the primitive group and the progress of an individualization dominated by ego-consciousness, religious ritual and art become ineffectual; and we approach the crisis of modern man, with his sharp separation of systems, his split between consciousness and unconscious, his neurosis, and his incapacity for total creative transformation.[5]

The loss of traditional means for symbol-creation has led us to turn to the potentialities of art and the creative artist:

> The creative individual seems to enjoy such prestige partly because he exemplifies the utmost transformation possible in our time, but above all because the world he creates is an adequate image of the primordial *one* reality, not yet split by consciousness—a reality that only a personality creating from out of its wholeness is able to create.[6]

According to Neumann, the key to our understanding of man and the world is located at that point where creativity and symbolic reality meet:

> It cannot be stressed enough that the key to a fundamental understanding, not only of man, but of the world as well, is to be sought in the relation between creativity and symbolic reality. Only if we recognize that symbols reflect a more complete reality than can be encompassed in the rational concepts of consciousness can we appreciate the full value of man's power to create symbols.[7]

The emphases that Tillich, Jung, and Neumann place upon the: (1) creative role of symbolism in art; (2) access to hidden dimensions of inner and outer realities; and (3) search for primordial unity in the work of the creative individual are all matters of interest to anyone who wants to discover the symbolic content and significance of Vincent van Gogh's work. Is Vincent's popular appeal today in both the East and West a result of the world's growing appreciation of the creative individual—the artist who stands outside the generally accepted cultural mannerisms and methods of his time; the artist who is somewhat apart from the clichés of the culture to which he was born?

Was van Gogh one of the first artists to sense that the formerly acceptable academic approaches were no longer serviceable means of reaching newly valued primal realities and personal transformations?

Does van Gogh's work tap a natural, symbol-producing unconscious that provides meaning to people of many origins? Do his life and work merge in some unique way as an effective example of transformation, presenting an experience of primordial reality?

All these questions are relevant to any inquiry regarding van Gogh and the role of his spiritual quest. The problem of symbolic meaning in the paintings of van Gogh is both complex and confusing, and it has inspired some very good, and much very bad, analytical writing that is sometimes revealing but is more often dryly mechanistic or unbelievably bizarre.

That Vincent himself mused long and hard on the meaning and significance of symbolism in art is clear from his letters. In the autumn of 1885, beginning to feel isolated in his studio in the Dutch village of Nuenen and longing to see examples of great art, Vincent responded to a comment by Theo about the Poussins in the Louvre with this affirmation of the need for sensitivity to symbolism.

> I firmly believe that my work will improve by seeing more pictures, because when I see a picture, I can analyze how it is done. As to Poussin, he is a painter and a thinker who always gives inspiration, in whose pictures all reality is at the same time symbolic. In the work of Millet, of Lhermitte, all reality is also at the same time symbolic. They are different from what are called realists. (Letter 425)

Vincent's mention of two favorite artists, Millet and Lhermitte, in relation to a symbolic content in art, and his assertion that "all reality is at the same time symbolic," indicate the positive role he attributed to symbolism and cast light on his own intentions and aspirations.

Three years later, in the midst of some of his most significant work in Arles, Vincent shared with Theo one of his fondest hopes in painting, the discovery he was "always in hope of making":

> I am always in hope of making a discovery there, to express the love of two lovers by a wedding of two complementary colors, their mingling and their opposition, the mysterious vibrations of kindred tones. To express the thought of a brow by the radiance of a light tone against a somber background.
>
> To express hope by some star, the eagerness of a soul by a sunset radiance. Certainly there is no delusive realism in that, but isn't it something that actually exists? (Letter 531)

This focus upon the force of complementary colors and the sense of a correspondence between elements of nature and human aspirations occurs often in Vincent's writings, and is contrasted to "delusive realism," an expression he applied to the lifelessness he abhorred in photographs. Vincent was committed to reality, but to a reality not pursued through photographic realism, but a reality that is "at the same time symbolic."

Specific scenes, persons, and elements of nature in his own work could be described by Vincent as symbolic. He wrote to Bernard from Arles in 1888 of his special love for the countryside and the memories it brought to mind:

> ... I am still charmed by the magic of hosts of memories of the past, of a longing for the infinite, of which the sower, the sheaf are the symbols—just as much as before. (Letter B 7)

Similarly, writing from Saint-Rémy in 1889, Vincent described in symbolic terms his painting of a reaper, "an image of death as the great book of nature speaks of it. . . ":

> For I see in this reaper—a vague figure fighting like a devil in the midst of the heat to get to the end of his task—I see in him the image of death, in the sense that humanity might be the wheat he is reaping. So it is—if you like— the opposite of that

sower I tried to do before. But there is nothing sad in this death, it goes its way in broad daylight with a sun flooding everything with a light of pure gold. (Letter 604)

But it was not simply color relationships or specific symbolic associations that comprised the dynamic of Vincent's symbolism. A broader and a deeper sense of resonances between nature and the human quest, a "comforting," quality in paintings with "heart and soul" was central to Vincent's spiritual sense of artistic vocation:

> And in a picture I want to say something comforting, as music is comforting. I want to paint men and women with that something of the eternal which the halo used to symbolize, and which we seek to convey by the actual radiance and vibration of our coloring. (Letter 531)

Current debates regarding the foundations of interpretation itself render the question of symbolic meaning in van Gogh even more complex and confusing; however, a grasp of Vincent's own understanding and use of symbolism in art, and the discovery of the deeper dynamic of his world-view which fed such symbolism, are likely to challenge and to enrich the most independent interpreter of his work.

First, it is helpful to glimpse the promises and failures of a few current approaches to Vincent's symbolism, approaches that have until now predominated in the study of van Gogh. The most obvious starting point is the three-hundred page work by H. R. Graetz, *The Symbolic Language of Vincent Van Gogh.*[8] Graetz's book, published in 1963, is reported to be the result of "ten years of relentless labor." The author received "hearty congratulations" for his "new approach" from Vincent's nephew, Mr. Vincent W. van Gogh; Gustav Bally, president of the Psychiatric Society of Switzerland, whose "professional advice" is noted by Graetz, has written an appreciative preface.[9] The great strength of Graetz's book is its intimate knowledge and wise use of Vincent's correspondence and an acknowledgement of the integrity and interdependence of Vincent's images and words. The failure of Graetz's work is the same failure of others who have turned their attention to Vincent's symbolism; that is, the author's basic tendency to allegorize details of the individual paintings,

thereby creating a static code book in which each image delivers a fixed meaning. Though Graetz speaks of wholeness, he ends with static equivalences and reductive psychological interpretations of details. Summarizing a series of Vincent's paintings, Graetz writes:

> While the light of the lamp, the sun, the stars symbolize his love, the gnarled, knotty tree expresses his struggle, and the broken branch or stump is symbolic of defeat and frustration.[10]

For Graetz, birds and butterflies symbolize Vincent's thoughts (pp. 58, 77), with white birds being equivalent to happy thoughts (p. 94). The "key" to the meaning of Vincent's *Sunflowers* is the "place where Vincent chose to sign his name," which was on the vase, a symbol for "female" and "home" (p. 108). A sunflower drooping below the horizon is falling below the lifeline, while two such drooping flowers indicate an awareness of the death of the two brothers (p. 109). In Vincent's still life of a breakfast table with coffee-pot, dishware, and fruit, the coffeepot is the "nourishing mother," its inserted filter is the "male character," and the two oranges are symbols of the two brothers (p. 93). A still life of two shoes has the lace of a falling shoe touching the upright shoe, Vincent's attaching himself to Theo, while two sunflowers, "their faces turned away from each other, intimate the negative side of their relationship" (pp. 48, 64).

While many of Graetz's suggestions might certainly be admitted as possible plays of meaning, as resonances which might suggest themselves within a host of possible correspondences, he falls victim to a static, allegorical approach. Graetz often injects a calculating and petrifying quality into his interpretations that precludes alternative meanings. This approach does not allow for an openness to experience that Vincent himself seems to have had, whereby reality constantly initiates ripples of meaning. As Vincent wrote:

> I believe one gets sounder ideas when the thoughts arise from direct contact with things than when one looks at them with the set purpose of finding certain facts in them. (Letter 233)

Bernard Zurcher in his book *Vincent Van Gogh: Art, Life, and Letters* (1985), falls victim to the same reductionism as does

Graetz. Zurcher, in fact, sometimes even allows his eyes to be deceived in order to provide a detail for one of his preconceived allegorical equivalences. For example, his interpretation of Vincent's *Still Life with Drawing Board* (F 604), a painting done just prior to Gauguin's departure from Arles, includes the following:

> The green jar, whose handle, the symbol of union, is "opened" by the top edge of the picture, clearly shows that the collaboration between the two artists was coming to a close. . . .The hammer, near the candle, could be used as a weapon—by Gauguin, the "murderer.". . . [11]

What Zurcher has convinced himself is a hammer, a "murder" weapon, is, in fact, simply Vincent's box of wooden matches lying perpendicular to a stick of red wax used for sealing letters.

Albert Lubin in *Stranger on the Earth* (1972) forces a single direction of symbolic interpretation upon a large part of Vincent's work in order to demonstrate the view that Vincent felt himself to be "a burden his depressed mother was forced to tolerate" during her grief for the stillborn son buried just a year before Vincent's own birth.[12] Not only does Lubin find this unconscious theme in Vincent's paintings of figures carrying burdens, but also in all the ditches, holes, bogs, diggers, and shovels that he painted.[13] He relates two quite different paintings to his favorite symbolic theme in this passage:

> In *The Drawbridge*, a woman holding an umbrella stands in the center of the bridge. The canal beneath it is analogous to the road in *Road with Cypress and Star*. Like the fused cypresses on the side of the road in the latter, a pair of cypresses reaches into the sky from the canal bank. Too, the curve of the umbrella repeats the curve of the cab roof in *Road with Cypress and Star*. Viewed from the standpoint of his unconscious fixation, both paintings symbolize Vincent and his double, born from the same womb and the same birth canal, united as they will be in heaven.[14]

Even apart from the dangers involved in such reductionism, Vincent's symbolism is not easily solved, and even the best of critics on occasion stumbles by failing to evaluate properly the material in Vincent's letters, literary sources, or biblical usage. In chapter three we pointed out the failure of critics to grasp the

dynamic of Vincent's still life of his father's Bible with a Zola novel. One must understand both the context of Isaiah's "proclaiming of good tidings" and the role of Pauline Quenu in *La Joie de Vivre* to understand Vincent's sense of their relationship. Similarly, one might question Meyer Shapiro's suggestion of "a possible element of apocalyptic fantasy" in *The Starry Night*, an ". . . unconscious reminiscence of the apocalyptic theme of the woman in pain of birth, girded with the sun and moon and crowned with the stars, whose newborn child is threatened by the dragon" (Revelation 12:1ff).[15] A study of Vincent's use of the Bible indicates his avoidance of apocalyptic images and of the Book of Revelation generally, and would suggest the greater likelihood of biblical connections to heavenly lights in such passages as chapter sixty of Isaiah, response to astral imagery in Victor Hugo and Walt Whitman, and perhaps a reflection of Hokusai's print, *The Great Wave*, in the swirling pattern of the sky as a sea of stars.

In considering Vincent's own sense of symbolism, we have already quoted one of Vincent's statements about his open endorsement of symbolism and his estimate of its proper relationship to reality:

> . . . all reality is also at the same time symbolic. (Letter 425)

Further, we have already noted that he discovered symbolic meaning in the relationships among colors and in correspondences between elements of nature and human aspirations; he could speak of color alone as a "symbolic language," and could interpret "sower and sheaf" as symbols (Letters 531, 503, B 7, 604). But this kind of information does not relieve the interpreter of van Gogh's symbolism from the formidable task of first detecting the origin, intent, and meaning-center of Vincent's own sense of the symbolic. Although many references related to symbolism are found throughout Vincent's letters, they often tend to be fragmentary and so vague that they frustrate the interpreter and complicate the issue. The best help we have in this regard can be found in his correspondence with other artists. In those letters something can be learned about his views on symbolism; for example, he did make revealing comments to Anthon van Rappard, a fellow Dutch artist, and to the young French artist, Émile Bernard.

To Rappard he presented arguments against painting from the nude at the academy in Brussels, where Rappard was apparently learning established techniques for rendering beauty and sublimity. Vincent urged Rappard to "stick to reality," to "draw or paint ordinary people with their clothes on," to concentrate on the beauty of a "poor woman gathering potatoes in a field, a digger, a sower. . ." (letters R 2, R 4). Personifying the academy as a female who "freezes you, who petrifies you, who sucks your blood," Vincent warned:

> Without knowing it, this academy is a mistress who prevents a more serious, a warmer, a more fruitful love from awakening in you. Let this mistress go, and fall desperately in love with your real sweetheart: Dame Nature or Reality. (Letter R 4)

Vincent noted his own love of "Dame Nature or Reality," both her divinity and her earthliness. He described her "intentions":

> She? Where she dwells? I well know where, and it is not far from any of us.
> She? Her intentions? What do I know of them, how can I express myself? I want to be silent—and yet, because I *must* speak—well then—as it seems to me: to love and to be lovable—to live—to give life, to renew it, to restore it, to preserve it—and to work, giving a spark for a spark, and above all to be good, to be useful, to be helpful in something, for instance lighting a fire, giving a slice of bread and butter to a child, a glass of water to a sufferer (Letter R 4).

It was not an academic concept of beauty or studio accomplishments that Vincent considered the aim of true art. He saw the straight path of art, exemplified in the peasant scenes of The Hague School, in the wood engravings of Daumier, in the novels of Dickens, Hugo, and George Eliot, as a path of "virile strength, truth, good faith and honesty" (letters R 32, R 34, R 36). The "everlasting conventions" and "stinking" sapience of studio techniques disgusted and angered Vincent, who saw far more in art:

> . . . art is something greater and higher than our own adroitness or accomplishments or knowledge; that art is something which although produced by human hands, is not created by

these hands alone, but by something which wells up from a
deeper source in our souls; and that with regard to adroitness
and technical skill in art I see something that reminds me of
what in religion may be called self-righteousness. (R 43)

Vincent's approach to art, is parallel to, perhaps identical with,
the inner dynamic of his spiritual quest. The very forces of self-
righteousness and "pharisaism" he found to be monopolizing
the institutions of religion, he found also to be monopolizing the
institutions of art. A coldness that shut out genuine emotion, an
emphasis on technique that shut out "heart and soul," an artifi-
cial imitation of life through the sterile values of "proper" soci-
ety, all threatened to stultify the young artist as they had threat-
ened to destroy the young evangelist. Vincent rebelled in both
instances and insisted upon an experiential approach to religion
and to art, a way of grace to be received by faith. Symbolism was
viewed as a gift to be received by those who believed in the reality
of a shared life of transformation and mutual service focused
upon the crude, the ordinary, the disinherited. As Meyer Shapiro
describes it, Vincent's art became the new channel for his spiri-
tual search:

> ... art was for him... a choice made for personal salvation, after
> he had failed in another hope, a religious mission as an evan-
> gelist among the poor miners of the Borinage. . . .
> What is most important is that van Gogh converted all this
> aspiration and anguish into his art, which thus became the
> first example of a truly personal art, art as a deeply lived means
> of spiritual deliverance or transformation of the self. . . .[16]

In his comments to Theo regarding great paintings that
inspire us, he noted that "all reality is at the same time symbolic"
(letter 425). In his correspondence with the artist Rappard,
Vincent described that reality, contrasting it with the "academy
as mistress" (letter R 4). From the negative perspective, Vincent
described reality as not "too wise and righteous," not artificial or
petrifying, not punctilious or intent on technical proficiency,
neither "everlastingly conventional" nor submissive to estab-
lished authorities or borrowed dogmas. From the positive per-
spective, he has noted that reality dwells close to us, is committed
to the poor and to laborers, serves in simple and practical ways
where there is need, demonstrates individuality, sentiment,

heart and soul. According to Vincent, the "reality that is at the same time symbolic" is served by an art that seeks its subjects "in the hearts of the people," and will embody

> a certain vitality and raison d'etre of its own that will hurl the errors into the shade—in the eyes of those who *appreciate* character and the spiritual conception of things. (Letter R 57)

Such an art will be transparent, for its "work is outside the paint" (letter R 43). It will be an art produced by human hands but created by and revelatory of "something which wells up from a deeper source in our souls. . . " (letter R 43). Symbolism for Vincent was not a clever code created by artists, but a dynamic *given* from a deeper or a higher source which opened itself to that artist who lived in love and simplicity, persisting in daily labor within nature:

> I see that nature has told me something, has spoken to me, and that I have put it down in shorthand. In my shorthand there may be words that cannot be deciphered, there may be mistakes or gaps; but there is something of what wood or beach or figure has told me in it, and it is not the tame or conventional language derived from a studied manner or a system rather than from nature itself. (Letter 228)

To come into communication with that profound level where symbolism occurs, the artist must give up the ego self and its cautious, conventional ways, and venture everything in an act of feeling and faith. As Vincent wrote Rappard:

> . . . I am not ashamed of my feelings, I do not blush to own that I am a man with principles and a creed. But where does my fanaticism seek to drive people, especially myself? To the open sea! And what is the doctrine I preach? My friends, let us give our souls to our cause, let us work with our heart, and truly love what we love. (Letter R 5)

The "open sea" was further defined for Rappard by Vincent:

> . . . whither I am trying to drive myself, and whither I am trying to drive others too, is to be fishermen on the sea that we call the Ocean of Reality. . . .(Letter R 6)

The open sea was for Vincent the very reality that was at the same time, in its depths, *symbolic,* an understanding that might well suggest Jung's "primordial images from the unconscious contents of the psyche," Neumann's "image of the primordial one reality not yet split by consciousness," or, Jacques Lacan's language of the *other* hidden in plain sight.[17] For Vincent, to render "reality which is at the same time symbolic" was to "render what I see" (letter R 57), "confronted immediately with nature" (letter R 37). But that nature or reality must involve the artist totally, it must be "deeply *felt*" until "the thing has shaped itself in my mind. . . ," until ". . . I *feel*—I *know*—a subject. . . " (letter R 37).

In a final letter to Rappard, written in the autumn of 1885, Vincent had discovered a new way of describing such painting, using an expression he had found in anecdotes regarding Delacroix. Delacroix, after conversing with a friend "about the question of working absolutely after nature," shouted after his friend ". . . in a lusty voice, to the consternation of the respectable citizens passing by, 'Par coeur! Par coeur!' (letter R 58)." Certainly the translation offered in *The Complete Letters* misses the point. Vincent did not restrict Delacroix's words to the sense "from memory," but intended "from the heart," *by heart*, in a deeper and more original way. To know a subject by heart describes that profound point at which the center of the artist's being and the center of reality meet and interpenetrate. In the language of Paul Tillich, that is the place where we "encounter reality in a dimension which is closed for us without such works," and at the same moment the place which "unlocks dimensions and elements of our soul which correspond to the dimensions and elements of reality."

One further element in Vincent's correspondence with Rappard is critical. Symbolism as grace, a *given* to be received by faith that dares to venture on the "open sea," must persist in the daily task which the artist finds through loving attraction to places of simplicity and need. Vincent warned Rappard that life outside the academy would not be easy. There would, in fact, be a "very peculiar difficulty":

> Suppose at some time you leave the academy for good, then I think that you will eventually have to struggle against a very peculiar difficulty, which is not quite unknown to you even now. A man, who, like you, is working at the academy

regularly cannot help feeling more or less out of his element when, instead of knowing, This or that is my task for today, he is forced to improvise, or rather *create*, his task every day anew. Especially in the long run this looking for and finding your work will not prove such an easy job by any means. At least it could not surprise me if, after having broken away from the academy for good, you did not occasionally feel that the ground was giving way under your feet. (Letter R 5)

Liberated from the assigned tasks of the academy, an artist would be "forced to improvise, or rather *create*, his task every day anew." That quest for the day's task and persistence in the work itself were for Vincent a source of revelation, a way to the hidden aspect of reality which is also symbolic. Both the quest for the object to be painted and the expression of it in a painting, create a harmony and open depths of meaning. This sense of daily work itself as revelatory may have come in part through Vincent's reading of Thomas Carlyle, himself an independent-minded Calvinist.[17] During the period of his correspondence with Rappard, to whom he recommended Carlyle's *Sartor Resartus,* Vincent wrote to Theo:

> . . .I think a painter is happy because he is in harmony with nature as soon as he can express a little of what he sees. And that's a great thing—one knows what one has to do, there is an abundance of subjects, and as Carlyle rightly says, "Blessed is he who has found his work." (Letter 248)

Over a dozen times in his correspondence, Vincent cited Carlyle approvingly, especially on the topic of the need for work and its deepening effect on the worker. Years later from Provence, Vincent could say of the essential contribution of "slow, long work":

> . . . if you work diligently from nature without saying to yourself beforehand—"I want to do this or that," if you work as if you were making a pair of shoes, without artistic preoccupations, you will not always do well, but the days you least expect it, you find a subject which holds its own. . . . So slow, long work is the only way, and all ambition and keenness to make a good thing of it, false. (Letter 615)

Vincent's correspondence to Rappard between 1881 and

1885 included almost sixty letters, and the one subject he touches upon more than any other is his argument for painting (with feeling) a reality that is also strongly symbolic rather than painting a reality in what was the academically approved conventional art manner.

In 1887, while living with Theo in Paris, Vincent met the young French artist, Émile Bernard. Twenty-two of Vincent's letters to Bernard from 1887 to 1889 remain—letters emphasizing a commitment to painting the real world of people and nature in preference to creating works purely from the imagination. While Vincent's letters to Rappard refuse the cold and conventional object in favor of reality found in ordinary places by an artist who learns through each day's work, the letters to Bernard specify that Vincent could not give himself up to pure imagination, for he was committed through love to painting the real world. Both cold and conventional objects and an exclusive concern for the "subjective" imagination missed the profound way to symbolism so far as Vincent's view of his own work was concerned.

In Vincent's discussion with Bernard, and indirectly with Gauguin, it is Vincent's positive view of Zola's words, "A work of art is a corner of nature seen through a temperament" that is opposed to Gauguin's "Art is an abstraction; extract it from nature while dreaming before it. . . . [18] Though the difference between the words of Zola and of Gauguin may not be immediately apparent, Gauguin's association with the symbolists moved in the direction of placing such emphasis upon abstraction and dreaming that finally the ordinary forms of nature were excluded as subjects for the artist. On the general issue of reliance upon imagination in painting, Vincent remained rather diplomatic and admitted that for some persons "abstraction" might be acceptable, but that his own attention was "fixed on what is possible and really exists":

> . . . to tell the honest truth, my attention is so fixed on what is possible and really exists that I hardly have the desire or the courage to strive for the ideal as it might result from my abstract studies.
>
> Others may have more lucidity than I do in the matter of abstract studies, and it is certainly possible that you are one of their number, Gauguin too. . . .
>
> But in the meantime I am getting well acquainted with nature. I exaggerate, sometimes I make changes in a motif; but

for all that, I do not invent the whole picture; on the contrary,
I find it already in nature, only it must be disentangled. (Letter
B 19)

The arrival of photographs of religious scenes painted by
Bernard, and word of Gauguin's paintings with traditional reli-
gious images, was another matter, as noted in an earlier chapter.
From Saint-Rémy in 1889, Vincent wrote Bernard a scathing
attack on his revival of "medieval tapestries," his "fat ecclesias-
tical frogs," the "mystification" and "counterfeit" in his *Annun-
ciation*, his "appalling" and "spurious . . . Christ Carrying His
Cross," and his *Garden of Gethsemane*.

> . . . that nightmare of a "Christ in the Garden of Olives,"
> good Lord, I mourn over it, and so with the present letter I ask
> you again, roaring my loudest, and calling you all kinds of
> names with the full power of my lungs—to be so kind as to
> become your own self again a little. (Letter B 21)

As to the entire "enchanted ground" of "abstraction," Vin-
cent relented a bit:

> I won't say that one might not venture on it after a virile
> lifetime of research, of a hand-to-hand struggle with nature,
> but I personally don't want to bother my head with such
> things. (Letter B 21)

Vincent's own love for reality, his interest in the actual olive
trees around him, led him not toward abstraction but to an atti-
tude of "wait and see" within nature:

> I have let myself be saturated with the air of the little moun-
> tains and the orchards; this much gained, I shall wait and see.
> My ambition is limited to a few clods of earth, sprouting wheat,
> an olive grove, a cypress. . . . (Letter B 21)

Bernard's interest in the Bible, according to Vincent, was
admirable, but personal experience in reality itself was primary
in painting:

> Oh! undoubtedly it is wise and proper to be moved by the
> Bible, but modern reality has got such a hold on us that, even
> when we attempt to reconstruct the ancient days in our

thoughts abstractly, the minor events of our lives tear us away
from our meditations, and our own adventures thrust us back
into our personal sensations — joy, boredom, suffering, anger,
or a smile. (Letter B 21)

Vincent illustrated his preference for reality over imagina-
tion through reference to three paintings, and these paintings
become prime examples of his sense of "reality that is at the same
time symbolic." The first is a painting by Millet he opposes to
Bernard's *Adoration of the Magi*:

> ... *if* I am capable of spiritual ecstasy, I adore the Truth,
> the possible, and therefore I bow down before that study—
> powerful enough to make a Millet tremble—of peasants carry-
> ing home to the farm a calf which has been born in the fields.
> Now this, my friend, all people have felt from France to
> America. . . . (Letter B 21)

The very act of Millet's discovering such a scene and disentan-
gling its essential *adoration* symbolism from the confusion of life,
the sense of a peasant woman and her children in awe at the
presence of the life of a newly born calf, the very accessibility of
the scene to all people, opened for Vincent a hidden depth of
symbolic potentiality.

Vincent also selected two of his own paintings as illustration
for Bernard. The first is a scene in the asylum garden where a
sawed-off pine is juxtaposed to a "last rose." The other is "the sun
rising over a field of young wheat." Of the first painting, Vincent
writes of the "enormous trunk, struck by lightning and sawed
off":

> This somber giant—like a defeated proud man—contrasts,
> when considered in the nature of a living creature, with the
> pale smile of a last rose on the fading bush in front of him. . . .
> You will realize that this combination of red-ocher, of
> green gloomed over by gray, the black streaks surrounding the
> contours, produces something of the sensation of anguish,
> called "noir-rouge," from which certain of my companions in
> misfortune frequently suffer. Moreover the motif of the great
> tree struck by lightning, the sickly green-pink smile of the last
> flower of autumn serve to confirm this impression. (Letter
> B 21)

Here resonances between the dynamics of nature and human feelings are expressed through color and form, as disentangled from an actual scene.

About the second painting of the the sun and wheatfield, he writes, "I have tried to express calmness, a great peace." Clarifying the significance of the symbolism of the two paintings, he says:

> I am telling you about these two canvases, especially about the first one, to remind you that one can try to give an impression of anguish without aiming straight at the historic garden of Gethsemane; that it is not necessary to portray the characters of the Sermon on the Mount in order to produce a consoling and gentle motif. (Letter B 21)

Whether Vincent's early critics understood the resonances that he found in reality itself is problematic.

The letters to Bernard, who had worked closely with Gauguin at Pont-Aven in Brittany, brought Vincent's concerns into conflict with synthetism, one aspect of the symbolist movement; with currents of neo-Platonic thought then prevalent; with "decadence;" with the "cult of the dandy;" with occult and mystical movements; with neo-Catholicism; and with a visionary approach to art that would issue in the Nabis and the Salon de la Rose+Croix.[19] The symbolists, claiming Gauguin and Bernard among their number, sought mystery, ambiguity, and an elusive symbolism in their work. Mallarmé, who presided over a symbolist banquet in Gauguin's honor in 1891, had earlier set a tone of suggestiveness and dream-vision in his poetry which excluded the "real world" on the grounds that it was likely to spoil the mystery of the world of art.[20] The Salon de la Rose+Cross declared that it would exclude from its exhibitions "all representations of contemporary life," in favor of "Legend, Myth, Allegory, the Dream, the Paraphrase of great poetry and finally all Lyricism. . . ."[21] The symbolist artist could affirm, "I paint ideas, not things."[22]

Vincent's own commitment to a "reality that is at the same time symbolic" stood over against the symbolist approach, though he himself was only indirectly in contact with its viewpoint, often through conversations with Bernard and Gauguin. Bernard, in fact, had interested the symbolist critic G.-Albert

Aurier in both Vincent's letters and paintings, and Aurier wrote the first and only lengthy review of Vincent's work published during the artist's lifetime. The review itself is revealing, Aurier having interpreted Vincent largely as a symbolist artist:

> Without doubt, like all painters of his race, he is very conscious of pigment, of its importance and beauty, but also, more often, he only considers this bewitching pigment as a kind of marvelous language destined to translate the Idea. He is almost always a symbolist. Not, I am aware, a symbolist in the manner of the Italian Primitives, those mystics who felt the need to dematerialize their dreams, but a symbolist who feels the constant necessity to clothe his ideas in precise, ponderable, tangible forms, in intensely corporeal and material envelopes. In almost all his canvases, beneath this morphic envelope, beneath this very fleshly flesh, beneath this very material matter, there lies, for the spirit that knows how to see it there, a thought, an Idea, and this Idea, the essential substratum of the work, is, at the same time, its efficient and final cause.[23]

While struggling to accommodate Vincent's love of the real world, Aurier, nevertheless, saw the "efficient and final cause" of the paintings in an "idea," and saw reality as something that simply served to clothe his ideas in "material envelopes." It is that first review by Aurier in *Le Mercure de France* of January 1890 that set a course of misinterpretation of Vincent's symbolism and this misinterpretation persists in the works of Graetz, Zurcher, and a majority of critics to this day. If it is the "idea" that is the only essential, then those material envelopes hardly support the love of reality and the consolation Vincent himself claimed were offered in his work. By missing this point, Aurier, and most critics who have followed, find a savagery and threat in Vincent's portrayal of reality. As Aurier described Vincent's paintings:

> . . .there is the universal and mad and blinding coruscation of things; it is matter, it is nature frantically twisted, in paroxysm, raised to the exteme of exacerbation; it is form becoming nightmare, color becoming flames, lavas and precious stones, light setting fire to itself, life a burning fever.[24]

Such a view of nature as "frantically twisted in paroxysm," and the threat to human life it implies, hardly matches Vincent's own

claim that he sought to "express hope by some star, the eagerness of a soul by a sunset radiance," that "young corn has something inexpressibly pure and tender about it, which awakens the same emotion as the expression of a sleeping baby," that "in a picture I want to say something comforting, as music is comforting." It is this chasm between Vincent's symbolic intention and critical interpretation of his work that signals the need for reexamination and suggests the inadequacy of the perspective from which Vincent's symbolism has been viewed.

The problem of understanding Vincent van Gogh's sense of the symbolic in art, exemplified in the work of critics as early as Aurier and as recent as Graetz and Zurcher, may well indicate that the philosophic and cultural context, the Western frames of reference, have not been adequate to accommodate the dimension of Vincent's broad spiritual quest which intuitively merged to some degree Western Christian and Eastern Buddhist perspectives. Though Tillich, Jung, and Neumann, quoted at the opening of this chapter, suggest creative directions, Tillich's essentially Western orientation and Jung and Neumann's focus on psychic depth almost to the exclusion of the reality of nature finally limit their usefulness. I therefore suggest that we glimpse the sort of context for interpreting van Gogh which a broadly global philosophy might provide, a philosophy that consciously focuses on spiritual quest, the bridging of East and West, and aesthetic experience in nature, elements important to van Gogh himself. The school of philosophy that I will cite is a radically experiential approach to reality based on Zen yet seeking a global viewpoint, the Kyoto School of philosophy developed in Japan from the time of Kitaro Nishida (1870–1945) to the present. I will focus on the words of one of its most recent scholars, a professor of philosophy and religion in Kyoto, Keiji Nishitani [25]

Nishitani, using Einstein's model of fields of force, views Western thought as placing its confidence in either a field of reason focused on the idea or a field of sensation focused on the object. Both sides of this subject-object dualism assume a man-centeredness, for even the object is simply how things present themselves to our field of consciousness. Nishitani notes that from the time of Kierkegaard and Nietzsche to Sartre and Heidegger, both this rationality and materialism have been undermined in the West by political events and modern science which have uncovered the disintegration of confidence in human ra-

tionality and of material things, leaving the threat of *nihility,* or relative emptiness. Nishitani, using the organic-totalistic and existential-aesthetic direction of Eastern thought , posits a field of absolute emptiness or, in Buddhist terminology, *sunyata.* This absolute emptiness moves beyond the relative emptiness of nihility that threatens the Western perspective, and opens a context without limitations, a field of sunyata that includes both nothingness and being, a field where the illusory or impermanent nature of all things is recognized, yet where the center of all things is everywhere and all things interpenetrate:

> That is to say, on the field of sunyata, *the center is everywhere.* Each thing in its own selfness shows the mode of being of the center of all things. Each and every thing becomes the center of all things and, in that sense, becomes an absolute center. This is the absolute uniqueness of things, their reality.[26]

Each thing in its uniqueness, or, in Buddhist terminology, in its *tathata,* ("suchness") interpenetrates all other things, and finds its center not in itself in isolation, but in absolute emptiness or sunyata where the center has no limits. Nishitani writes, regarding each thing in sunyata:

> Figuratively speaking, its roots reach across to the ground of all other things and helps to hold them up and keep them standing. It serves as the constitutive element of their being so that they can be what they are, and thus provides an ingredient of their being. . . . [W]hen a thing is on its own homeground, everything else is there too; that the roots of every other thing spread across into its home-ground.[27]

This realization of the interpenetration of all things in their impermanence yet their shared center in emptiness gives to all things a role in salvation or deliverance:

> Goethe says that things that will pass are metaphors of the Eternal. . . . yet so long as there is nothing like an eternal thing to serve as its archetype, the metaphor as such is the primal reality or fact. It is metaphor even as primal fact, and primal fact even as metaphor. A Zen master extends his staff and says: "If you call this a staff you cling to it; if you do not call it a staff you depart from the facts. So what should you call it

then?" . . . The fact that the staff is this staff is a fact in such a way as to involve at the same time a deliverance of the self. In this the fact appears as a primal factuality. The point at which this fact can be comprehended in a primal manner is the point of deliverance where one becomes a Son of God, a Son of Buddha.[28]

Here we arrive at the Zen practice focused upon the *koan*, a teaching device unique to certain forms of Zen Buddhism. Originating in China, *koan,* or *kung-an*, "public cases," were generally question-answer exchanges between Zen masters and their students, terse conversations that were intended to result in a student's becoming enlightened. Because these conversations involving creative masters of the past had been effective in bringing enlightenment, later Zen teachers in China and Japan treasured them and passed them on to new generations of students as focal points for meditation. Often the question embedded in the koan was given to a beginning monk who was expected to solve the apparent riddle with his own personal answer. Those whose responses were acceptable to the master were judged to be enlightened. Koan questions often seem absurd: "What is the sound of one hand clapping?" "How can you greet a man without either words or silence?" "How do you step forward from the top of a hundred foot pole?" The answers to koan involved spontaneous, often surprising responses, including shouts, kicks, slaps, silence, or references to very ordinary things. The question, "Who is the Buddha?" received such responses as "This oak tree," "Three pounds of flax," "No Buddha" or a sudden shout. Although there is no agreement on the meaning of such answers, certainly there is a sense that effective answers avoided academic or studied responses. Further, it appears that anything, no matter how ordinary, might serve as the answer to our questions, if experienced intensely at this very moment in an enlightened manner. "Is this a staff or is it not a staff?" Because when viewed from the perspective of absolute emptiness all things interpenetrate, their center is everywhere, anything can be displayed as primal truth, the simplest object, gesture, act of the moment opens the way to salvation.[29]

Is this the intuitive understanding that Vincent experienced through his solitude in nature, his contemplation of Japanese art, and his study of "a single blade of grass?" Are his images best seen

as was the Zen master's staff, a real staff that so interpenetrates all things that it is, as primal fact, a way of salvation? Does the power of Vincent's images reside in their suchness or koan-nature, in their existence as primal fact that is also metaphor for the Eternal?

I believe that Vincent did fathom the suchness of things, that his art in some intuitive sense embodied the primal saving fact to which the koan witnesses. But the question remains, how does one experience things in their suchness; how could Vincent paint reality that might "involve at the same time a deliverance of the self"? Nishitani provides a description of such a mode of existence that draws on the same passage from the haiku poet Basho cited in the chapter "The Oriental Connection." Nishitani writes:

> We have here a completely different concept of existence, one that has not up to now become a question for people in their daily lives, one that even philosophers have yet to give consideration. The haiku poet Basho seems to hint at it when he writes:
>
>> From the pine tree
>> learn of the pine tree
>> and from the bamboo
>> of the bamboo.
>
> He does not simply mean that we should "observe the pine tree carefully." Still less does he mean for us to "study the pine tree scientifically." He means for us to enter into the mode of being where the pine tree is the pine tree itself, and the bamboo is the bamboo itself, and from there to look at the pine tree and the bamboo. He calls on us to betake ourselves to the dimension where things become manifest in their suchness, to attune ourselves to the selfness of the pine tree and the selfness of the bamboo.[30]

A change of consciousness is required, an enlightenment through sharing the center of the simplest of things in their impermanence on the field of emptiness. The Buddhist term for such a consciousness is *samadhi*:

> From ancient times the word *samadhi* ("settling") has been used to designate the state of mind in which a man gathers his own mind together and focuses it on a central point, thereby taking a step beyond the sphere of ordinary consciousness and

self-conscious mind and, in that sense, forgetting his ego. . . .
The form of things as they are on their own home-ground is
similar to the appearance of things in samadhi.[31]

Any number of selections from Vincent's own letters quoted
earlier in chapter five, "The Oriental Connection," seem to de-
scribe that very state, a concentration on some facet of nature
until the ego disappears and the tree, flower, and landscape speak
for themselves through the center they share with the artist.
Vincent connected his understanding of such an attitude to his
study of Japanese art, and he related the discovery to religion
rather than to artistic technique:

> Come now, isn't it almost a true religion which these
> simple Japanese teach us, who live in nature as though they
> themselves were flowers? (Letter 542)

Absorbed in his work, recognizing "all ambition and keenness to
make a good thing of it, false" (letter 615), working "without
knowing one works" (letter 504), Vincent affirmed:

> I have a terrible lucidity at moments, these days when nature
> is so beautiful, I am not conscious of myself any more, and the
> picture comes to me as in a dream. (Letter 543)

Vincent had entered that mode of being where he was saturated
by nature, where he was simply to "wait and see," where "ambi-
tion is limited to a few clods of earth, sprouting wheat, an olive
grove, a cypress" . . . (letter B 21).

In the chapter entitled "The Oriental Connection" we iden-
tified "the profound center of the Zen inspired Oriental philoso-
phy of nature" as impermanence, seasonality, or transformation.
According to Abe Masao, associated with the Kyoto School:

> Buddhist salvation is . . . the existential realization of the
> transiency common to all things in the universe. . . . "Awaken-
> ing" in Buddhism is never for a single instant ever in the slight-
> est something other than, or separated from, the realization of
> universal transitoriness.[32]

We noted that Vincent's collection of Japanese "floating-world"
prints demonstrated this focus on transitoriness. Vincent's own

experience in Provence, his "equivalent of Japan," intensified his
sense of impermanence as seasonality in nature:

> Will my work really be worse because, by staying in the same
> place, I shall see the seasons pass and repass over the same
> subjects, seeing again the same orchards in the spring, the
> same fields of wheat in summer? . . . It will mean work of a
> deeper calm at the end of a certain time. (Letter 535)

Nishitani makes explicit the essential role an appreciation of
time and impermanence play in understanding the "field of
emptiness" where all things interpenetrate through a shared
center, where all apparent contradictions find their unity.[33] He
rejects Toynbee's view that "the Buddhist concept of time is
merely cyclical," and gives his own more complex description:

> . . . in Buddhism, time is circular, because all its time systems
> are simultaneous; and, as a continuum of individual "nows"
> wherein the systems are simultaneous, it is rectilinear as well.
> Time is at once circular and rectilinear.[34]

This broader concept of time focuses on impermanence, but
displays impermanence in unity with the Eternal, opening time
at both ends and at its foundation:

> The idea of a stratified formation of simultaneous time
> systems necessitates the idea of an infinite openness at the
> bottom of time, like a great expanse of vast, skylike emptiness
> that cannot be confined to any systematic enclosure. Having
> such an openness at its bottom, each and every now, even as
> it belongs to each of the various layers accumulated through
> the total time system, is itself something new and admits of no
> repetition in any sense. The sequence of "nows" is really irre-
> versible. Accordingly, in the true sense, each now passes away
> and comes into being at each fleeting instant. It is, in other
> words, something *impermanent* in the fullest sense of the word.
> As such a succession of nows with an infinite openness be-
> neath it, time must be conceived of without beginning or end.
> Conversely, only when so conceived is it possible for every
> now to come about as a new now and as impermanent. More-
> over, in time this newness and impermanency are tied to one
> another inseparably.[35]

The impermanent aspect of time contains an ambiguity, for on the one hand "it indicates the volatility of time," time as "continually vanishing into thin air," existence as "fragile," "swift'" "a flash of lightning."[36] On the other hand, impermanence is "non-permanence," and determined modes of being do not become a hindrance:

> Here time and nothingness as the nullification of all things signify the freedom and effortless flight of a bird gliding across the sky. . . . [37]

Finally, in Nishitani's view of time, the "infinite openness" at the foundation of time reveals a further ambiguity:

> In a word, it can mean both nihility and sunyata in its original sense. According to the meaning it takes on, time and all matters related to time will assume meanings fundamentally opposed to one another. The true Form of time consists in the simultaneous possibility of these opposing meanings. The essential ambiguity in the meaning of time means that time is essentially the field of fundamental conversion, the field of a "change of heart" or *metanoia*. . . . [38]

Here Nishitani and the Kyoto School return us to the focus of our subject, Vincent's spiritual quest as a key to an understanding of his life and work. If Vincent's intuitive grasp of time approached the global view of Nishitani, and opened time at both ends and at its foundation, then fragility, the swift passing away of things, became for him a unity with the Eternal. Further, the opposite meanings of burden and freedom, chaos of meaninglessness and ecstasy of creation, lie deceptively close to one another in his work, and it was only spiritual transformation or "change of heart" that converted burden to freedom and chaos to creation. It is my view that Western critics, leaving Vincent's spiritual quest unexamined and using a purely Western frame of reference based upon dualities, have missed the openness of time and the unity of fragile transitoriness and the Eternal in Vincent's work. Critics have most often detected only burden and chaos where Vincent's transformative view also discovered freedom and creation.

That Vincent came to focus on impermanence as seasonality

was demonstrated in our view of his work in Arles and Saint-Rémy. That Vincent also found fragility and transitoriness as a unity with the Eternal, and opened time at both ends and at its foundation, is demonstrated in the chapter entitled "The Vulnerability of God." Experiencing God "idiomorphically" in his own failures as artist, Vincent came to view the "flaws" and "flimsiness" of creation as evidence that God is a daring Artist who always attempts more than He can do, thus promising greater works as the total "oeuvre" unfolds. So Vincent wrote of this world:

> ... the study is ruined in so many ways. It is only a master who can make such a blunder, and perhaps that is the best consolation we can have out of it, since in that case we have a right to hope that we'll see the same creative hand get even with itself. (Letter 490)

In the mystery of our flimsiness itself Vincent located the hope of the Eternal:

> If we are *as flimsy as that*, so much the better for us, for then there is nothing to be said against the unlimited possibility of future existence. (Letter 518)

It was transitoriness as evidence of the Eternal which Vincent sought to express in his work. As he wrote in his last letter to sister Wil regarding his most recent works, including the portrait he had done of Dr. Gachet, the portrait he had compared to Gauguin's painting of Christ:

> I am working a good deal and quickly these days; by doing this I seek to find an expression for the desperately swift passing away of things in modern life. . . .
> I painted a portrait of Dr. Gachet with an expression of melancholy, which would seem like a grimace to many who saw the canvas. And yet it is necessary to paint like this, for otherwise one could not get an idea of the extent to which, in comparison with the calmness of the old portraits, there is expression in our modern heads, and passion—like a waiting for things as well as a growth. (Letter W 23)

Further, Vincent's view of God as Divine Artist who did not

create a masterpiece all at one time, but rather who creates, re-creates, and is continually creating, opens time at both its beginning and its end. Vincent focused neither on creation "in the beginning" nor upon an apocalyptic conclusion, but rather upon continual transformation. Vincent could, with some humor, picture painter-butterflies traveling to other planets to continue their work (letter B 8), and could picture an individual artist as "only a link in a chain" stretching beyond view into the past and the future (letter 590). That open-ended time is also open at its foundation accords with his image of the artist as driven to the "open sea," the ground having given way under his feet, ". . . forced to improvise or rather *create*, his task every day anew" (letter R 5).

In concluding our inquiry regarding the inner dynamic of Vincent van Gogh's symbolism, let us turn to the painting often viewed as his final masterpiece, *Wheatfield with Crows*. This painting of a field of ripe, golden wheat, bent by the wind under a stormy sky, with a flock of black crows in flight, was painted in July 1890, the month Vincent shot himself, perhaps in that very field. The artist or viewer of the painting stands at the convergence of three dirt paths, one moving off right, one off left, and one directly ahead, disappearing into the grain just before reaching the horizon. The fifty or more crows may be decending from the dark sky at the upper right into the field, or are perhaps just taking flight.

This painting is generally viewed as one of several Vincent described in one of his last letters to Theo. Vincent had just returned from a visit to Theo's troubled Paris household, where he found his godchild ill, the mother exhausted, and Theo faced with the possible loss of his job:

> . . . once back here I set to work again—though the brush almost slipped from my fingers, but knowing exactly what I wanted, I have painted three more big canvases since.
>
> They are vast fields of wheat under troubled skies, and I did not need to go out of my way to express sadness and extreme loneliness. I hope you will see them soon—for I hope to bring them to you in Paris as soon as possible, since I almost think that these canvases will tell you what I cannot say in words, the health and restorative forces that I see in the country. (Letter 649)

Ronald Pickvance, in *Van Gogh in Saint-Rémy and Auvers,* notes ". . . the obsessive concern with dating, decoding, and symbolism of that picture. . . ":

> It has been interpreted as Christian iconography from Crucifixion to Last Judgment; as an image of cosmic chaos projected through van Gogh's inner torment; as a psychic graph of his imminent suicide.[39]

Jan Hulsker, in *The Complete Van Gogh,* finds it impossible to believe that Vincent's letter to Theo describing paintings of "vast fields of wheat under troubled skies" was intended to include *Wheatfield with Crows:*

> It is inconceivable that Vincent would have wanted to take the painting with the crows along with him in order to show what he saw in the countryside that was "wholesome and invigorating."[40]

Hulsker joins the majority of critics in viewing *Wheatfield with Crows* as a "doom-filled painting with threatening skies and the ill-omened crows. . . ."[41] Both Graetz and Zurcher, whose views of Vincent's symbolism we noted earlier, emphasize death and disintegrative forces in the painting. Graetz sees the "stormy swarm of the huge crows" as "sinister and foreboding," the central path "a dead end," symbolic of "Vincent's own road," the overripe wheat as "a huge wild fire" and the crows as an "image of death."[42] Zurcher describes the painting as Vincent's last "cry of revolt" with its "foreboding" crows: ". . . he was disintegrating in the heart of a maelstrom. The path led nowhere."[43]

Meyer Shapiro's *Van Gogh* brings to sharp focus the general direction of Western interpretation of *Wheatfields with Crows.* "Disturbing violence," "pathetic disarray," "flickering void," "chaos" are among the terms he chose for his interpretation. For Shapiro:

> . . . space had suddenly lost its focus and all things turned aggressively upon the beholder. The blue sky and yellow fields pull away from each other with disturbing violence; across their boundary, a flock of black crows advances toward the unsteady foreground.[44]

But Shapiro also sees a movement up into the sky:

> He is caught up across the yellow fields from the chaos of the paths and the dread of the approaching birds and carried to the deep blue sky, the region of most nuanced sensibility, a pure, all-absorbing essence in which at last subject and object, part and whole, past and present, near and far, can no longer be distinguished.[45]

Albert Lubin, in *Stranger on the Earth*, focuses on "gloomy warning and impending doom," seeing the painting's despair as the "despair of Christ," the three paths forming Vincent's own cross. He suggests that the painting depicts the moment:

> . . . in which "there was darkness over the land." and Christ cried out, "My God, My God, why hast Thou forsaken me?"[46]

For Lubin, "the painting remains a gloomy warning of impending doom," yet as a crucifixion, there is the wish-fulfillment that the martyred Vincent enter heaven:

> At last Vincent has made up for his mother's neglect. In dying as God's favorite child, he has finally outdone the first Vincent.[47]

It should also be noted that Graetz, in *The Symbolic Language of Vincent Van Gogh,* detected in the painting a sense of resurrection in a cloud near the horizon:

> . . . his soul rises to the sky, symbolized by the light cloud just above the road which has come to its end.[48]

But have the critics interpreted *Wheatfield with Crows* accurately? Vincent's spiritual pilgrimage with its broadening way, its love of many things, its Christ and Buddha, its loss of self in nature through a "more Japanese eye," suggests quite another symbolic dynamic in the painting. We might apply the words of Nishitani:

> We have here a completely different concept of existence, one that has not up to now become a question for people in

their daily lives, one that even philosophers have yet to give consideration.[49]

Seen in proper context, I believe Vincent's painting "calls on us to betake ourselves to the dimension where things are manifest in their suchness," where storms and wheat and crows "comprehended in a primal manner" are facts ". . . in such a way as to involve at the same time a deliverance of the self."[50] On their "home-ground," I believe the storm, crows, and wheat are not "aggressively turned upon the beholder," nor are they a focus for "disturbing violence," the "sinister," the "foreboding," the "disintegrative," or "an image of cosmic chaos." One might, of course, argue that if the critics regularly experience violence and chaos as the symbolic import of this work, if they find it "inconceivable" that Vincent would have thought of this painting as "wholesome and invigorating," then violence and chaos have in fact become its effective meaning. I would simply respond that our view of art itself is at stake here. Is art limited to presenting symbols to viewers in order to trigger ready-made responses formed by the viewer's culture? Vincent's belief was that art ought to avoid the traditional tasks and meanings perpetuated by the academy, ought to venture on the "open sea," find each day's task anew, and "teach" something. He claimed that on this open sea:

> . . . the secret of the depth, the intimate, serious charm of the Ocean of an artist's life—with Something on High over it—will take hold of you. (Letter 339)

Vincent believed his art could carry a message from another mode of being, that it could embody:

> . . . something of what wood or beach or figure has told me in it, and it is not the tame or conventional language derived from a studied manner or a system rather than from nature itself. (Letter 228)

If we allow the possibility of viewing art from Vincent's perspective, the presentation of a new way of seeing and experiencing, the *Wheatfield with Crows* might well challenge conventional interpretations, might well present its case that "sadness and extreme loneliness" need not be separable from "health and re-

storative forces," that what many view as "chaos," is, when experienced deeply, a way of comfort and salvation.

What is it that led Aurier to see in Vincent's work "the mad and blinding coruscation of things. . . nature frantically twisted, in paroxysm," and Shapiro to find "violence," "void," and "chaos" in a simple wheatfield and crows under a stormy sky? Could it be that the Western limitations of "human-centeredness" cannot abide nature presented on its own "home-ground," wheat, trees, rocks, birds allowed to express life that is not filtered through the human ego and its needs? Could it be that self-centered humanity finds aggression and threat in all forms of life that have not been translated into the "tame and conventional language derived from a studied manner?" If Vincent succeeded in sharing the one center on the "field of emptiness" with wheat, crows, and sky, couldn't it be that his radical message of shared impermanence might seem to the human-centered viewer to be a threat, nature and time turning aggressively against the viewer's self-centered projects? If human-centeredness refuses to view impermanence as inseparable from being itself, then a vision of "death," "chaos," or nihility might well result. But if our interpenetration with all things in shared impermanence is celebrated as Eternal, then "burden" might well become "freedom" and "newness and impermanency" reveal their inseparability. In the "ambiguity of time," on the "field of fundamental conversion," our viewpoint is capable of transformation. Perhaps it is this quality of ambiguity and its call for a "change of heart" that has so intrigued, yet disturbed, viewers of van Gogh's art. The viewer is undergoing a call to conversion, a judgment, in the presence of the painting.

Let us consider Vincent's own feelings regarding the elements in his painting of *Wheatfield with Crows*. Throughout his letters, "storms in nature" are "preferred," are likened to the deepening suffering of humans who choose to be servants to the world's needs. Vincent preferred storms for their restorative power, their beauty, and their revelation of the Divine. For Vincent, it was "thunderstorms" that symbolized "the better times of pure air and the rejuvenation of all society. . . " (letter 451). Inhabitants of the Belgian village where Vincent served as evangelist remembered a "thunderstorm episode" which they cited to characterize the strange preacher from Holland. According to one eye-witness account:

On a very hot day a violent thunderstorm burst over our region. What did our friend do? He went out to stand in the open field to look at the great marvels of God, and so he came back wet to the skin.[51]

And in what sense are Vincent's crows "sinister," "foreboding," "images of death?" According to his sister Elizabeth, Vincent was enchanted by birds and birds' nests from his youth. Later, as artist, he painted both birds and nests. Perhaps the most revealing of his letters on the subject is the final letter he wrote to the Dutch artist Rappard, a letter intended in part to reconcile the two after Rappard's refusal to take Vincent's work *The Potato Eaters* as worthy of serious consideration. Vincent began the letter by referring to a gift he had just sent Rappard:

I sent a basket containing birds' nests to your address today. I have some in my own studio too. (Letter R 58)

After discussing a number of things, the letter concludes:

I thought that you might like the birds' nests as much as I do myself, for really and truly birds—such as the wren and the golden oriole—rank among the artists too. (Letter R 58)

Nevertheless, might it be that a bird lover, even one who ranked birds among the artists, could still exclude the "crow" from all but sinister roles? This is hardly likely in Vincent's case. He knew that Japanese artists painted lovingly the commonest of birds. His own collection of Japanese prints contained numerous flights of birds, and a folding album in his possession featured eight *Kacho-ga,* prints focusing on flowers and birds, including Hiroshige studies of the common shrike.[52] The crow was a favorite subject for both Zen painting and haiku, and Vincent must certainly have seen many powerful images of crows in the thousands of prints in Bing's attic and among the more expensive scrolls displayed in Bing's gallery. From the Zen point of view, anyone can find beauty in the graceful heron or stork, but only the enlightened saw the ordinarily "coarse" and "ugly" crow as possessing a beauty of its own, the beauty of disinherited creatures. This matches precisely Vincent's own approach to life and art.

We have, in fact, demonstration that the crow was viewed as

among the wisest of birds, a symbol of enlightened life in nature, by one of Vincent's favorite authors in one of Vincent's favorite books, Jules Michelet's *The Bird*. Michelet's description of the crow echoes a number of themes we find in Vincent's own view of nature:

> They interest themselves in everything, and observe every-thing. The ancients, who lived far more completely than ourselves in and with nature, found it no small profit to follow, in a hundred obscure things where human experience as yet affords no light, the directions of so prudent and sage a bird.[53]

But it is neither the stormy sky nor the crows that is the focus of *Wheatfield with Crows*, it is the wheat itself. Two-thirds of the canvas is ripe wheat disappearing beyond the edges of the painting to right and left, and stretched across the entire horizon. The viewer looks directly into the stand of windswept wheat, as it might rise before one on one of the many hillsides of Auvers. It is as if the painting demonstrates the words Vincent wrote Theo from the Saint-Rémy asylum:

> Only I have no news to tell you, for the days are all the same, I have no ideas, except to think that a field of wheat or a cypress is well worth the trouble of looking at close up. . . . (Letter 596)

In Vincent's painting, one is called upon to take "the trouble of looking" at wheat, an empty path calling one to enter the sea of twisted, golden stalks. Staccato brush strokes in brown and gold form a pattern of ripe wheat ears bending toward the earth, calling for the viewers attention. Again, it is as if Vincent gives form to the sentiments he addressed to those close to him, in this case, his sister Wil:

> Did you ever read *King Lear*? But never mind, I think I am not going to urge you too much to read books or dramas, seeing that I myself, after reading them for some time, feel obliged to go out and look at a blade of grass, the branch of a fir tree, an ear of wheat, in order to calm down. (W 13)

In spite of the violence, disintegrative forces, and cosmic chaos critics have found in *Wheatfield with Crows*, Vincent

counted among his greatest discoveries the simple fact that a
"field of wheat is well worth looking at close up," and he expected
that one could find there a calming influence. Hulsker, as we
noted, believes it "inconceivable" that Vincent could have in-
tended to depict anything "wholesome and invigorating" in
Wheatfield with Crows, but consider this affirmation of Vincent to
the recently married Theo:

> Well, do you know what I hope for, once I let myself begin
> to hope? It is that a family will be for you what nature, the clods
> of earth, the grass, the yellow wheat, the peasant, are for me,
> that is to say, that you may find in your love for people
> something *not only to work for,* but to comfort and restore you
> when there is need for it. (Letter 604)

Though it may seem inconceivable to critics, Vincent's own
words make clear that he discovered peace, comfort, and resto-
ration in a wheatfield, perhaps especially under his favorite
aspect of nature, the storm, with the most ordinary of presences
likely to be found where there is ripe grain, a flock of crows.

The question remains, what is it about a wheatfield that
made it a preeminent gateway to symbolism, to the deepest levels
of meaning and restoration for the artist? Vincent's description
of his painting *The Reaper* points the direction to an answer, and
so opens the way to our understanding of the inner dynamic of
the symbolism that came to feed his mature art:

> For I see in this reaper—a vague figure fighting like a devil in
> the midst of the heat to get to the end of his task—I see in him
> the image of death, in the sense that humanity might be the
> wheat he is reaping. So it is—if you like—the opposite of that
> sower I tried to do before. But there is nothing sad in this death,
> it goes its way in broad daylight with a sun flooding everything
> with a light of pure gold. (Letter 604)

It is in the presence of "death," in the shared center of the
impermanence of all things, that wheat and humanity inter-
penetrate. Just as Vincent was fascinated by the potato eaters
who planted, dug, and ate potatoes on the same earth where they
were born and where they would one day be planted, so he was
moved by the resonance between humans and wheat, in their
seedtime and harvest, their deep patterns of cooperative sympa-

thy in the field, the gathered sheaves, the loaf of bread. When searching for an example of truly symbolic, sacred art, Vincent had rejected Bernard's *Adoration of the Magi* in favor of Millet's painting of peasants carrying a new-born calf to their home, where mother and children stood waiting to care for it. Vincent, in *Wheatfield with Crows*, provided a similar image of deep religious import, the impermanence of wheat and humanity which is both our shared fragility and our shared Eternity. The transitoriness of things is intensified in Vincent's work through the quickly passing summer storm, the crows disappearing into the sky, and the wheat so soon to be stacked in sheaves and ground for bread or stored for a new seedtime and harvest. The painting itself enters the mode of being of all things in their impermanence yet transformation, becoming a koan that poses the Zen Master's question: "If you call this wheat, you cling to it; if you do not call it wheat you depart from the facts. So what do you call it then?" The wheat of Vincent's painting is wheat "in such a way as to involve at the same time a deliverance of the self." The impermanence of humanity and wheat is freedom, creativity, the Eternal. But in the ambiguity of time, those who have not been transformed by the experience may well find only violence, foreboding, and chaos. If this sounds too philosophic for a painter who worked like a peasant from dawn to dusk in the fields, consider again his mature musings:

> I feel so strongly that it is the same with people as it is with wheat, if you are not sown in the earth to germinate there, what does it matter? —in the end you are ground between the millstones to become bread.
>
> The difference between happiness and unhappiness! Both are necessary and useful, as well as death or disappearance. . . (Letter 607)

For Vincent, a great unifying takes place at that point where shared impermanence and the Eternal are one, and anguish and joy, life and death find their meaning together. It is interesting that the critics who cannot imagine peace and restoration in a scene with so much energy of color and stroke seek to find an escape from the impermanence of the wheat into some kind of resurrection or vague merging of things in the sky. For Vincent, motion and stillness, the impermanent and the Eternal, unify

wheat and sky, and either of them is both reality and symbol of our gateway to salvation, the deep roots from which meaning wells up, the sun and stars from which the "ray from on high" visits us.

One further facet of *Wheatfield with Crows* moves beyond Millet. In Vincent's painting, his own isolation is signaled in the empty paths, the beckoning path directly ahead swallowed up in the wheat itself. Circumstance and his mission as suffering servant had deprived Vincent of wife and children, and left him on an Auvers hillside without human companionship. Anguish and loneliness are not absent from the totality of the scene. In such isolation, Vincent might well have been tempted to make of his art an exclusive, mystical way of holiness, a personal ritual with himself as high-priest of the sacred art. Vincent refused. He rejected authoritative, self-righteous pharisaism in religion, and he did the same in art. His paintings, as every good koan, were intended to embody their own self-destruction in the very rapidity and coarseness of their making. They were fingers pointing at the moon of enlightenment, not the moon itself. Vincent pointed away from his art to the awe he experienced in the presence of the simplest laborers, the earth they worked, and the cradle where their fragile new hopes rested. He wrote of one day seeing "the dweller in nature":

> But when Chavannes or someone else shows us that human being, we shall be reminded of those words, ancient but with a blissfully new significance, Blessed are the poor in spirit, blessed are the pure in heart, words that have such a wide purport that we, educated in the old, confused and battered cities of the North, are compelled to stop a great distance from the threshold of those dwellings. (Letter 614a)

Vincent saw himself as simply one small "link in a chain" that would work for a better art and a better humanity. Once his own paintings had worked their transformation on the artist and on the viewer, they too were to be harvested to provide the bread and the seed for new generations. His own suicide would begin the harvest that would make a healthier life possible for an ill child in a Paris cradle. Holiness did not exist in paintings and painters any more than it had existed in religious institutions and evangelists. So he wrote sister Wil:

Why is religion or justice or art so very holy?

It may well be that people who do nothing but fall in love are more serious and holier than those who sacrifice their love and their hearts to an idea. However this may be, in order to write a book, perform an action, paint a picture in which there is life, one ought to be a live human being oneself. (Letter W 1)

Illustrations

Marsh with Water Lilies F845 Pencil, Pen, Reed
One of the earliest existing works 9 1/2" x 12 1/4"
of Vincent van Gogh
Etten, Holland; spring 1881

Collection of Mr. and Mrs. Paul Mellon
Virginia Museum of the Fine Arts

✳

Every day that it does not rain, I go out in the fields,
generally to the heath. I make my studies on a rather large
scale, like the few you saw at the time of your visit; so I have
done, among other things, a cottage on the heath, and also
that barn with a thatched roof on the road to Roozendaal,
which locally they call the Protestant barn.

Letter to Theo, #145

✳

You must know that Rappard has been here for about
twelve days, and now he has gone. Of course he sends you his
best regards. We have taken many long walks together—have
been, for instance, several time to the heath, near Seppe, to
the so-called Passievaart, a big swamp. . . . While he was
painting, I made a drawing in pen and ink of another spot in
the swamp, where all the water lilies grow (near the road to
Roozendaal).

Letter to Theo, #146

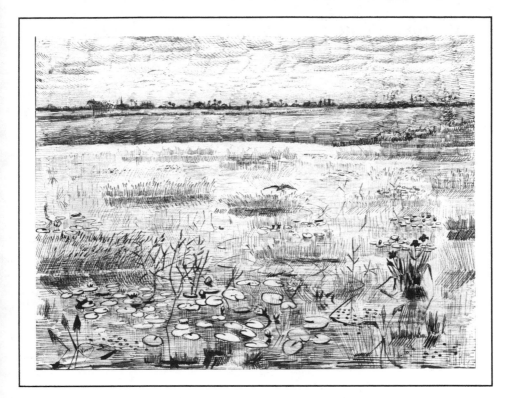

At Eternity's Gate F1662, Lithograph
The Hague, autumn 1882 22" x 14 5/8"

Vincent van Gogh Foundation
National Museum Vincent van Gogh, Amsterdam

<center>✳</center>

Now one need not agree exactly with the form of that religious sentiment, but if it is sincere, it is a feeling one must respect. And personally, I can fully share it and even need it, at least to a certain extent, just the way I have a feeling for such a little old man and a belief in "something on high," even though I am not exactly sure *how* or *what* it may be.

<div align="right">Letter to Theo, #253</div>

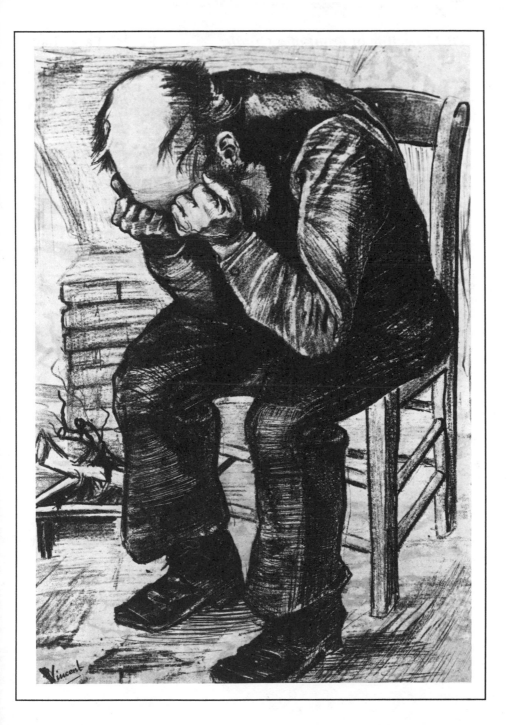

Girl Kneeling in Front of a Cradle　　　　F1024, Black chalk
The Hague, autumn 1883　　　　　　　　　　　　and pencil
　　　　　　　　　　　　　　　　　　　　　　18 7/8" x 12 5/8"

Vincent van Gogh Foundation
National Museum Vincent van Gogh, Amsterdam

❋

　　But if one feels the need of something grand, something
infinite, something that makes one feel aware of God, one
need not go far to find it. I think I see something deeper, more
infinite, more eternal than the ocean in the expression of the
eyes of a little baby when it wakes in the morning, and coos
or laughs because it sees the sun shining on its cradle. If there
is a 'ray from on high,' perhaps one can find it there.

Letter to Theo, #242

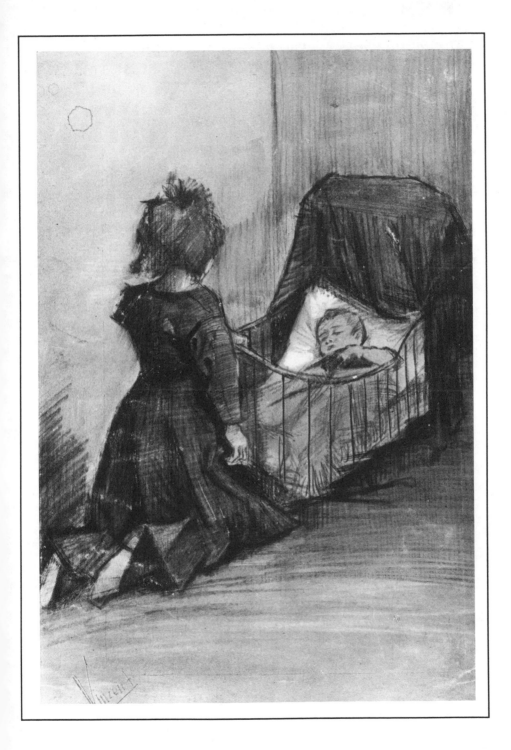

The Potato Eaters (or *Five Persons at a Meal*)
Nuenen, April 1885 F1661, Lithograph
 10 1/2" x 12"
Vincent van Gogh Foundation
National Museum Vincent van Gogh, Amsterdam

❊

If a peasant picture smells of bacon, smoke, potato steam—
all right, that's not unhealthy; if a stable smells of dung—all
right, that belongs to a stable; if the field has an odor of ripe
corn or potatoes or of guano or manure—that's healthy, es-
pecially for city people.

Such pictures may teach them something. But to be per-
fumed is not what a peasant picture needs.

Letter to Wilhelmina van Gogh, #W 1

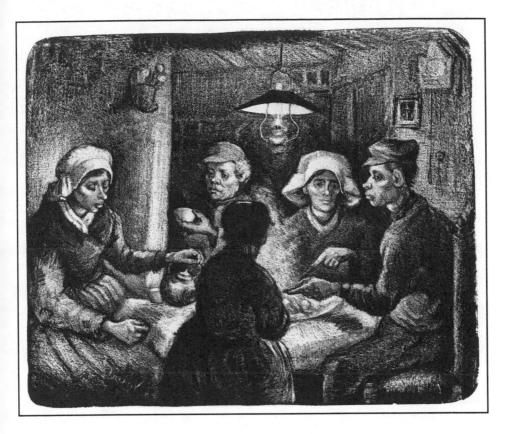

Still Life with Open Bible and Zola Novel
Neunen, autumn 1885 F117, oil on canvas
 25 5/8" x 30 3/4"
Vincent van Gogh Foundation
National Museum Vincent van Gogh, Amsterdam

✳

 I myself am always glad that I have read the Bible more
thoroughly than many people nowadays, because it eases my
mind somewhat to know that there were once such lofty
ideas. But because of the very fact that I think the old things
so beautiful, I must think the new things beautiful with all the
more reason.

Letter to Wilhelmina van Gogh, #W 1

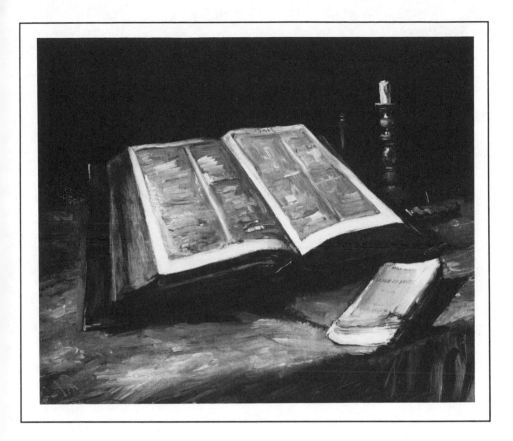

Self-Portrait
Paris, winter 1886

F1379, pencil
7 1/2" x 8 1/4"

Vincent van Gogh Foundation
National Museum Vincent van Gogh, Amsterdam

✳

"My dear friend, if you had spent rainy nights in the streets of London or cold nights in the Borinage—hungry, homeless, feverish—you would also have such ugly lines in your face and perhaps a grating voice too."

Letter to Theo #191

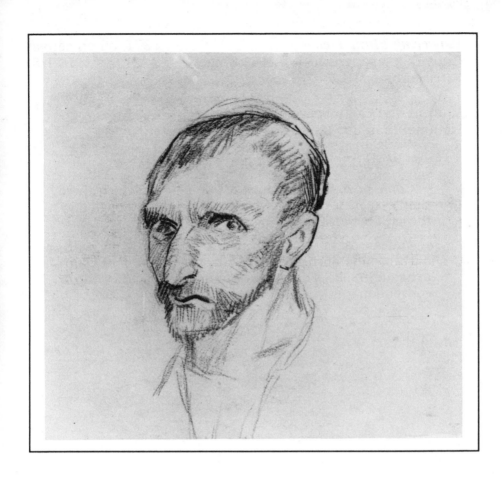

Flowering Plum Tree
Copy of a Japanese Print by Hiroshige
Paris, summer 1887

F371, oil on canvas
21 5/8" x 18 1/8"

Vincent van Gogh Foundation
National Museum Vincent van Gogh, Amsterdam

❊

Come now, isn't it almost a true religion which these simple Japanese teach us, who live in nature as though they themselves were flowers?

And you cannot study Japanese art, it seems to me, without becoming much brighter and happier and we must return to nature in spite of our education and our work in a world of convention.

Letter to Theo, #542

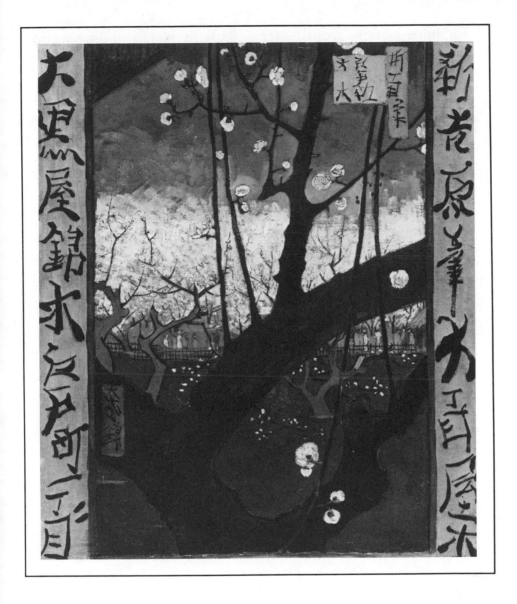

Facsimile of page from Letter 558a with sketch of Sower and
 Setting Sun
Arles, autumn 1888

Vincent van Gogh Foundation
National Museum Vincent van Gogh, Amsterdam

<p style="text-align:center">✳</p>

 This is a sketch of the latest canvas I am working on,
another Sower. An immense citron-yellow disk for the sun. A
green-yellow sky with pink clouds. The field violet, the sower
and the tree Prussian blue. Size 30 canvas. Let's quietly post-
pone exhibiting until I have some thirty size 30 canvases.
Then we are gong to exhibit them only once in your apart-
ment for our friends, and even then without exercising any
pressure. And don't let's do anything else.

<p style="text-align:right">Letter to Theo, #558a</p>

Est ce qu'ils ont lu le livre de Silvestre sur Eug Delacroix ainsi que l'article sur la *couleur* dans la grammaire des arts du dessin de Ch. Blanc.
Demandes leur donc cela de ma part et savoir s'ils n'ont pas lu cela qu'ils le lisent. Je pense moi à Rembrandt plus qu'il ne peut paraître dans mes études.

Voici croquis de ma dernière toile en train encore en demeure. Immense disque citron comme soleil. Ciel vert jaune à nuages roses. le terrain violet le semeur et l'arbre bleu de prusse. toile de 30

La Berceuse (Woman Rocking Cradle) F507, oil on canvas
Arles, spring 1889 35 7/8" x 28 3/8"

Collection Stedelijk Museum, Amsterdam

<div align="center">✳</div>

. . . I have just said to Gauguin that following those inti-
mate talks of ours the idea came to me to paint a picture in
such a way that sailors, who are at once children and martyrs,
seeing it in the cabin of their Icelandic fishing boat, would
feel the old sense of being rocked come over them and re-
member their own lullabys.

<div align="right">Letter to Theo, #574</div>

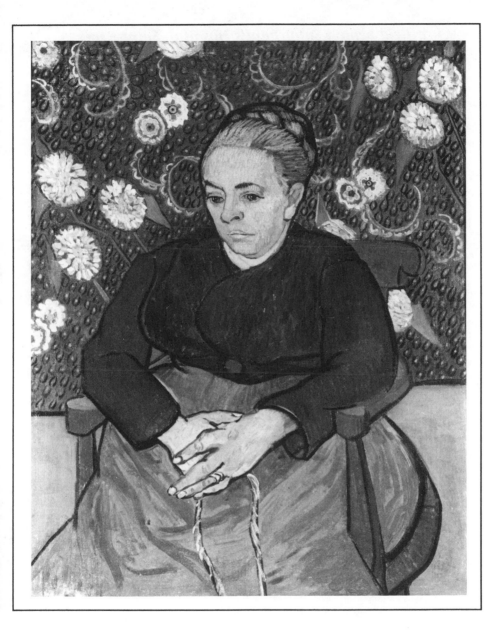

Wheatfield behind Saint Paul's Hospital, Saint-Rémy

November-December 1889 F718, oil on canvas
9 1/2" x 13 1/4"

Collection Mr. and Mrs. Paul Mellon
Virginia Museum of the Fine Arts

✳

Since I have been here, the deserted garden, planted with large pines beneath which the grass grows tall and unkempt and mixed with various weeds, has sufficed for my work, and I have not yet gone outside. However, the country round St. Rémy is very beautiful and little by little I shall probably widen my field of endeavor.

But if I stay here, the doctor will naturally be better able to see what is wrong, and will, I hope, be more reassured as to my being able to paint.... Through the iron-barred window I see a square-field of wheat in an enclosure, a perspective like Van Goyen, above which is the morning sun in all its glory.

Letter to Theo, #592

The Starry Night 1732 (F1540), Pen
Destroyed, formerly Kunsthalle, Bremen 18 1/2" x 24 3/4"

Vincent van Gogh Foundation
National Museum Vincent van Gogh, Amsterdam

※

Enfin, I have a landscape with olive trees and also a new study of a starry sky.

Though I have not seen either Gauguin's or Bernard's canvases, I am pretty well convinced that these two studies I've spoken of are parallel in feeling.

When you have looked at these two studies for some time, and that of the ivy as well, it will perhaps give you some idea, better than words could, of the things that Gauguin and Bernard and I sometimes used to talk about, and which we've thought about a good deal; it is not a return to the romantic or to religious ideas, no. Nevertheless, by going the way of Delacroix, more than is apparent, by color and a more spontaneous drawing than delusive precision, one could express the purer nature of a countryside compared with the suburbs and cabarets of Paris.

Gauguin, Bernard and I may stop at that point perhaps and not conquer, but neither shall we be conquered; perhaps we exist neither for the one thing nor for the other, but to give consolation or to prepare the way for a painting that will give even greater consolation.

Letter to Theo, #595

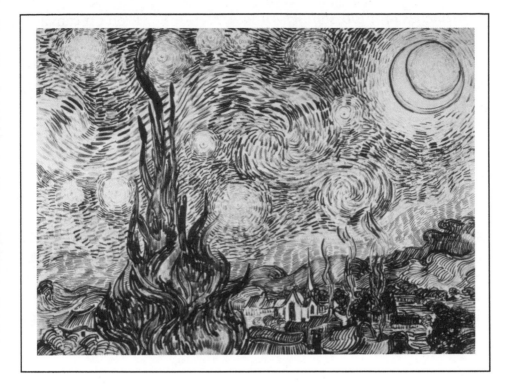

Branches of a Blossoming Almond F671, oil on canvas
 28 3/4" x 36 1/4"
Saint-Rémy, February 1890
Gift to brother Theo and Jo's newborn child

Vincent van Gogh Foundation
National Museum Vincent van Gogh, Amsterdam

✳

I should have greatly preferred him to call the boy after Father, of whom I have been thinking so much these days, instead of after me; but seeing it has now been done, I started right away to make a picture for him to hang in their bedroom, big branches of white almond blossom against a blue sky.

Letter to his mother, #627

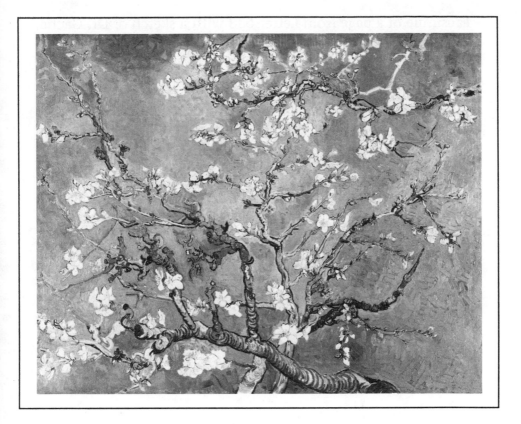

Facsimile of a page from Letter 638 with a sketch of Dr. Gachet
Auvers-sur-Oise, spring 1890

Vincent van Gogh Foundation
National Museum Vincent van Gogh, Amsterdam

✳

I am working at his portrait, the head with a cap, very fair,
very light, the hands also a light flesh tint, a blue frock coat
and a cobalt blue background, leaning on a red table, on
which are a yellow book and a foxglove plant with purple
flowers. It has the same sentiment as the self-portrait I did
when I left for this place.

Letter to Theo, #638

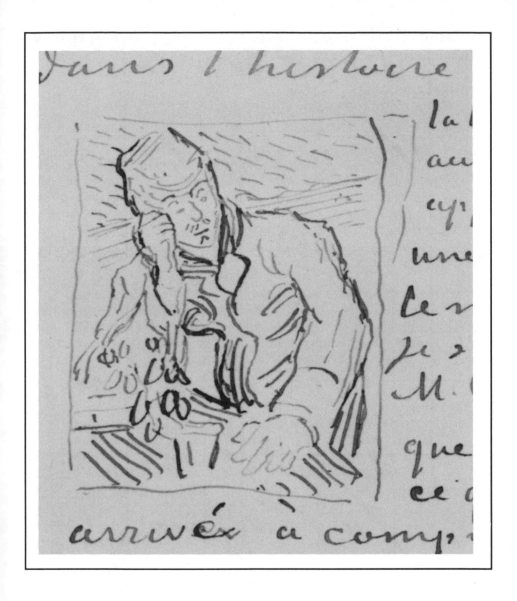

Portrait of Doctor Gachet with Pipe G1664, etching
Auvers-sur-Oise, spring 1890 7 1/8" x 5 7/8"

Anderson Gallery
Virginia Commonwealth University, Richmond, Virginia

✳

I have seen Dr. Gachet, who gives me the impression of being rather eccentric, but his experience as a doctor must keep him balanced enough to combat the nervous trouble from which he certainly seems to me to be suffering at least as seriously as I.

Letter to Theo, #635

✳

. . . . I can print them without cost at M. Gachet's, who is kind enough to print them for nothing if I do them. That is certainly something that ought to be done, and we will do it in such a way that it will form a sort of sequel to the Lauzet-Monticelli publication, if you approve. . . .

Letter to Theo, #642

✳

I think we must not count on Dr. Gachet *at all.* First of all, he is sicker than I am, I think, or shall we say just as much, so that's that. Now when one blind man leads another blind man don't they both fall in the ditch?

Letter to Theo, #648

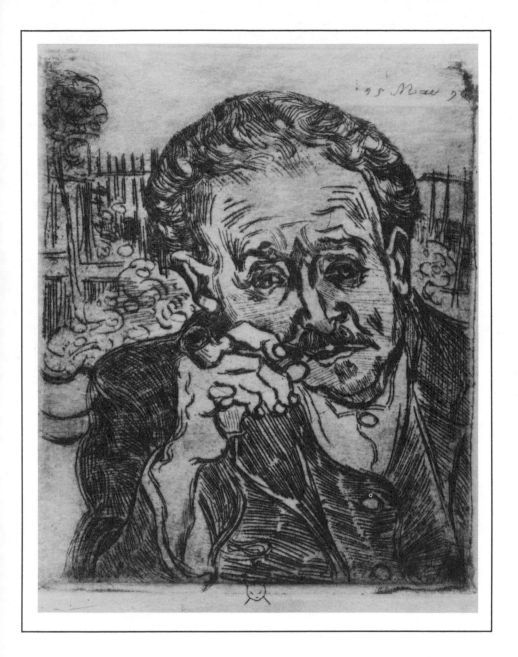

Blossoming Stalks F1612, Pencil, reed pen, brown ink,
Auvers-sur-Oise, summer 1890 16 1/8" x 12 1/4"

Vincent van Gogh Foundation
National Museum Vincent van Gogh, Amsterdam.

❋

If we study Japanese art, we see man who is undoubtedly wise, philosophic and intelligent, who spends his time doing what? In studying the distance between the earth and the moon? No. In studying Bismark's policy? No. He studies a single blade of grass.

Letter to Theo, #542

Wheatfield with Crows under a Stormy Sky F779
Auvers-sur-Oise, July 1890 oil on canvas
 20 1/8" x 39 3/4"

Vincent van Gogh Foundation
National Museum Vincent van Gogh, Amsterdam

❋

They are vast fields of wheat under troubled skies, and I did
not need to go out of my way to try to express sadness and
extreme loneliness. I hope you will see them soon—for I hope
to bring them to you in Paris as soon as possible, since I almost
think that these canvases will tell you what I cannot say in
words, the health and restorative forces that I see in the
country.

Letter to Theo, #649

Notes

Preface—pp. xi–xvii

[1] Julius Meier-Graefe, *Vincent Van Gogh: A Biographical Study*, trans. Holroyd-Reece (N.Y.: The Literary Guild of America, 1933), xvi.

[2] Meyer Shapiro, *Van Gogh* (Garden City, N.Y.: Doubleday and Company, 1980), 11–12.

[3] There are, of course, exceptions to this rule, and a few creative theologians have pioneered in the effort to open theology toward the visual arts. For an account of the problems involved in the relationship between art and religion, see Samuel Laeuchli, *Religion and Art in Conflict* (Phila.: Fortress Press, 1980). For examples of creative works, see John Wesley Dixon, *Art and the Theological Imagination* (N.Y.: The Seabury Press, 1978), and Roger Lipsey, *An Art of Our Own: The Spiritual in Twentieth-Century Art* (Boston: Shambhala, 1988). *Art, Creativity, and the Sacred*, edited by Diane Apostolos-Cappadona, provides a collection of essays and excerpts on the topic (N.Y.: Crossroad, 1986).

Chapter One: A Pilgrim's Progress—pp. 1–14

[1] "Vincent's Sermon" in *The Complete Letters of Vincent Van Gogh*, 3 vols. Introduction by V. W. van Gogh; Preface and Memoir by J. van Gogh-Bonger (Boston: New York Graphic Society, 1981), 1:87–88; hereafter referred to as *Complete Letters*.

[2] Elisabeth du Quesne van Gogh, *Personal Recollections of Vincent Van Gogh*, trans. K. Dreier (New York: Houghton Mifflin Co., 1913), 4; hereafter, *Personal Recollections*.

[3] Ibid., 5–7. Compare Marc Tralbaut, *Vincent Van Gogh* (Lausanne: Edita Lausanne, 1969), 29–31.

[4] Tralbaut, *Vincent Van Gogh*, 25.

[5] Ibid.

[6] "Vincent Van Gogh as Bookseller's Clerk" in *Complete Letters, entry* 94a, 1:112.

[7] Ibid., Interview of P. C. Görlitz, 1:112. See also 3:595–600.

[8] Ibid.,"Personal Memories" of Dr. M. B. Mendes da Costa, entry 122a, 1:170.

[9] A. S. Hartrick, "A Painter's Pilgrimage through Fifty Years," in *Van Gogh: A Retrospective*, ed. Susan Stein (New York: Macmillan Publishing Co., 1986), 81.

[10] *Complete Letters*, 590b, 3:168.

[11] See Judith Wechsler, *A Human Comedy: Physiognomy and Caricature in 19th Century Paris* (Chicago: University of Chicago Press, 1982), 70. Note Vincent's positive reference to his own reading of Lavater and Gall, *Physiognomy and Phrenology*, in *The Complete Letters*, letter 138, 1:211.

[12] Jan Hulsker, *The Complete Van Gogh* (New York: Harry N. Abrams, Inc., 1980), 946 (F117), p. 208 depicts the open Bible with the clear marking "ESAIE LIII." Vincent associates Isaiah's "Man of Sorrows" and "Imitation of Christ" in a sermon in letter 127, *Complete Letters*, 1:184.

[13] See George Knight, *Isaiah 40–55: Servant Theology* (Grand Rapids: Wm. B. Eerdmans, 1984), 170.

[14] See Charles Torrey, *The Second Isaiah* (New York: Charles Scribner's Sons, 1928); also "Who is the Servant?" in A. Herbert, *The Book of the Prophet Isaiah: Chapters 40–66* (Cambridge: Cambridge University Press, 1975), 10–14.

[15] Herbert, *Book of the Prophet Isaiah*, 10–14. John Calvin interpreted the Servant to be "Christ and his whole kingdom." John Calvin, *Commentary on the Book of the Prophet Isaiah*, trans. W. Pringle (Edinburgh: Calvin Translation Society, 1853), 113–15.

Chapter Two: Religious Transformation—pp. 15–37

[1] Johanna van Gogh-Bonger "Memoir of Vincent Van Gogh" in *Complete Letters*, 1:xxiv–xxv.

[2] Frank Elgar, *Van Gogh*, trans. J. Cleugh (New York: Frederick A. Praeger Publishers, 1958), 18.

[3] Pierre Cabanne, *Van Gogh*, trans. D. Woodward (New York: Thames and Hudson, 1986), 14.

[4] Albert Lubin, *Stranger on the Earth* (New York: Holt, Rinehart and Winston, Inc., 1972), 36.

[5] Tralbaut, *Vincent Van Gogh*, 46.

[6] *Complete Letters*, 1:1–4, 7–14. See especially letters 1–5, 9–11.

[7] Van Gogh-Bonger, "Memoir of Vincent Van Gogh" in *Complete Letters*, 1:xxiv–xxvi.

[8] Pierre Cabanne, *Van Gogh*, 14.

[9] Elgar, *Van Gogh*, 18.

[10] Tralbaut, *Vincent Van Gogh*, 44.

[11] Hulsker, *Complete Van Gogh*, 8.

[12] Ibid., footnote, p. 8.

[13] Jules Michelet, *Love*, trans. J. Palmer (New York: Rudd and Carleton, 1859), chapters 4 and 5, book 5:291–303.

[14] Humberto Nagera, *Vincent van Gogh: A Psychological Study* (New York: International Universities Press, 1967), 14, 45.

[15] Ibid., 13, 42.

[16] Jean Leymarie, *Van Gogh*, trans. J. Emmons (New York: Rizzoli, 1977), 11.

[17] Tralbaut, *Vincent Van Gogh*, 23.

[18] Lubin, *Stranger on the Earth*, 88–89.

[19] Ibid., 93–94.

[20] Ibid., 100.

[21] Ibid., 102.

[22] Ibid.

[23] *Complete Letters*, 1:260–66. See especially letters 156 and 157.

[24] Michelet, *Love*, 301.

[25] C. D. Batson and W. L. Ventis, *The Religious Experience: A Social-Psychological Perspective* (New York: Oxford, 1982), 7–8.

[26] Thomas à Kempis, *The Imitation of Christ* (New York: Penguin Books, 1952), chapters 1 and 2, book 1:28–29.

[27] *Complete Letters*, see letter 614, 3:228–30, letter 643, 3:284–87, and letter B 21, 3:521–25.

[28] *Complete Letters*, entry 122a, 1:171. Mendes da Costa, describing van Gogh's lithograph collection, notes: ". . .they were always completely spoiled: the white borders were literally covered with quotations from Thomas à Kempis and the Bible. . . ."

[29] John Calvin, *Institutes of the Christian Religion,* ed. John McNeill, 2 vols. (Philadelphia, 1960), 1:36.

[30] See Kai Erikson, *Wayward Puritans: A Study in the Sociology of Deviance* (New York, Wiley, 1966), 141–58, and *The Works of President Edwards* (New York, 1879), vol. 4, especially the sermons entitled "Men Naturally God's Enemies," "The Eternity of Hell Torments," and "Sinners in the Hands of an Angry God."

[31] *Complete Letters*, letter 50, 1:45–46.

[32] "Vincent's Sermon," in *Complete Letters*, 1:87–91.

[33] Van Gogh-Bonger, "Memoir of Vincent Van Gogh," in *Complete Letters*, 1:xxvi and xxviii.

[34] Ibid., xxvi.

[35] Ibid., xxvii.

[36] "Twenty-third report of the Synodal Board of Evangelization" (1879–1880), in *Complete Letters*, 1:227.

Chapter Three: From *Book* to Books—pp. 39–62

[1] In *Calvin: Theological Treatises*, Library of Christian Classics, 26 vols., trans. J. Reid (Philadelphia: The Westminster Press, 1954), 22:26.

[2] See Ronald Wallace, *Calvin's Doctrine of the Word and Sacrament* (Grand Rapids: Wm. B. Eerdmans Publishing Company, 1957), 24–25.

[3] Reid, *Calvin: Theological Treatises*, 1:83, 99.

[4] Ibid., 99.

[5] Ibid., 99 (I, Ch. 14, section 4 of Calvin's *Institutes of the Christian Religion*).

[6] Tralbaut, *Vincent van Gogh*, 12.

[7] Compare *Complete Letters* (entry A3), 3:592-93 on the Groningen party. Kenneth Latourette, *Christianity in a Revolutionary Age: A History of Christianity in the Nineteenth and Twentieth Centuries ; vol. 2, The Nineteenth Century in Europe:The Protestant and Eastern Churches* (New York: Harper and Brothers, 1959), indicates the complexity of the religious situation in Holland, 237–49. Steven Meyer, *Calvinism and the Rise of the Protestant Political Movement in the Netherlands* (Ph. D., Diss. Georgetown University, 1976), gives an even more detailed picture of divisions within Dutch Calvinism.

[8] Tralbaut, *Vincent van Gogh*, 12–13.

[9] "Vincent Van Gogh as Bookseller's Clerk," in *Complete Letters*, 1:108.

[10] *Complete Letters*, letter 69, 1:59. In this letter, Vincent wrote of becoming a "missionary among the working people in the suburbs of London," and in letter 70, 1:61, of becoming "a London missionary."

[11] See *Complete Letters*, letter R 37, 3:389.

[12] See Hulsker, *Complete Van Gogh*, 946 (F 117) on page 208.

[13] For example, his comments on the Dr. Gachet portrait in letters 643 and W 22, the Patience Escalier portrait in letter 520, and an interpretation of the "Reaper" in letter 604, *Complete Letters*, vol. 3.

[14] "ESAIE LIII" can be seen clearly in color plate xi, Hulsker, *Complete Van Gogh*, 187.

[15] Ibid., 206.

[16] H. R. Graetz, *The Symbolic Language of Vincent Van Gogh* (New York: McGraw-Hill Book Company, 1963), 40–42.

[17] The French text can be found in *Les Rougon-Macquart: Histoire Naturelle et Social d'une Famille Sous le Second Empire,* 5 vols., ed. Henri Mitterand (Dijon: Bibliotèque de la Pléiade, 1965), 3:833.

[18] Ibid., 1129–1130.

[19] See, for example, letter 594, in *Complete Letters,* 3:180; for earlier references, see his appreciation of Rembrandt's *Bible Reading* in letter 30, 1:29. He especially admired *Burgomaster Six* who is "reading before the window" (letter 37, 1:35), and Ph. de Champaigne's painting of a nun with a copy of the *Imitation* beside her (letter 31, 1:30).

[20] Hulsker, *Complete Van Gogh,* 1349 (F 360), p. 304.

[21] Ibid., 1566 (F 593), p. 359, 1624 (F 488), p. 374, 1632 (F 497), p. 375.

[22] Ibid., 1636 (F 499), p. 376, 1656 (F 604), p. 380.

[23] Ibid., 1894 (F 542), p. 435.

[24] Ibid., 2007 (F 753), p. 460–61.

[25] See *Complete Letters,* letter R 34, 3:383, for Vincent's view of the importance of books as an influence on an artist's work; for examples, note the influence of a Daudet novel in letter 552, and a Loti novel as discussed in Hulsker, *Complete Van Gogh,* 342–46.

[26] How highly Vincent valued his collection of prints becomes clear in *Complete Letters,* vol. 1, letters 169, 205, 229; vol. 2, letter 297 to Theo; and in vol. 3, letters R 15 to R 33 to Rappard.

[27] See especially the letters to Bernard in *Complete Letters:* letter B 8, 3:495–98, and letter B 9, 3:498–500.

[28] See J. Soggin, *Introduction to the Old Testament* (Philadelphia: Westminster Press, 1980), 85–87 on Wellhausen; Robert Grant and David Tracy, *A Short History of the Interpretation of the Bible* (Philadelphia: Fortress Press, 1984), 112–13, discuss the Tübingen School.

[29] The Preface is found in Edmond and Jules de Goncourt, *Germinie Lacerteux,* trans. L. Tancock (New York: Penguin Books, 1984), 15–16.

[30] On The Hague School, see *The Hague School: Dutch Masters of the 19th Century,* ed. Ronald de Leeuw, John Sillevis, Charles Dunas (London: Royal Academy of Arts, 1983). On Vincent's relationship to Social Realism, see André Krauss, *Vincent van Gogh: Studies in the Social Aspects of His Work* (Tel Aviv: Gothenburg Studies in Art and Architecture, 2, 1983); cf. David Stark, *Charles De Groux and Social Realism in Belgian Painting, 1848–1875* (Ph. D. Diss., Ohio State University, 1979).

[31] Thomas Carlyle, *Sartor Resartus* (London: Chapman and Hall, 1897), 178–79; see also Eloise M. Behnken, *Thomas Carlyle: Calvinist without the Theology* (Columbia: University of Missouri Press, 1978), 25–26.

[32] Cited and discussed in Ziva Amishai-Maisels, *Gauguin's Religious Themes* (New York: Garland, 1985), 21–23.

[33] *Complete Letters,* 3:521–25, letter B 21.

[34] Victor Hugo, *Notre Dame de Paris,* in *Victor Hugo's Works,* (New York: The Century Company, 1909), 6:189–90.

[35] Ibid., 191–206.

[36] Charles Dickens, *The Works of Charles Dickens,* 34 volumes, (New York: Charles Scribner's Sons, 1899), *Christmas Books,* 18:9–98.

[37] See *Complete Letters,* letter R 30, 3:374; compare his comments on archaic symbolism in letter B 21, 3:521–25, and his refusal of a "sort of freemasonry" for painters, in B 18, 3:515.

[38] See Vincent's letter in response to Aurier's review, *Complete Letters,* letter 626a, 3:257: "I do not see the use of so much sectarian spirit as we have seen these last years, *but I am afraid of the preposterousness of it."*

Chapter Four: The Vulnerability of God—pp. 63–83

[1] "Vincent's Sermon" in *Complete Letters,* vol. 1:87–91.

[2] Ibid., 87.

[3] Notes by P. Driutte, in *Complete Letters,* 1:230.

[4] See, for example, E. A. Speiser, *Genesis* (Garden City, N.Y.: Doubleday and Company, 1964), xxvii: ". . .God himself becomes anthropomorphic."

[5] Shubert Ogden, "Toward a New Theism," in *Process Philosophy and Christian Thought,* ed. Delwin Brown, Ralph James, Jr., and Gene Reeves (N.Y.: The Bobbs-Merrill Company, 1971), 173–87. See p. 185.

[6] Martin Buber, *The Eclipse of God* (N.Y.: Harper and Brothers, 1952), 23.

[7] A. Sensier and P. Mantz, *La vie et l'oeuvre de Jean-François Millet* (Paris: 1881); trans. H. de Kay, *Jean-Francis Millet, Peasant and Painter* (Cambridge, Mass.: J. R. Osgood and Company, 1881.

[8] "Memoir of Vincent Van Gogh" by Johanna van Gogh-Bonger, in *Complete Letters,* 1:xxxiii.

[9] There are five versions of "La Berceuse." In Hulsker's *Complete Van Gogh* they are: nos. 1655 (F 504), 1669 (F505), 1670 (F 506), 1671 (F 508), and 1672 (F 507). The original can be seen in the Rijksmuseum Kröller-Muller in Otterlo, Holland, with copies by Vincent at both the Art Institute of Chicago and the Museum of Fine Arts in Boston.

Chapter Five: The Oriental Connection—pp. 85–116

[1] On the complexity of the city/countryside conflict in van Gogh, see Griselda Pollack, "Van Gogh as Painter of Peasants: Van Gogh and the Poor Slaves" in *Peasants and Countrymen in Literature* (London: Roehampton Institute, 1982), 183–205.

[2] Vincent may have seen Japanese prints earlier in Holland; see his January 1884, letter to Furnée (letter 351a). Fred Orton emphasizes the availability of Japanese art in Holland from the 1830s in his essay "Vincent van Gogh and Japanese Prints" in *Japanese Prints Collected by Vincent van Gogh.* Introduction by Willem van Gulik. Amsterdam: Rijksmuseum Vincent van Gogh, 1978.

[3] *Manette Salomon* with its references to "experiments with the techniques of Japanese painting," is described by Richard Grant in *The Goncourt Brothers* (New York: Twayne Publishers, 1972), 85–96.

[4] On S. Bing, see Siegfried Wichman, *Japonisme* (New York: Park Lane, 1985), 8–9; Frank Whitford, *Japanese Prints and Western Painters* (Lon-

don: Studio Vista, 1977), *passim.*, and *Dialogue in Art: Japan and the West,* ed. Chisaburoh Yamada (Tokyo: Kodansha International, 1976), 153–54.

⁵ The Rijksmuseum Vincent van Gogh publication *Japanese Prints Collected by Vincent van Gogh* gives the details of the Japanese prints Vincent owned and includes essays on the context of his association with Japanese art. Vincent's Japanese print collection is housed at the Rijksmuseum Vincent van Gogh in Amsterdam.

⁶ Several of Vincent's letters to Theo return to the subject of S. Bing's collection of Japanese prints. See letters 510 and 511, *Complete Letters,* 2:611–15.

⁷ Hulsker, *Complete van Gogh,* 1296 (F371), 1297 (F372), 1298 (F373) on page 289. These paintings also appear in the context of the Japanese originals in Wichman, *Japonisme,* 41–43.

⁸ Chapters on Manet, Degas, van Gogh, Gauguin and Vallotton can be found in Wichman, *Japonisme*; see Frank Whitford, *Japanese Prints and Western Painters* for chapters on Seurat, Signac, and Mary Cassatt.

⁹ See Joel Isaäcson, *Claude Monet: Observation and Reflection* (Oxford: Phaidon, 1978).

¹⁰ Genevieve Aitken and Marianne Delafond, *La Collection d'Estampes Japonaises de Claude Monet à Giverny* (Giverny: Maison de Monet, 1983).

¹¹ For general discussions of ukiyo-e, see Hugo Munsterberg, *The Japanese Print: A Historical Guide* (New York: Weatherhill, 1982), and Seiichiro Takahashi, *Traditional Woodblock Prints of Japan,* trans. R. Stanley-Baker, (New York: Weatherhill, 1972).

¹² S. *Bing, comp., Le Japon Artistique.* In English: *Artistic Japan: A Monthly Illustrated Journal,* compiled by S. Bing, ed. Marcus Huish, vol. I, no. 1 (May 1888), 6.

¹³ *Dialogue in Art: Japan and the West,* 13.

¹⁴ Ibid., 27–70.

¹⁵ Masao Abe, "Man and Nature in Christianity and Buddhism," 148–56 in *The Buddha Eye: An Anthology of the Kyoto School,* ed. Frederick Franck (New York: Crossroad, 1982), 150.

[16] D. T. Suzuki, *Zen and Japanese Culture*, (Princeton: Princeton University Press, 1970), 31.

[17] Nobuyuki Yuasa, *Basho: The Narrow Road to the Deep North and other Travel Sketches* (New York: Penguin Books, 1966), 71.

[18] Ibid., 33.

[19] Albert Schweitzer, *Out of My Life and Thought* (New York: Holt, Reinhart, and Winston, 1933), 156.

[20] Ibid., 158–59.

[21] Gary Snyder, *The Old Ways* (San Francisco: City Lights Books, 1977), 42.

[22] Masao Abe, in *The Buddha Eye*, 153–54.

[23] Heinrich Dumoulin, *Zen Enlightenment: Origins and Meaning*, trans. J Maraldo (New York: Weatherhill, 1979), 123.

[24] Nobuyuki Yuasa, *Basho*, 71.

[25] See the discussion of the Isaäcson review in Carol Zemel, *The Formation of a Legend: Van Gogh Criticism, 1890–1920* (Ann Arbor: UMI Research Press, 1980), 14–15; for Vincent's reply to Isaäcson, see letter 614a, *Complete Letters*, 3:231–33. J. Hulsker has argued that Vincent wrote 614a from Auvers; see Appendix I in Ronald Pickvance, *Van Gogh in Saint-Rémy and Auvers* (New York, Harry N. Abrams, 1986).

[26] "Memoir of Vincent Van Gogh" in *Complete Letters*, 1:L

Chapter Six: Symbolism—pp. 117–53

[1] Paul Tillich, *Dynamics of Faith* (New York: Harper and Row, 1957), 42.

[2] Ibid., 42–43.

[3] Carl Jung, *Man and His Symbols* (Garden City: Doubleday, 1964), 20.

[4] Ibid., 102.

[5] Eric Neumann, *Art and the Creative Unconscious*, trans. Ralph Manheim (Princeton: Princeton University Press, 1974); see the essay "Creative Man and Transformation," 159–60.

⁶ Ibid.,167.

⁷ Ibid.,170.

⁸ Graetz, *Symbolic Language of Vincent van Gogh.*

⁹ Ibid., 7, 9–10, 307.

¹⁰ Ibid., 23.

¹¹ Bernard Zurcher, *Vincent van Gogh: Art, Life and Letters* (New York: Rizzoli, 1985) 206.

¹² Lubin, *Stranger on the Earth,* 88–89.

¹³ Ibid., 91–95.

¹⁴ Ibid., 97.

¹⁵ Shapiro, *Van Gogh,* 33–34, 100.

¹⁶ Ibid., 11–12.

¹⁷ See, for example, "The subversion of the subject and the dialectic of desire in the Freudian unconscious," 292–325, in Jacques Lacan, *Écrits: A Selection,* trans. Alan Sheridan (New York: W. W. Norton and Company, 1977.

¹⁸ See chapter one, "The Significance of Labor," in Behnken, *Thomas Carlyle,* 10-40.

¹⁹ For van Gogh's admiration of Zola's method, see letter 429, *Complete Letters,* 2:427–29; the Gauguin quotation is located and discussed in Amishai-Maisels, *Gauguin's Religious Themes,* 21–23.

²⁰ See, for example, Edward Lucie-Smith, *Symbolist Art* (New York: Praeger Publishers, 1972), especially chapters 4 through 9, pp. 51–124.

²¹ Ibid., 54–58.

²² Ibid.,109–24.

²³ Ibid., 47.

[24] The text of Aurier's article in both French and English appears as Appendix III in Ronald Pickvance, *Van Gogh in Saint-Rémy and Auvers* (New York: The Metropolitan Museum of Art, 1986), 312–13.

[25] Ibid., 311.

[26] See especially Keiji Nishitani, trans. Jan Van Bragt, *Religion and Nothingness* (Berkeley, University of California Press, 1982).

[27] Ibid., 146.

[28] Ibid., 149.

[29] Ibid., 157.

[30] See, for example, Daisetz Suzuki, *An Introduction to Zen Buddhism* (New York: Grove Press, 1964), chapter 7, "The Koan," 99–117; also, Katsuki Sekida, *Two Zen Classics* (New York: Weatherhill, 1977) and Zenkei Shibayama, *Zen Comments on the Mumonkan* (New York: Harper and Row, 1974).

[31] Nishitani, *Religion and Nothingness*, 128.

[32] Ibid.

[33] In Frederick Franck, *The Buddha Eye*, 153–54.

[34] Nishitani, *Religion and Nothingness*, 159–222.

[35] Ibid., 218–19.

[36] Ibid., 219.

[37] Ibid., 221.

[38] Ibid., 222.

[39] Ibid., 222.

[40] Pickvance, *Van Gogh in Saint-Rémy and Auvers*, 274–76.

[41] Hulsker, *Complete van Gogh*, 478.

[42] Ibid., 478–80.

[43] Graetz, *Symbolic Language of Vincent Van Gogh*, 275–76.

[44] Zurcher, *Vincent Van Gogh*, 277, 283–84.

[45] Shapiro, *Van Gogh*, 130.

[46] Ibid., 34.

[46] Lubin, *Stranger on Earth*, 239–40.

[47] Ibid., 240.

[48] Graetz, *Symbolic Language of Vincent Van Gogh*, 278.

[49] Nishitani, *Religion and Nothingness*, 128.

[50] Ibid.,128, 157.

[51] *Complete Letters*, 1:226.

[52] See the prints numbered 57, 53a, 22, and 348, for example, in *The Japanese Prints of Vincent Van Gogh*. See also n. 2, chapter 5.

[53] Jules Michelet, *The Bird* (London:Wildwood House Ltd.,1981), 16.

Works Cited

ABE, Masao. "Man and Nature in Christianity and Buddhism" in *The Buddha Eye: An Anthology of the Kyoto School*, ed. Frederick Franck. New York: Crossroad, 1982.

AITKEN, Genevieve and Marianne DELAFOND. *La Collection d'Estampes Japonaises de Claude Monet à Giverny*. Giverny: Maison de Monet, 1983.

AMISHAI-MAISELS, Zive. *Gauguin's Religious Themes*. New York: Garland, 1985.

APOSTOLOS-CAPPADONA, Diane, ed. *Art, Creativity, and the Sacred*. New York: Crossroad, 1986.

BATSON, Daniel C. and W. L. VENTIS. *The Religious Experience: A Social-Psychological Perspective*. New York: Oxford, 1982.

BEHNKEN, Eloise M. *Thomas Carlyle: Calvinist without the Theology*. Columbia: University of Missouri Press, 1978.

BING, S., comp. *Le Japon Artistique*. In English, *Artistic Japan: A Monthly Illustrated Journal*, ed. Marcus Huish. See vol. 1, no. 1 (May 1888).

BUBER, Martin. *The Eclipse of God*. New York: Harper and Brothers, 1952.

CABANNE, Pierre. *Van Gogh*. Trans. D. Woodward. New York: Thames and Hudson, 1986.

CALVIN, John. *Commentary on the Book of the Prophet Isaiah*. Trans. W. Pringle. Edinburgh: Calvin Translation Society, 1853.

————. *The Institutes of the Christian Religion*, 2 vols. Ed. John McNeill. Philadelphia 1960.

CARLYLE, Thomas, *Sartor Resartus*. London: Chapman and Hall, 1897.

DE GONCOURT, Edmond and Jules A. *Germinie Lacerteux*. Trans. L. Tancock. New York: Penguin Books, 1984.

DE LEEUW, Ronald, John SILLEVIS, and Charles DUNAS, eds. *The Hague School: Dutch Masters of the 19th Century.* London Royal Academy of Arts, 1983.

DICKENS, Charles. *The Works of Charles Dickens,* 34 vols. New York: Charles Scribner's Sons, 1899. *Christmas Books,* vol. 18.

DIXON, John Wesley. *Art and the Theological Imagination.* New York: The Seabury Press, 1978.

DUMOULIN, Heinrich. *Zen Enlightenment: Origins and Meaning.* Trans. John Maraldo. New York: Weatherhill, 1979.

EDWARDS, Jonathan. *The Works of President Edwards.* 4 vols. New York: Robert Carter and Brothers, 1879.

ELGAR, Frank. *Van Gogh.* Trans. J. Cleugh. New York: Frederick A. Praeger Publishers, 1958.

ERIKSON, Kai. *Wayward Puritans: A Study in the Sociology of Deviance.* New York: Wiley, 1966.

FRANCK, Frederick, ed. *The Buddha Eye: An Anthology of the Kyoto School.* New York: Crossroad, 1982.

GRAETZ, H. R. *The Symbolic Language of Vincent Van Gogh.* New York: McGraw-Hill Book Company, 1963.

GRANT, Richard. *The Goncourt Brothers.* New York: Twayne Publishers, 1972.

GRANT, Robert M. and David TRACY. *A Short History of the Interpretation of the Bible.* 2d rev. Philadelphia: Fortress Press, 1984.

HARTRICK, A. S. "A Painter's Pilgrimage through Fifty Years." In *Van Gogh: A Retrospective,* ed. Susan Stein. New York: Macmillan Publishing Co., 1986.

HERBERT, A. *The Book of the Prophet Isaiah: Chapters 40-66.* Cambridge University Press, 1975.

HUGO, Victor. *Victor Hugo's Works.* Vol. 6, *Notre Dame de Paris.* New York: The Century Company, 1909.

HULSKER, Jan. *The Complete Van Gogh.* New York: Harry N. Abrams, Inc., 1980.

ISAÄCSON, Joel. *Claude Monet: Observation and Reflection.* Oxford: Phaidon, 1978.

JUNG, Carl. *Man and His Symbols.* Garden City: Doubleday, 1964.

KNIGHT, George. *Isaiah 40–55: Servant Theology.* Grand Rapids: Wm. B. Eerdmans, 1984.

KRAUSS, André. *Vincent van Gogh: Studies in the Social Aspects of His Work.* Tel Aviv: Gothenburg Studies in Art and Architecture, 2, 1983.

LACAN, Jacques. *Écrits: A Selection.* Trans. Alan Sheridan, New York: W. W. Norton and Company, 1977.

LAEUCHLI, Samuel. *Religion and Art in Conflict.* Philadelphia: Fortress Press, 1980.

LATOURETTE, Kenneth. *Christianity in a Revolutionary Age: A History of Christianity in the Nineteenth and Twentieth Centuries.* Vol. 2, *The Nineteenth Century in Europe: The Protestant and Eastern Churches.* New York: Harper and Brothers, 1959.

LEYMARIE, Jean. *Van Gogh.* Trans. J. Emmons. New York: Rizzoli, 1977.

LIPSEY, Roger. *An Art of Our Own: The Spiritual in Twentieth-Century Art.* Boston: Shambhala, 1988.

LUBIN, Albert. *Stranger on the Earth.* New York: Holt, Rinehart and Winston, Inc., 1972.

LUCIE-SMITH, Edward. *Symbolist Art.* New York: Praeger Publishers, 1972.

MEIER-GRAEFE, Julius. *Vincent Van Gogh: A Biographical Study.* Trans. Holroyd-Reece. New York: The Literary Guild of America, 1933.

MEYER, Steven. *Calvinism and the Rise of the Protestant Political Movement in the Netherlands.* Ph. D. Diss., Gerogetown University, 1976.

MICHELET, Jules. *The Bird.* London: Wildwood House Ltd., 1981.

———. *Love.* Trans. J. Palmer. New York: Rudd and Carleton, 1859.

MITTERAND, Henri, ed. *Histoire Naturelle et Social d'une Famille sous le Second Empire.* 5 vols. Dijon: Bibliotèque de la Pléiade, 1965.

MUNSTERBERG, Hugo. *The Japanese Print: A Historical Guide.* New York: Weatherhill, 1982.

NAGERA, Humberto. *Vincent van Gogh: A Psychological Study.* New York: International Universities Press, 1967.

NEUMANN, Eric. *Art and the Creative Unconscious.* Trans. Ralph Manheim. Princeton: Princeton University Press, 1974.

NISHITANI Keiji. *Religion and Nothingness.* Trans. Jan Van Bragt. Berkeley: University of California Press, 1982.

OGDEN, Shubert. "Toward a New Theism." In *Process Philosophy and Christian Thought.* Ed. Delwin Brown, Ralph James, Jr., and Gene Reeves. New York: The Bobbs-Merrill Company, 1971.

ORTON, Fred. "Vincent van Gogh and Japanese Prints" in *Japanese Prints Collected by Vincent van Gogh.* Introduction by Willem van Gulik. Amsterdam: Rijksmuseum Vincent van Gogh, 1978.

PICKVANCE, Ronald. *Van Gogh in Saint-Rémy and Auvers.* New York: Harry N. Abrams, 1986.

POLLACK, Griselda. "Van Gogh as Painter of Peasants: Van Gogh and the Poor Slaves." In *Peasants and Countrymen in Literature.* London: Roehampton Institute, 1982.

REID, J. Trans. *Calvin: Theological Treatises.* Library of Christian Classics. 26 vols. Philadelphia: The Westminster Press, 1954.

RENAN, Ernest. *La Vie de Jésus.* Paris: Michel Lévy, 1863. English ed., *The Life of Jesus.* Introduction by John Haynes Holmes. New York: Modern Library, 1927.

SCHWEITZER, Albert. *Out of My Life and Thought.* New York: Holt, Rinehart, and Winston, 1933.

SENSIER, A. and P. MANTZ. *La vie et l'oeuvre de Jean-François Millet.* Paris 1881. Trans. H. de Kay. *Jean-Francis Millet, Peasant and Painter.* Cambridge, Mass.: J. R. Osgood and Company, 1881.

SHAPIRO, Meyer. *Van Gogh.* Garden City, N.Y.: Doubleday and Company, 1980.

SNYDER, Gary. *The Old Ways.* San Francisco: City Lights Books, 1977.

SOGGIN, J. *Introduction to the Old Testament.* Philadelphia: Westminster Press, 1980.

SPEISER, E. A. *Genesis.* Garden City, N. Y.: Doubleday and Company, 1964.

STARK, David. *Charles De Groux and Social Realism in Belgian Painting, 1848–1875.* Ph. D. Diss., Ohio State University, 1979.

STEIN, Susan, ed. *Van Gogh: A Retrospective.* New York: Macmillan Publishing Co., 1986.

SUZUKI, Daisetz. *An Introduction to Zen Buddhism.* New York: Grove Press, 1964.

———. *Zen and Japanese Culture.* Princeton: Princeton University Press, 1970.

TAKAHASHI Seiichiro. *Traditional Woodblock Prints of Japan.* Trans. R. Stanley-Baker. New York: Weatherhill, 1972.

THOMAS à Kempis. *The Imitation of Christ.* New York: Penguin Books, 1952.

TILLICH, Paul. *Dynamics of Faith.* New York: Harper and Row, 1957.

TORREY, Charles. *The Second Isaiah.* New York: Charles Scribner's Sons, 1928.

TRALBAUT, Marc. *Vincent Van Gogh.* Lausanne: Edita Lausanne, 1969.

VAN GOGH, Elisabeth du Quesne. *Personal Recollections of Vincent Van Gogh.* Trans. K. Dreier. New York: Houghton-Mifflin Co., 1913.

VAN GOGH, Vincent. *The Complete Letters of Vincent Van Gogh.* Introduction by V. W. Van Gogh. Preface and Memoir by J. van Gogh-Bonger. 3 vols. Boston: New York Graphic Society, 1981.

WALLACE, Ronald. *Calvin's Doctrine of the Word and Sacrament.* Grand Rapids: Wm. B. Eerdmans Publishing Company, 1957.

WECHSLER, Judith. *A Human Comedy: Physiognomy and Caricature in 19th Century Paris.* Chicago: University of Chicago Press, 1982.

WHITFORD, Frank. *Japanese Prints and Western Painters.* London: Studio Vista, 1977.

WICHMAN, Siegfried. *Japonisme.* New York: Park Lane, 1985.

YAMADA Chisaburoh, ed. *Dialogue in Art: Japan and the West.* Tokyo: Kodansha International, 1976.

YUASA Nobuyuki. *Basho: The Narrow Road to the Deep North and Other Travel Sketches.* New York: Penguin Books, 1961.

ZEMEL, Carol. *The Formation of a Legend: Van Gogh Criticism, 1890–1920.* Ann Arbor: UMI Research Press, 1980.

ZURCHER, Bernard. *Vincent van Gogh: Art, Life, and Letters.* New York: Rizzoli, 1985.

Index to Subjects
in the
Letters of Vincent van Gogh
as Cited

209

Name and Title Index